P■CKET
Visual Encyclopedia

The Art of the Pacific
Kunst des Pazifikraums
Kunst van Oceanië
Arte del Pacífico

SCALA

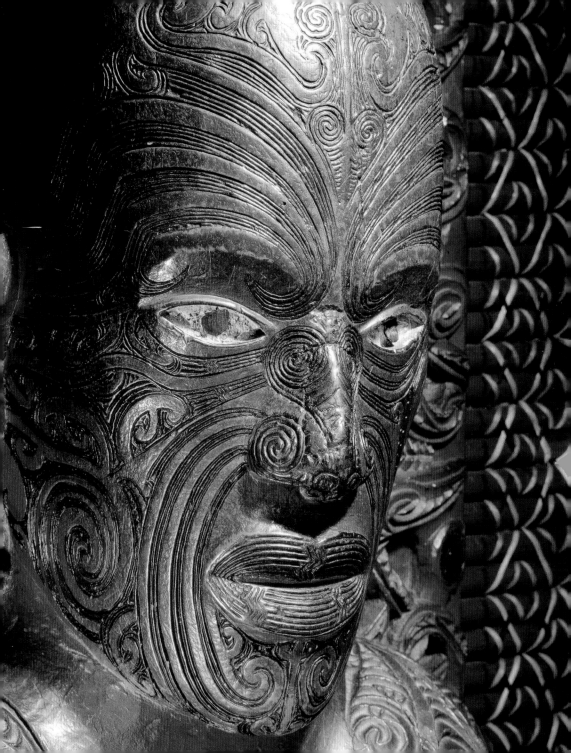

Contents

Inhalt

Inhoudsopgave

Índice

Contents

The immense expanse that opens up between Asia and the coast of America represents an ancient and fascinating world. On the routes traced by the winds and currents, populations and cultures appeared, integrated and split up over the course of the centuries, adapting themselves to a powerful nature that generated unique religious practices that also became part of artistic manifestations. The history of Australia, Melanesia, Micronesia, Easter Island and Polynesia originated with ancient migrations from the continent of Asia. The most distant in time, which took place about 40,000 years ago, brought populations to Papua New Guinea and Australia. The following migration, about 10,000 years ago, brought populations to the more distant archipelagos and to New Zealand. Around 1,500 BCE the Lapita culture spread, which expanded from its ancestral centers in New Caledonia and provided fertile ground for local artistic traditions until the extreme limits of Oceania.

Inevitably, the distance from its original location, the different environmental conditions, and later fragmentations led to a differentiation in cultures, which were open to external influences. From Asia, but soon also from the American coasts, transcontinental routes increasingly affected wider areas in the Pacific, and the process of evolution was slow, but constant. European exploration along with colonization and the spread of missionaries enormously influenced the local cultures. While this initially hastened the crisis, it later played a part in their recovery and conservation.

Einführung

Die riesige Weite, die sich zwischen dem asiatischen Kontinent und der Küste Amerikas auftut, gilt als eine alte und faszinierende Welt. Entlang der vom Wind und von den Strömungen vorgegebenen Richtungen haben sich die Völker und Kulturen im Laufe der Jahrhunderte verstreut, zusammengeschlossen und zersplittert, wobei sie sich den Naturgewalten angepasst haben, die ursprüngliche religiöse Praktiken geschaffen haben, welche sich auch im künstlerischen Schaffen niederschlagen. Die geschichtlichen und traditionellen Wurzeln von Australien, Melanesien, Mikronesien, der Osterinsel und Polynesien sind die alten Völkerwanderungen vom asiatischen Kontinent. Die zeitlich am weitesten entfernte Völkerwanderung hat sich vor circa 40.000 Jahren zugetragen und Papua-Neuguinea sowie Australien bevölkert. Die darauf folgende fand vor ungefähr 10.000 Jahren statt. Sie brachte die brachte die Bevölkerung von den entferntesten Inselwelten bis nach Neuseeland. Um 1.500 v. Chr. verbreitete sich hingegen die Kultur Lapita, welche von Neukaledonien ausgehend den regionalen künstlerischen Traditionen bis in die äußersten Gebiete Ozeaniens neue Anregungen schenkte. Unvermeidlich haben die Entfernung von ihrem Ausgangspunkt, die unterschiedlichen Umweltbedingungen und die folgenden Zersplitterungen zu einer unterschiedlichen Aufnahme in den Kulturen geführt, die stets äußerlichen Einflüssen gegenüber offen waren. Von Asien und sehr bald auch von den amerikanischen Küsten aus waren immer größere Gebiete im Pazifik den Einflüssen der überseeischen Routen ausgesetzt. Die Verbreitung und Entwicklung war beständig, wenn auch langsam. Die Erkundungen der Europäer haben schließlich, zusammen mit der Kolonialisierung und der Missionierung außerordentlich die hiesigen Kulturen beeinflusst. Wenn diese zu Beginn auch die Krise verschärft haben mögen, so haben sie später aber auch zur Wiederentdeckung und zur Bewahrung beigetragen.

Introductie

De enorme uitgestrektheid die ligt tussen het
Aziatische continent en de oevers van Amerika
is vol charme. Routes ontworpen door de wind
en stromingen, volkeren en culturen worden
voorgesteld, geïntegreerd en gefragmenteerd
door de eeuwen heen, zich aanpassend aan
een machtige natuur die heeft gezorgd dat de
oorspronkelijke religieuze praktijken ook deel
uitmaken van de artistieke uitingen.
Australië, Melanesië, Micronesië, Polynesië en
Paaseiland hebben aan de oorsprong van hun
geschiedenis en tradities oude migraties uit
Azië. De periode die het verst in de tijd ligt, die
eindigde ongeveer veertigduizend jaar geleden,
bevolkte Papoea-Nieuw-Guinea en Australië. De
periode erna, ongeveer tienduizend jaar geleden,
bracht de migraties verder weg en uiteindelijk
naar Nieuw-Zeeland. Rond 1500 v. Chr verspreidt
zich de Lapita cultuur, die zich uitbreidend van de
voorouderlijke centra in Nieuw-Caledonië, bracht
nieuwe inzichten bij de lokale artistieke tradities tot
de uiterste grenzen van de oceaan.
Onvermijdelijk leiden de afstand van de
oorspronkelijke locaties, de verschillende
leefomstandigheden en de daaropvolgende
versnippering tot een differentiatie in culturen,
altijd open voor invloeden van buitenaf. Vanuit
Azië, maar al snel ook vanaf de Amerikaanse kust,
hebben de transoceanische routes altijd regio's
breder dan de Stille Oceaan geboeid en het proces
van voortdurende evolutie is doorgezet, zij het
langzaam. De Europese verkenning was, ten slotte,
samen met de kolonisatie en de verspreiding door
missionarissen, van enorme invloed op de lokale
culturen. In het begin ontketende het een crisis,
vervolgens heeft het meegewerkt aan herstel en
behoud.

Introducción

La inmensa extensión que separa el continente
asiático y las costas de América representa un
mundo antiguo y fascinante. A través de rutas
trazadas por los vientos y las corrientes, pueblos
y culturas se han encontrado, integrado y
fragmentado a lo largo de los siglos, adaptándose
a una naturaleza poderosa que ha generado
prácticas religiosas originales que pasaron a ser
parte también de las manifestaciones artísticas.
En los orígenes de la historia y de las tradiciones de
Australia, Melanesia, Micronesia, la Isla de Pascua
y Polinesia se encuentran migraciones provenientes
del continente asiático. La más lejana en el
tiempo, concluida hace unos cuarenta mil años,
debía poblar Papúa-Nueva Guinea y Australia.
La siguiente, hace unos diez mil años, llevó las
migraciones a los archipiélagos más lejanos y hasta
Nueva Zelanda. Se difundió en torno al 1.500 a.C.
la cultura Lapita, que expandiéndose desde sus
centros ancestrales en Nueva Caledonia permitió
el desarrollo de las tradiciones artísticas locales,
llevándolas hasta los límites más extremos
de Oceanía.
Inevitablemente, la distancia desde las sedes
originarias, las distintas condiciones ambientales
y las sucesivas fragmentaciones han llevado a una
diferenciación en las culturas, siempre abiertas
a influencias externas. Desde Asia, pero pronto
también desde las costas americanas, las rutas
transoceánicas han involucrado regiones cada vez
más amplias del Pacífico, y el proceso evolutivo
ha sido lento, aunque constante.La exploración
europea, junto a la colonización y a la difusión
misionaria, debió influir enormemente en las
culturas locales. Si en un primer momento esto ha
apresurado la crisis, ha influido posteriormente en
su recuperación y conservación.

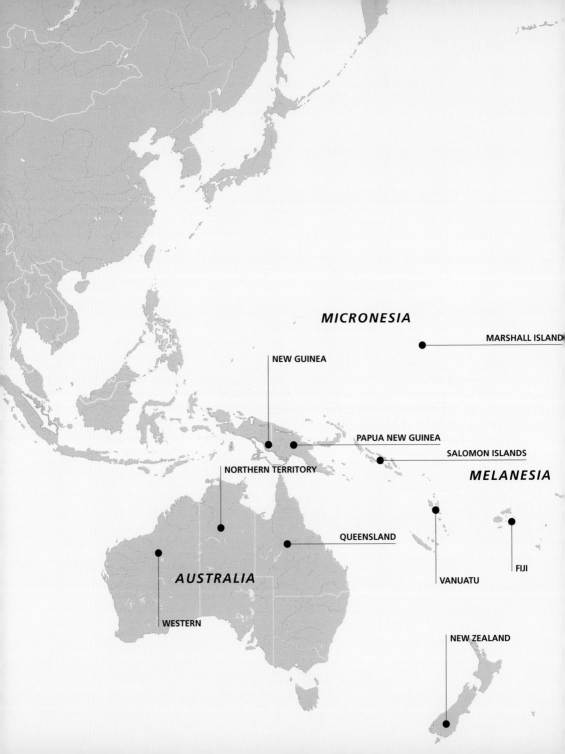

MICRONESIA

MARSHALL ISLAND

NEW GUINEA

PAPUA NEW GUINEA

SALOMON ISLANDS

NORTHERN TERRITORY

MELANESIA

QUEENSLAND

AUSTRALIA

VANUATU

FIJI

WESTERN

NEW ZEALAND

COOK ISLANDS

POLYNÉSIE FRANÇAISE

ISLA DE PASCUA

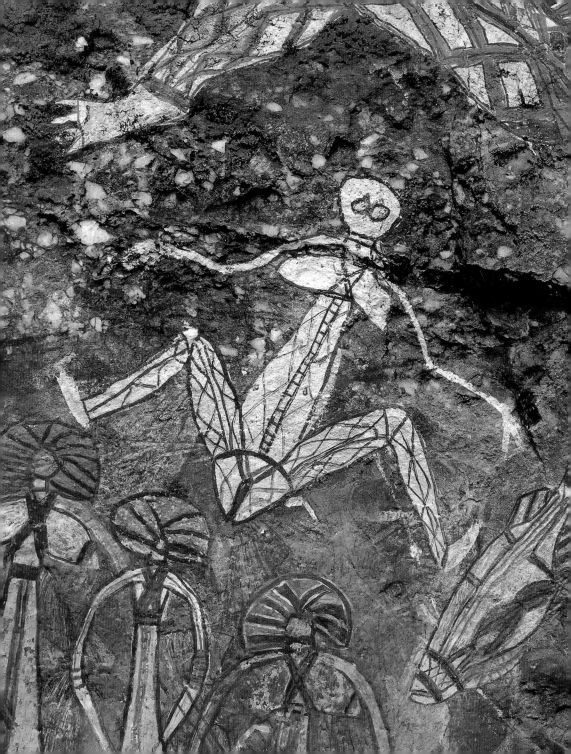

The Dreamtime and the
Time of Men

The indigenous concept that two
times exist contemporaneously, a
time of reality, known as the time of
Man, and a time of the spirit world,
known as the time of Dreams, has
influenced Australian aboriginal art
from the beginning, in its tendency to
represent these two aspects as part of
the local context of nature. A nature,
which also has dualistic properties:
the immense arid inland areas
and the moist costal regions were
populated by different groups with
diverse customs, but similar religious
and cultural traditions. Rupestrian
inscriptions, especially those found
at sacred ancestral sites, remain as
evidence of the myths of their origins.

Die Zeit der Träume
und die Zeit der Menschen

*Die Eingeborenen glauben, dass eine
Zeit der Wirklichkeit und eine Zeit des
Geistes, eine Zeit der Menschen und
eine der Träume gleichzeitig existieren.
Dies hat von Beginn an die Kunst der
australischen Aborigines beeinflusst. Sie
versucht nämlich diese beiden Aspekte
als elementarer Bestandteil der dortigen
Natur darzustellen.
Auch die Natur ist zweigeteilt einerseits das
Inland mit seinen enormen Trockenflächen,
andererseits die Küstenregion, in der
verschiedene Völker mit unterschiedlichen
Lebensgewohnheiten, aber ähnlichen
religiösen und kulturellen Traditionen
leben. Die Petroglyphen, insbesondere die
der heiligen Ahnenstätten, sind bleibende
Zeugnisse dieser Ursprungsmythen.*

Tijd van dromen
en tijd van mensen

*Het inheemse concept, volgens welke
men leeft in een werkelijke tijd en een
geestelijke tijd, die van de Mens en die
van de Droom, heeft vanaf het begin de
Australische Aboriginalkunst beïnvloed,
die de neiging heeft deze twee aspecten
weer te geven neergezet in de lokale
natuur. Natuur is ook tweeledig: het
uitgestrekte, dorre binnenland en
waterrijke gebieden en kustgebieden
zijn de thuisbasis van verschillende
bevolkingsgroepen en gewoonten, maar
blijft dicht bij de religieuze en culturele
tradities. De Graffitirotsen, vooral die
van vorouderlijke heiligdommen,
blijven een getuigenis van de mythen
van herkomst.*

El tiempo del Sueño
y el tiempo de los Hombres

*La concepción autóctona, según la cual
conviven un tiempo de la realidad y uno
del espíritu, "el tiempo de los Hombres"
y aquél definido como "el tiempo del
Sueño", ha influido desde sus comienzos
en el arte aborigen australiano, que
tiende a representar estos dos aspectos
impregnados en la naturaleza local.
Una naturaleza que es también dual: las
inmensas áreas áridas del interior y las
regiones húmedas de las costas albergan
pueblos que se diferencian entre sí por
sus usos y costumbres, pero semejantes
en tradición religiosa y cultural. Las
pinturas rupestres, en particular las de los
sitios sagrados ancestrales, quedan como
testimonio de los mitos de los orígenes.*

1

**Northern Territory,
Australia**
The Olgas (Kata Tjuta)
at the center of very
ancient cults
Die Olgas (Kata Tjuta)
im Mittelpunkt von sehr
alten Kulten
De Olga's (Kata Tjuta)
het centrum van de oude
culten
Montes Olga (Kata
Tjuta), protagonistas
de cultos antiquísimos

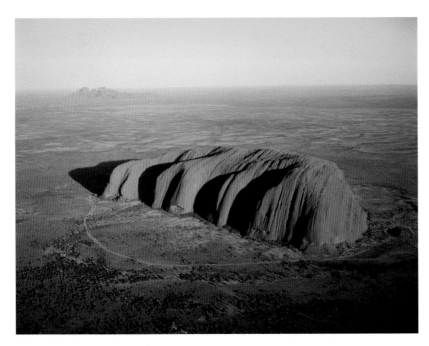

14

Northern Territory, Australia
Aerial view of Ayers Rock
Luftaufnahme des Ayers Rock
Luchtfoto van Ayers Rock
Vista aérea del monolito de Uluru (Ayers Rock)

Northern Territory, Australia
View of Ayers Rock, central site in Anangu Aboriginal tradition
Ansicht des Ayers Rock, zentraler Ort in der Tradition der Eingeborenen Anangu
Bekijk van Ayers Rock, centrale plaats in de Aboriginal traditie Anangu
Vista del monolito de Uluru (Ayers Rock), lugar central en la tradición aborigen Anangu

Northern Territory, Australia
Ngaltawaddi, sacred area near Ayers Rock
Ngaltawaddi, heiliges Gebiet bei Ayers Rock
Ngaltawaddi, heilig gebied op Ayers Rock
Ngaltawaddi, área sagrada en las cercanías de Ayers Rock

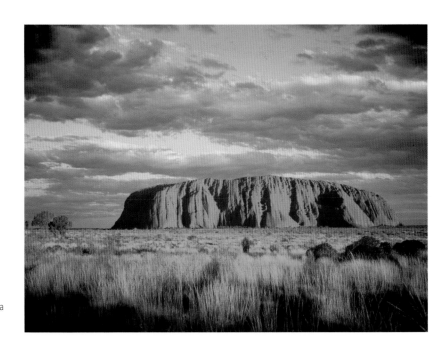

Northern Territory, Australia
Unmistakable outline of Uluru (Ayers Rock)
Die unverwechselbare Silhouette des Uluru (Ayers Rock)
Het onmiskenbare silhouet van Uluru (Ayers Rock)
La inconfundible silueta del monolito de Uluru (Ayers Rock)

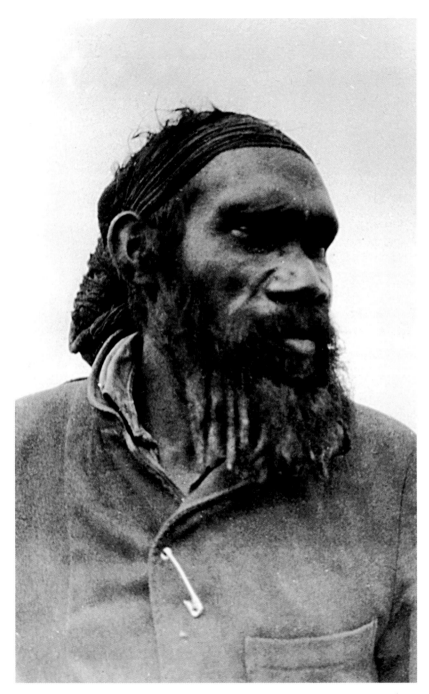

Walther Günther
Australian aborigine
Australischer
Eingeborener
Australische aboriginal
Aborigen australiano
1937

▶ **Charles Kerry**
Aborigines lighting a fire
Aborigines beim
Feuermachen
Aboriginals die een
vuur ontsteken
Aborígenes encendiendo
el fuego
1900

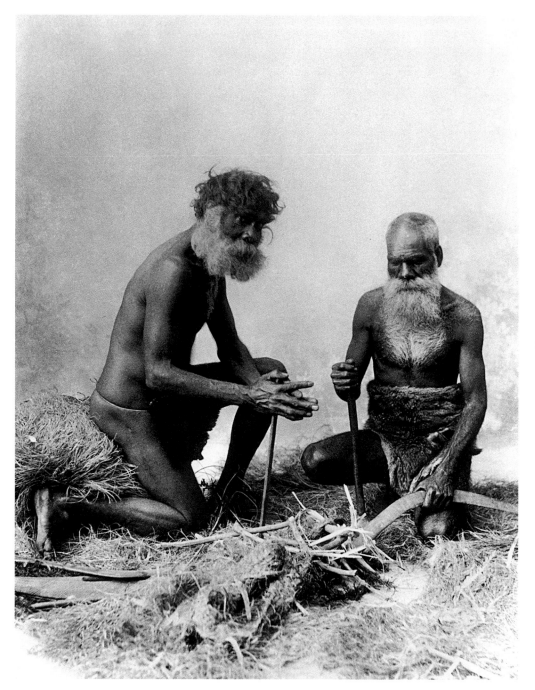

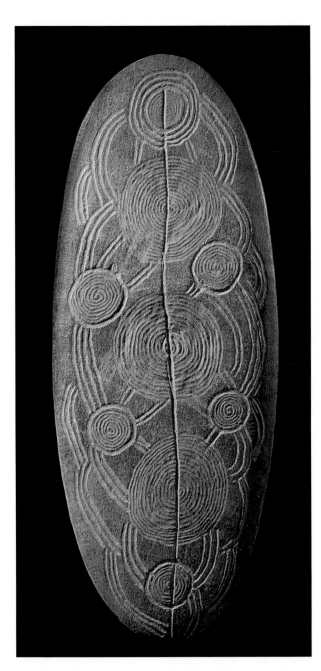

Example of *churinga*
Beispiel einer *Churinga*
Voorbeeld van *Churinga*
Ejemplar de *churinga*
1900-2000
Private collection, New York

▶ *Churinga*, discoid stone that represents
the immortal spirit of men
Churinga, scheibenförmiger Stein, der den
unsterblichen Geist der Menschen darstellt
Churinga, disc-vormige steen die de onsterfelijke
geest van de mens vertegenwoordigt
Churinga, piedra discoidal que representa
el espíritu inmortal de los hombres
1900-2000
Private collection, New York

▌ *In the Aboriginal worldview, nature, legend, and activity of the initial colonization of the continent of Australia - Dreamtime - converge in a map in the memory (Dream), an essential time that is still relevant today.*
▌ *Dem Weltbild der Aborigines zufolge bilden Natur, Legende und Beginn der Kolonialisierung des australischen Kontinents (die Zeit der Träume) eine Karte der Erinnerung (der Träume), einen essentiellen Zeitablauf, der nach wie vor gilt.*
▌ *In de opvattingen van de Aboriginals, worden de natuur, de mythe en activiteiten van de eerste kolonisatie van het Australische continent - De Droomtijd - samengebracht in een geschiedeniskaart (Droom), een essentiële tijd, maar nog steeds toegepast.*
▌ *En la concepción aborigen, la naturaleza, la leyenda y las actividades de la primera colonización del continente australiano - el Tiempo del Sueño - convergen en un mapa de la memoria (Sueño), en una época esencial relevante aún hoy.*

New South Wales, Australia
Carvings on rock. The artists are believed to be the ancestors who shaped the landscape during Dreamtime
Felseinritzungen. Die Künstler dürften Ureinwohner sein, welche die Landschaft in der Zeit der Träume entworfen haben
Rotskervingen. De auteurs waren de voorouders, die hebben het landschap gevormd in de Droomtijd
Grabado sobre roca. Los autores serían los antepasados que han modelado el paisaje en el Tiempo del Sueño

New South Wales, Australia
Water source in a sacred Aboriginal site
Wasserquelle an einem heiligen Ort der Aborigines
Pool van water in een heilige Aboriginal site
Manantial de agua en un sitio sagrado aborigen

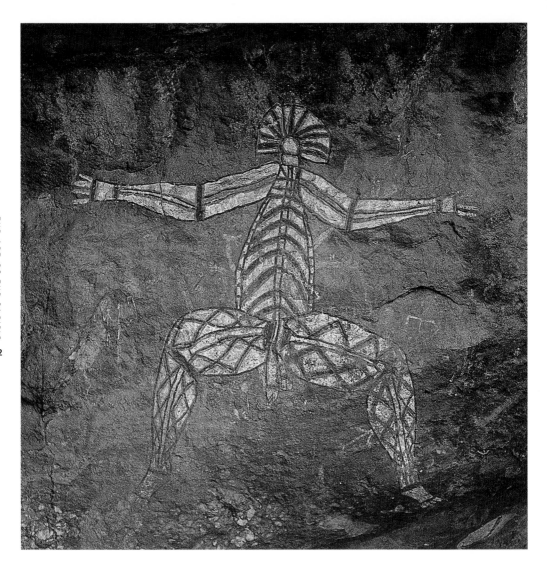

Arnhem Land, Australia
Rock paintings
Felsenmalereien
Grotschilderingen
Pinturas rupestres

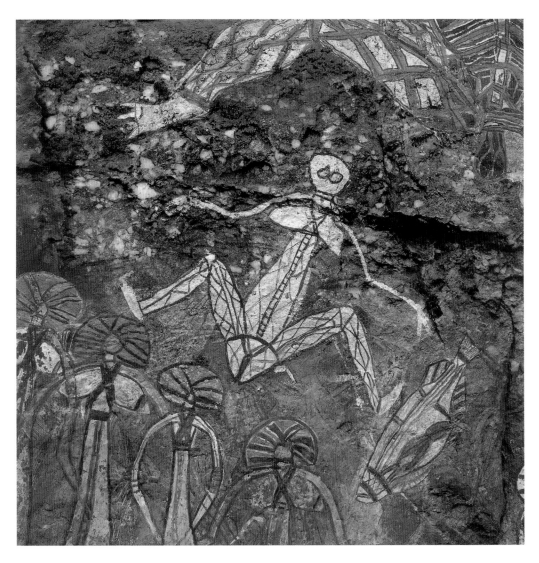

Kakadu National Park, Northern Territory, Australia
Detail of rock painting that recounts one of the myths of creation
Detail einer Felsenmalerei, die von einem der Schöpfungsmythen erzählt
Detail van een grotschildering die vertelt van de mythe van de schepping
Detalle de pintura rupestre que relata uno de los mitos de la creación

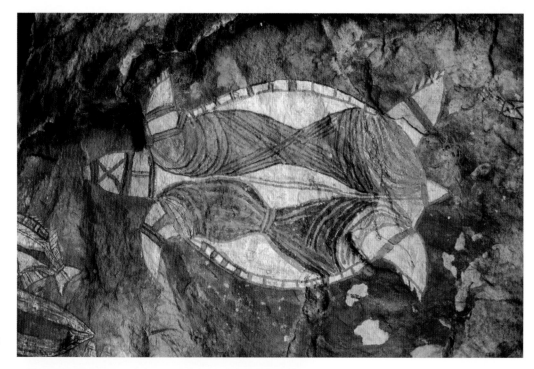

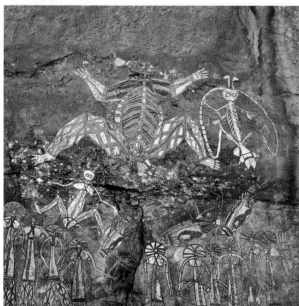

**Kakadu National Park,
Northern Territory, Australia**
Rock painting depicting a turtle
Felsenmalerei, die eine Schildkröte darstellt
Rotsschildering van een schildpad
Pintura rupestre representando una tortuga

**Kakadu National Park,
Northern Territory, Australia**
Rock paintings
Felsenmalereien
Grotschilderingen
Pinturas rupestres

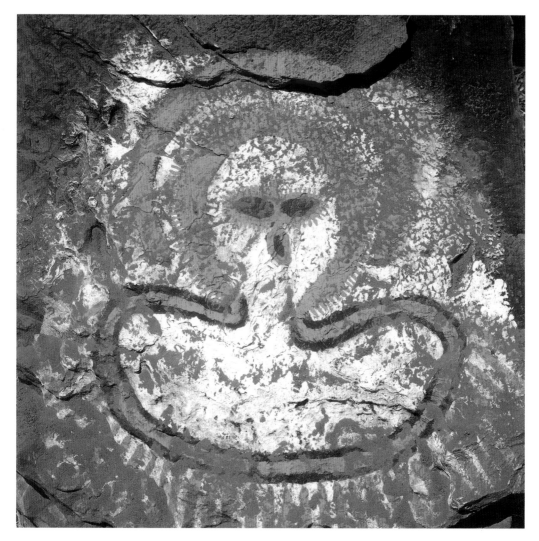

Kimberley, Australia
Rock painting
Felsenmalerei
Rotsschildering
Pintura rupestre

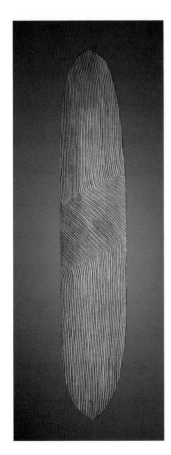

Georges Tjungurrayi
(1947)
Mythological paintings associated with the legend of the poisonous snake
that is supposed to infest Lake Kurrakurranya; acrylic on canvas
Mythologische Malerei einer Giftschlange, die den See Kurrakurranya heimgesucht zu haben
scheint; Acryl auf Leinwand
Mythologische tekeningen in verband met legende van de giftige slang
die het Kurrakurranya meer besmet; acryl op doek
Dibujos mitológicos asociados a la leyenda de la serpiente venenosa
que infestaría el lago Kurrakurranya; acrílico sobre lienzo
1990-2000
Musée du quai Branly, Paris

Shield; wood
Schild; Holz
Schild; hout
Escudo; madera
ca. 1850-1900
Musée du quai Branly,
Paris

Mike Namerari Tjapaltjari
(1926-1997)
Dream of Tjunginpa in Tjunginpa; acrylic on canvas
Traum des Tjunginpa in Tjunginpa; Acryl auf Leinwand
Droom van Tjunginpa op Tjunginpa; acryl op doek
Sueño de Tjunginpa en Tjunginpa; acrílico sobre lienzo
1990-2000
Musée du quai Branly, Paris

▌ *Contemporary artists are able to reproduce a universe, that of the Dreamtime, inaccessible to the uninitiated.*
▌ *Auch zeitgenössische Künstler können ein Universum, wie das der Zeit der Träume, so darstellen, dass es nicht Initiierten verschlossen bleibt.*
▌ *Zelfs hedendaagse kunstenaars zijn in staat om een universum te reproduceren, die van de Droomtijd, ontsloten voor niet-ingewijden.*
▌ *También los artistas contemporáneos son capaces de reproducir un universo, el del Tiempo del Sueño, inaccesible a los no iniciados.*

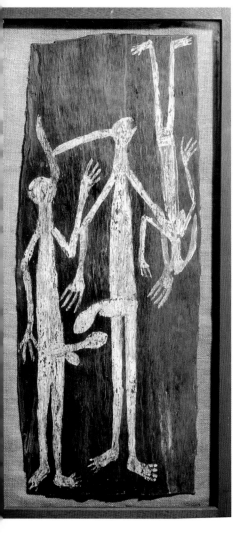

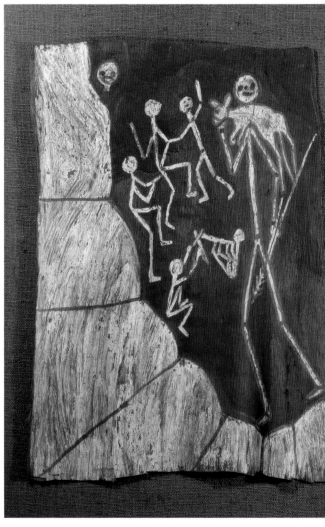

Painting that represents three spiritual figures; bark
Malerei, die drei spirituelle Figuren darstellt; Rinde
Schilderij met drie spirituele figuren; schors
Pintura que representa tres figuras espirituales; corteza
1900-2000
Art Gallery of New South Wales, Sydney

A hunter with spear and kangaroo with other human figures; bark
Ein Jäger mit Lanze, Känguru und weiteren menschlichen Figuren; Rinde
Een jager met speer en kangoeroe met andere menselijke figuren; schors
Un cazador con lanza y canguro con otras figuras humanas; corteza
1900-2000
Art Gallery of New South Wales, Sydney

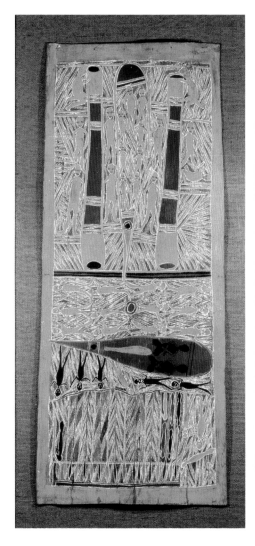

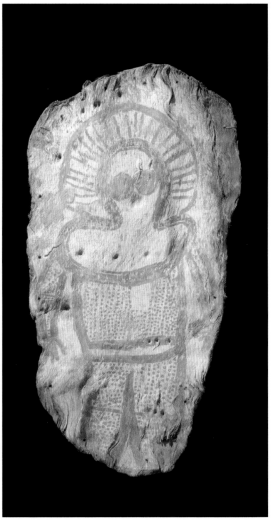

A *Wondjina*, ancestral spirit that brings rain and regulates
the fertility of the animals and the earth; bark
Ein *Windjina*, ein Urgeist, der Regen bringt und die Fruchtbarkeit der Tiere
und der Erde regelt; Rinde
Een *Windjina*, voorouderlijk wezen dat regen brengt
en de vruchtbaarheid regelt van de dieren en de aarde; schors
Un *Wondjina*, espíritu que atrae la lluvia y controla la fertilidad
de los animales y de la tierra; corteza
1900-2000
Private collection, New York

Episode from mythology of the clan of the ancestors; bark
Episode aus der Mythologie der Urahnen; Rinde
Episode uit de mythologie van de clan van de voorouders; schors
Episodio de la mitología del clan de los antepasados; corteza
1900-2000
Art Gallery of New South Wales, Sydney

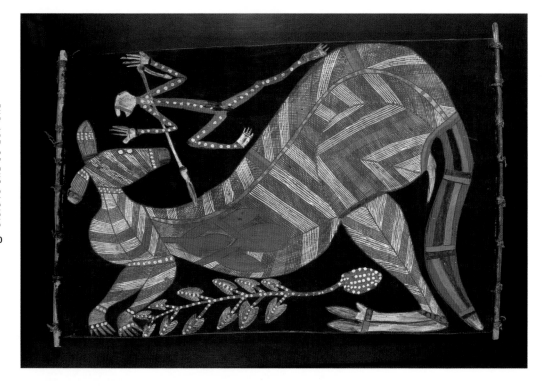

▮ *The kangaroo, an important animal in daily life and an instrument of conscience through hunting, occupies an important place in Aboriginal myths.*
▮ *Das Känguru, ein wichtiges Tier im Alltag und Erkennungsmittel über die Jagd, nimmt auch im Mythos einen zentralen Raum ein.*
▮ *De kangoeroe, belangrijk dier in het dagelijks leven en een instrument voor kennis bij de jacht, neemt een centrale plek in de mythe in.*
▮ *El canguro, animal importante en la vida cotidiana y herramienta de conocimiento a través de la caza, ocupa un espacio central también en el mito.*

A hunter and a kangaroo, animal with an important role in Aboriginal mythology; bark
Ein Jäger und ein Känguru, dem in der Mythologie der Eingeborenen eine zentrale Rolle zufällt; Rinde
Een jager en een kangoeroe, een dier dat een belangrijke rol in de Aboriginal mythologie speelt; schors
Un cazador y un canguro, animal con un importante rol en la mitología aborigen; corteza
1900-2000
Private collection / Private Sammlung / Privécollectie / Colección privada

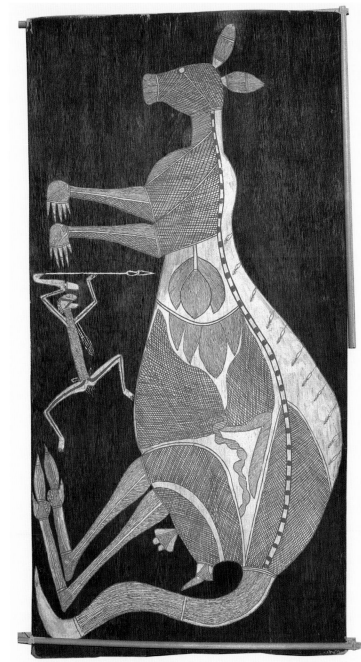

Painting that represents a hunter and a
kangaroo as if through "X-rays"; bark
Diese Malerei zeigt einen Jäger und
ein Känguru, das aussieht, als sei es
geröntgt worden; Rinde
Schilderij met een jager en een
kangoeroe "röntgen"; schors
Pintura que representa un cazador y un
canguro como a través de "rayos X";
corteza
1900-2000
Private collection / Private Sammlung
Privécollectie / Colección privada

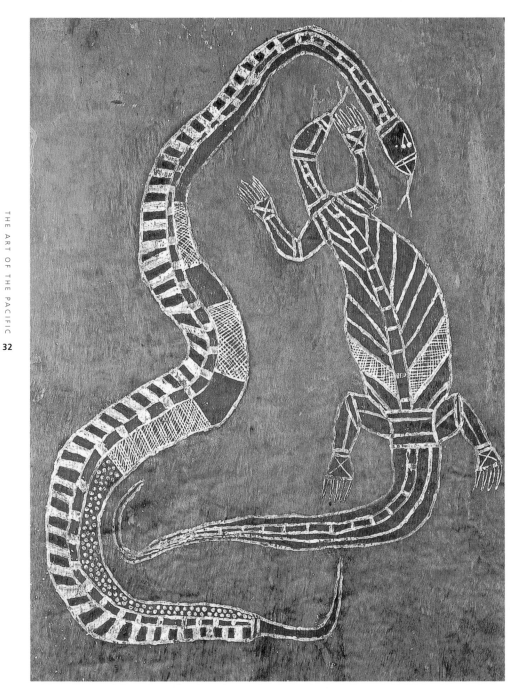

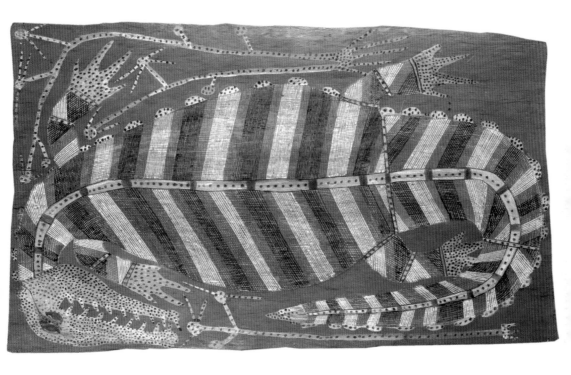

A crocodile, animal that traditionally plays an
important role in initiation rites; bark
Das Krokodil ist ein Tier, das traditionell eine wichtige Rolle in
den Initiationsriten spielt; Rinde
Een krokodil, een dier dat van oudsher een belangrijke
rol speelt in de initiatieriten; schors
Un cocodrilo, animal que tiene tradicionalmente
un rol importante en los ritos de iniciación; corteza
1900-2000
Art Gallery of New South Wales, Sydney

◀ Painting that represents a snake and a lizard; bark
Darstellung einer Schlange und einer Eidechse; Rinde
Schilderij met een slang en een hagedis; schors
Pintura que representa una serpiente y una lagartija; corteza
1900-2000
Art Gallery of New South Wales, Sydney

▌ *Not only the different cultural and technical evolutions
of the Aboriginal groups, but also the different symbols
explain varying representations, also involving humans.*
▌ *Nicht allein die verschiedenen kulturellen und technischen
Entwicklungen der Eingeborenen, sondern auch die sich
ändernde Symbolik führt zu Unterschieden in den Darstellungen
auch der menschlichen Figur.*
▌ *Niet alleen de verschillende culturele en technische
ontwikkelingen van de verschillende Aboriginalgroepen,
maar ook de verschillende inhoud lichten de symbolische
voorstellingen toe, met inbegrip van de menselijke figuur.*
▌ *No sólo las distintas evoluciones culturales y técnicas
de los grupos aborígenes, sino también la diferente carga
simbólica explican las diferencias en las representaciones,
incluso de la figura humana.*

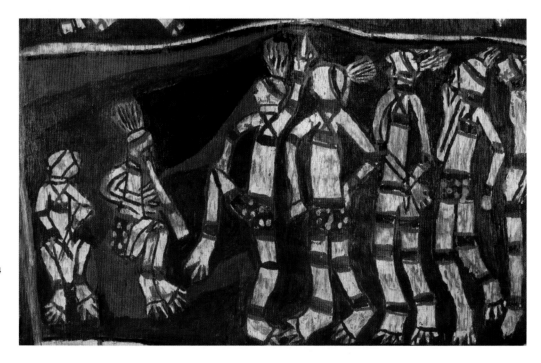

▌ *Dance, essential at encounters between human beings, is an act that regenerates power and energy.*
▌ *Der Tanz hat eine grundlegende soziale Funktion, außerdem dient er der Regeneration von Kräften und Energien.*
▌ *De dans, cruciaal in tijden van ontmoeting van de menselijke wezens, is een daad die macht en energie opwekt.*
▌ *La danza, fundamental en los momentos de encuentro entre los seres humanos, es un actor regenerador de poderes y de energías.*

Aboriginal painting depicting a ceremony
with musicians and dancers; bark
Darstellung eines Eingeborenen, auf der eine
Zeremonie mit Musikern und Tänzern zu sehen ist;
Rinde
Aboriginal schilderij van een ceremonie
met muzikanten en dansers; schors
Pintura aborigen que representa una ceremonia
con músicos y bailarines; corteza
1900-2000
Art Gallery of New South Wales, Sydney

▶ Painting that depicts two couples of male and female
figures, probably spirits, with two serpents; bark
Darstellung von zwei jeweils aus Mann und Frau
bestehenden Paaren, die wahrscheinlich Geister sind, und
zwei Schlangen; Rinde
Schilderij vertegenwoordigt twee paar van mannelijke en
vrouwelijke figuren, waarschijnlijk spirituele wezens met
twee slangen; schors
Pintura que representa dos parejas de figuras masculinas
y femeninas, probablemente seres espirituales, con dos
serpientes; corteza
1900-2000
Private collection / Private Sammlung
Privécollectie / Colección privada

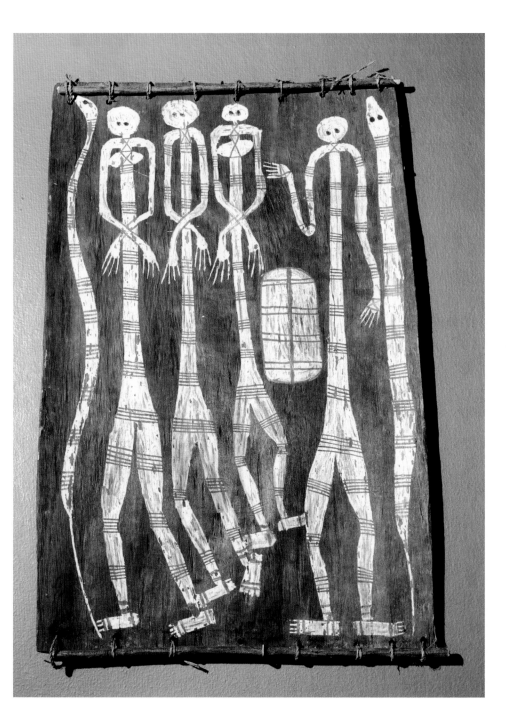

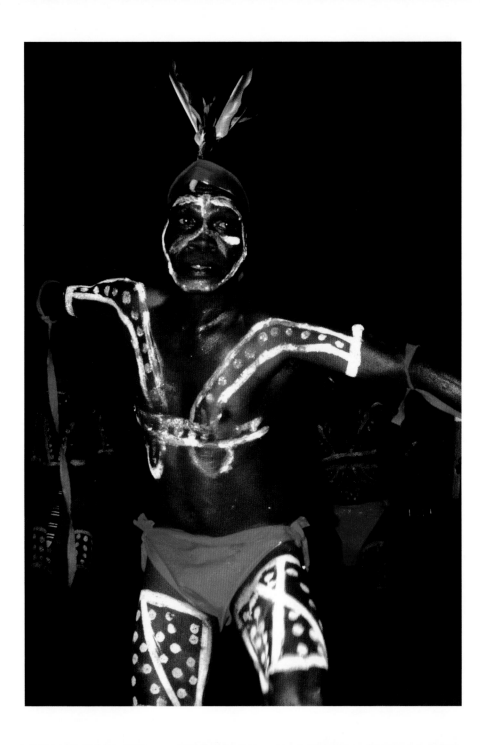

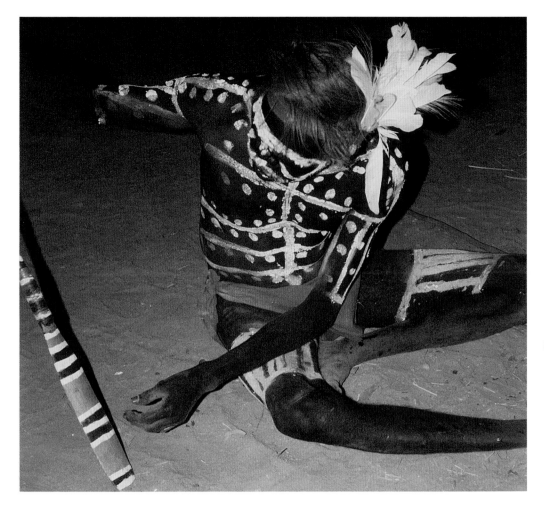

Northern Territory, Australia

Northern Territory, Australia
Body paintings and accessories are an integral part of Aboriginal sacred dances
Körperbemalung und Accessoires sind wichtige Bestandteile der heiligen Tänze der Aborigines
Body paint en accessoires zijn een integraal onderdeel van de Aboriginal heilige dansen
Las pinturas corporales y los accesorios son parte integrante de las danzas sagradas aborígenes

◀ **Northern Territory, Australia**
Dancers during a religious ceremony
Tänzer während einer religiösen Zeremonie
Dansers tijdens een religieuze ceremonie
Danzantes durante una ceremonia religiosa

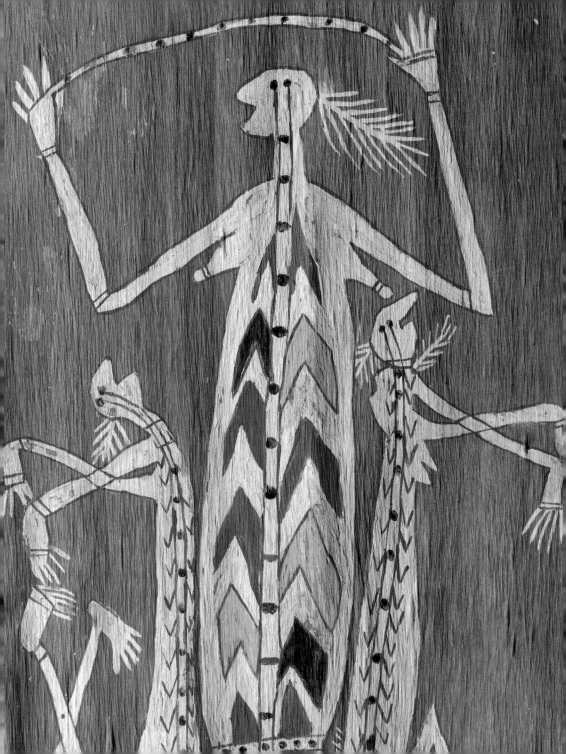

Aboriginal tradition and cultural fusion

After centuries of isolation, external influences resulted in dramatic changes to the existence of aboriginal populations, often bringing their isolation to an end in a traumatic way. The ancient, but fragile local art, associated with ancestral myths and natural rhythms, lost its daily function, but maintained its memory. Today aboriginal art contains external influences and fusions, coming out of isolation and offering itself in forms of art intending to restore tradition amid a growing international interest.

Die Tradition der Aborigines und die Vermischung der Kulturen

Nach Jahrhunderten der Isolation haben die äußeren Einflüsse dramatische Veränderungen für die Existenz der eingeborenen Bevölkerung mit sich gebracht und ihrer Isolation oft auf traumatische Weise ein Ende gesetzt. Die alte, aber zerbrechliche regionale Kunst, die von Mythen der Ahnen und Rhythmen der Natur geprägt ist und ihre tägliche Funktion verloren hatte, fungierte nur noch als Erinnerung. Heute zeigt sich die Kunst der Eingeborenen gezeichnet von äußeren Einflüssen und von Vermischungen. Sie hat sich aus der Isolierung befreit und zeigt sich in Kunstformen, die unter wachsendem internationalen Interesse wieder an die Tradition anknüpfen will.

2

Aboriginaltraditie en culturele synthese

Na eeuwen van isolement, hebben externe invloeden dramatische veranderingen gebracht in het bestaan van de aboriginals, traumatisch een eind makend aan aan hun isolement. De oude maar kwetsbare lokale kunst, gebonden aan de mythes van voorouders en de ritmes van de natuur, verloor zijn dagelijkse functie, maar heeft de herinnering bewaard. Vandaag staat de Aboriginalkunst in het teken van de besmetting en synthese, uit het isolement stappend om zich te te laten zien in kunstvormen die helpen bij het herstel van de traditie in de groeiende internationale belangstelling.

Tradición aborigen y síntesis cultural

Después de siglos de aislamiento, las influencias externas han comportado dramáticos cambios en la existencia de las poblaciones aborígenes, poniendo fin a su aislamiento, a menudo de manera traumática. El antiguo, pero frágil, arte local, ligado a los mitos ancestrales y a los ritmos naturales, una vez perdido su cometido cotidiano ha mantenido la función relacionada con la memoria. Hoy el arte aborigen, que se presenta contaminado y fusionado, está saliendo del aislamiento replanteándose en formas de arte tendentes a la recuperación de la tradición en medio de un creciente interés internacional.

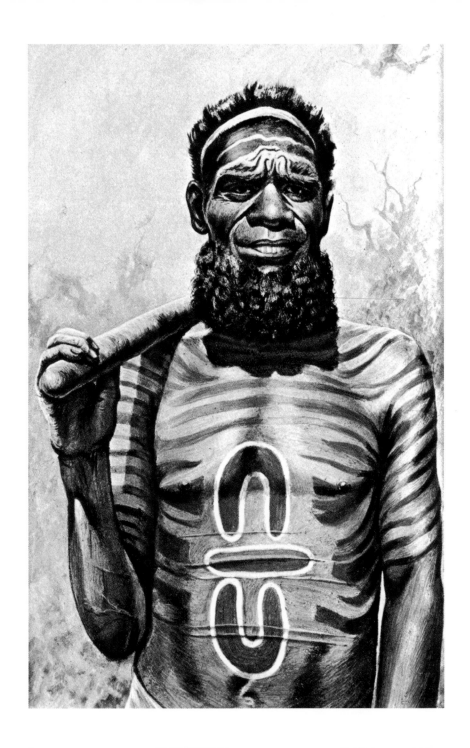

❚ *Local cultures, threatened by European colonization starting in the 18ᵗʰ century, have only recently obtained international recognition and protection.*
❚ *Die Lokalen Kulturen, die von der europäischen Kolonisierung seit dem 18. Jahrhundert gefährdet wurden, sind heute international anerkannt und geschützt.*
❚ *De lokale culturen, bedreigd door Europese kolonisatie die in de achttiende eeuw begon, genieten nu internationale erkenning en bescherming.*
❚ *Las culturas locales, amenazadas por la colonización europea iniciada en el siglo XVIII, han logrado hoy reconocimiento y protección internacional.*

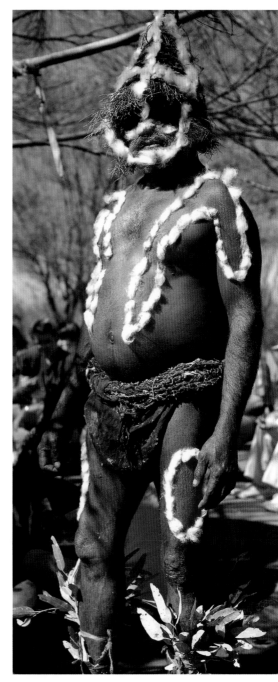

Northern Territory, Australia
Aborigine dancer with ritual decorations at Alice Springs
Eingeborener Tänzer mit rituellem Schmuck in Alice Springs
Aboriginal danser met rituele decoraties in Alice Springs
Danzante aborigen con decoraciones rituales en Alice Springs

◀ Medicine man of the Worgaia in Central Australia from *Peoples of All Nations, Their Life Today and the Story of Their Past*
Medizinmann des Stammes Worgaia in Zentralaustrallien aus da *Peoples of All Nations, Their Life Today and the Story of Their Past*
Heks van de stam Worgaia in Centraal Australië door *Volkeren van alle Volkeren, hun leven vandaag en het verhaal van hun verleden*
Brujo de la tribu Worgaia en Australia central de *Peoples of All Nations, Their Life Today and the Story of Their Past*
1922

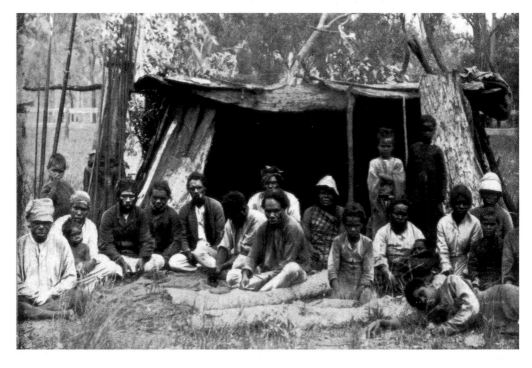

▌ *Aborigines from the Torres Strait have cultural characteristics tied to the ocean.*
▌ *Die Eingeborenen der Torres-Straße haben eine ganz eigene, eng mit dem Ozean verbundene Kultur.*
▌ *De Aboriginals en de Straat van Torres behouden hun eigen culturele profiel gekoppeld aan de oceaan.*
▌ *Los aborígenes del estrecho de Torres mantienen una fisonomía cultural propia, vinculada al océano.*

Group of Aborigines of Queensland from *Portfolio of Photographs, of Famous Scenes, Cities and Painting*
Aboriginegruppe in Queensland aus *Portfolio of Photographs, of Famous Scenes, Cities and Painting*
Groep van Aboriginals in Queensland door *Portfolio van foto's, van beroemde Scenes, Steden en schilderingen*
Grupo de aborígenes de Queensland de *Portfolio of Photographs, of Famous Scenes, Cities and Painting*
ca. 1880-1900

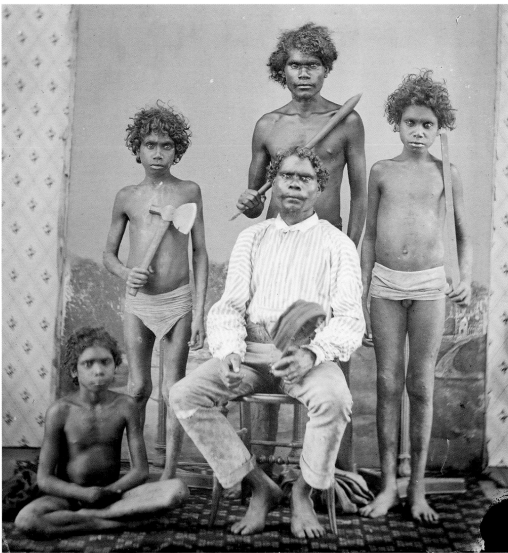

Claude-Joseph-Désiré Charnay
(Fleurieux-sur-l'Arbresle 1828 - Paris 1915)
Aborigine dressed in in Western clothes with members of his family
Als Europäer gekleideter Aboriginie mit Mitgliedern seiner Familie
Aboriginal in Europees kostuum met leden van zijn gezin
Aborigen vestido a la europea con miembros de su familia
1878-1879
Musée du quai Branly, Paris

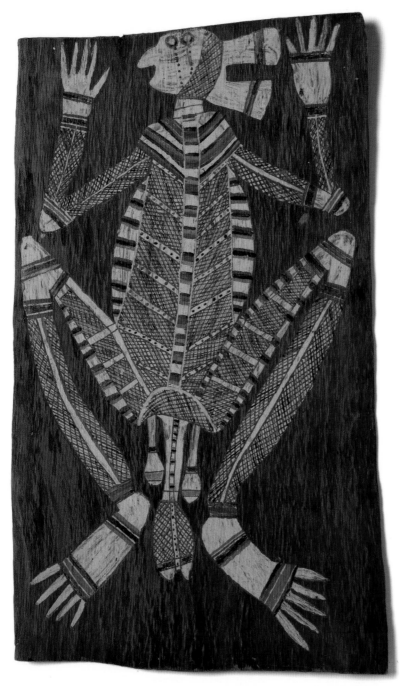

Irvala
Male *mimi* seated, Croker
Island, Northern Territory;
eucalyptus bark
Sitzender *Mimi*-Mann, Croker
Island, Northern Territory;
Eukalyptusrinde
Mimi man zittend, Croker
Island, Northern Territory;
eucalyptusschors
Hombre *mimi* sentado, Croker
Island, Northern Territory;
corteza de eucalipto
1963
Musée du quai Branly, Paris

▶ **Irvala**
Two *mimi* rock spirits, Croker
Island, Northern Territory;
eucalyptus bark
Zwei Geister des mimi-Felsens,
Croker Island, Northern
Territory; Eukalyptusrinde
Twee generaties van de
mimi, Croker Island, Northern
Territory; eucalyptusschors
Dos genios de las rocas
mimi, Croker Island, Northern
Territory; corteza de eucalipto
1963
Musée du quai Branly, Paris

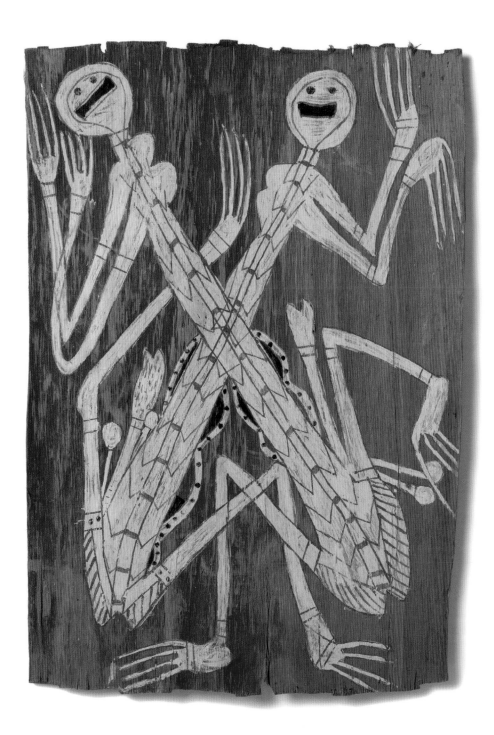

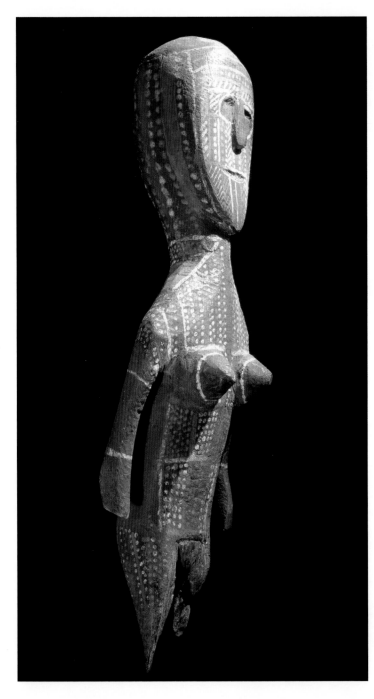

■ The evocative power of Australia's traditions and nature has been reproduced in innumerable European and American works of art.
■ Die Suggestivkraft australischer Traditionen wurde in zahlreichen Werken europäischer und amerikanischer Künstler wiedergegeben.
■ De suggestie van de tradities en de aard van Australië is weergegeven in talloze werken van kunstenaars uit Europa en Amerika.
■ La sugestión de las tradiciones y de la naturaleza australiana ha sido reproducida en innumerables obras de artistas europeos y americanos.

Sculpture of woman of the Land of Arnhem, used like other totemic images only in special ceremonies; wood
Frauenskulptur aus der Gegend von Arnhem, die wie andere Totembilder nur in besonderen Zeremonien verwendet wird; Holz
Beeldhouwkunst van de vrouw in Arnhem Land, zoals sommige totembeelden uitsluitend worden gebruikt bij bepaalde plechtigheden; hout
Escultura de mujer de la Tierra de Arnhem, utilizada, como otras imágenes totémicas, sólo en ceremonias especiales; madera
1900-2000
Private collection / Private Sammlung
Privécollectie / Colección privada

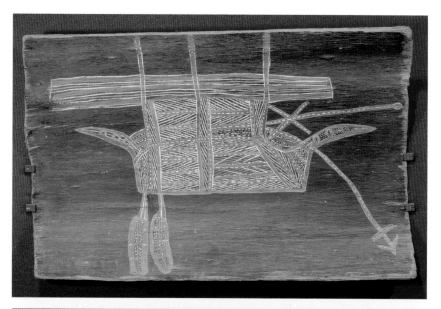

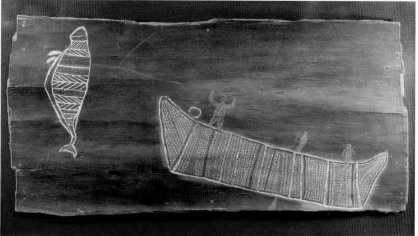

European three-masted ship
with rear anchor; bark
Europäisches Schiff mit drei
Masten und hinterem Anker; Rinde
Europese schip met drie masten
met achteranker; schors
Barco europeo de tres mástiles
con ancla posterior; corteza
1900-2000
Art Gallery of New South Wales, Sydney

Group of whalers harpooning
a whale; bark
Walfängergruppe beim Harpunieren
eines Walfischs; Rinde
Groep walvisvaarders harpoeneren
een walvis; schors
Grupo de balleneros arponeando
una ballena; corteza
1900-2000
Art Gallery of New South Wales, Sydney

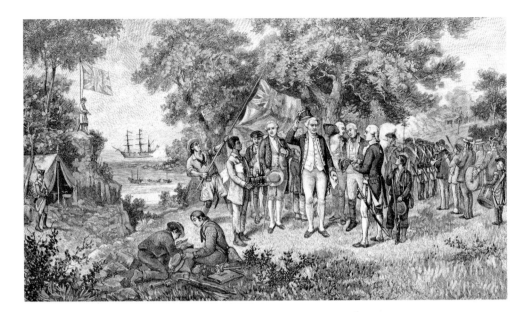

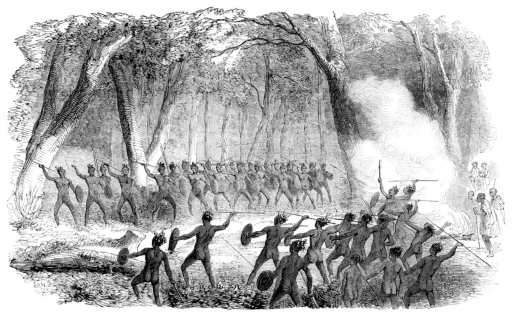

AFFRAY OF ABORIGINAL TRIBES, THREE MILES FROM BRISBANE, NEW SOUTH WALES.

◀ **Andrew Garran**
(1825-1901)
The landing of Captain James Cook at Botany Bay (1770),
xylography from *Picturesque Atlas of Australasia*
Die Landung von Kapitän James Cook in Botany Bay (1770),
Holzschnitt aus *Picturesque Atlas of Australasia*
De landing van Captain James Cook in Botany Bay (1770),
hout gravure van *Schilderachtig Atlas van Australazië*
El desembarco del capitán James Cook en Botany Bay
(1770), xilografía de *Picturesque Atlas of Australasia*
1886

◀ Engraving depicting a group of Aborigines
on the banks of the Murray River
Kupferstich einer Gruppe Eingeborener
am Ufer des Flusses Murray
Gravure afbeelding van een groep van aboriginals
aan de oevers van de rivier de Murray
Grabado que representa un grupo de aborígenes a orillas
del río Murray
1877

Clash between Aborigines near Brisbane, engraving
from *The Illustrated London News*
Auseinandersetzung unter Aborigines bei Brisbane,
Kupferstich aus *The Illustrated London News*
Aboriginals botsing in Brisbane, gravure uit *The
Illustrated London News*
Encuentro entre aborígenes cerca de Brisbane,
grabado de *The Illustrated London News*
1854

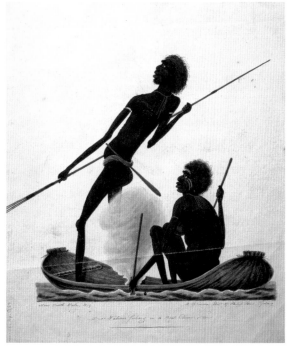

Aborigines butchering a kangaroo, chromolithography
from *Völkerkunde* of Friedrich Ratzel
Aborigines beim Schlachten eines Kängurus,
Chromolithografie aus *Völkerkunde* von Friedrich Ratzel
Aboriginals slachten een kangoeroe, chromolithograph
door *Völkerkunde* Friedrich Ratzel
Aborígenes faenando un canguro, cromolitografía
de *Völkerkunde* de Friedrich Ratzel
1885-1888

Richard Browne
(1776-1824)
Two Aborigines fishing
Zwei Aborigines beim Fischen
Twee Aboriginals die vissen
Dos aborígenes pescando
National Library of Australia, Canberra

John Skinner Prout
(Plymouth, England 1805 - Kentish Town, London 1876)
Landscape with waterfall and Aborigine hunting kangaroos; oil on canvas
Landschaft mit Wasserfall und Eingeborenen auf Kängurujagd; Öl auf Leinwand
Landschap met waterval en inheemse jacht op kangoeroes; olie op doek
Paisaje con cascada y aborigen cazando canguros; óleo sobre lienzo
1860-1870
Art Gallery of New South Wales, Sydney

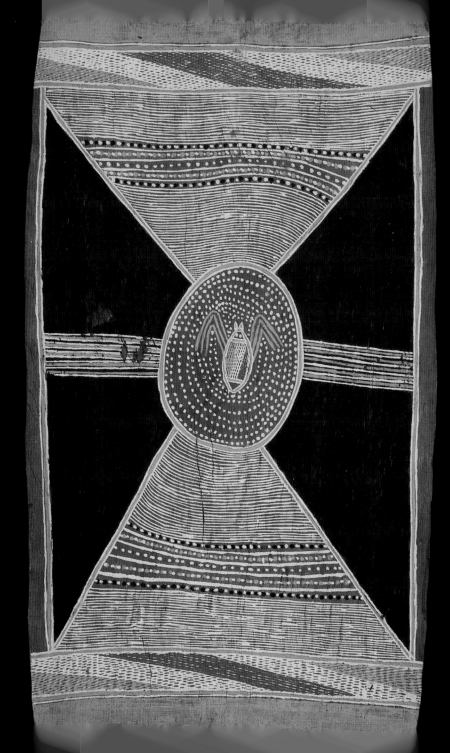

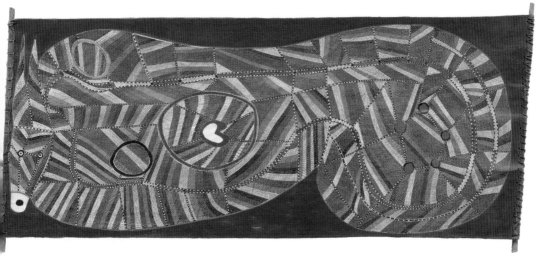

❚ *In recent times, recovering both descriptive and abstract techniques, Aboriginal artists have been able to repropose the theory of Dreams and ancestral myths.*

❚ *In der jüngeren Vergangenheit haben die eingeborenen Künstler, indem sie sowohl beschreibende als auch abstrakte Techniken angewandt haben, die Theorie des Traums und der Ahnenmythen neu beleben können.*

❚ *In recenter tijden, door het herstellen van zowel beschrijvende technieken als abstract, zijn Aboriginal kunstenaars in staat geweest om de theorie van de Droom en de mythen van voorouders te bevestigen.*

❚ *En tiempos recientes, recuperando tanto las técnicas descriptivas como las abstractas, los artistas aborígenes han sabido reproducir la teoría del Sueño y los mitos ancestrales.*

John Mawurndjul
(1952)
Rainbow serpent with horns; the rainbow serpent in the Land of Arnhem is protagonist of the Dreamtime myths and protector of the water; bark
Regenbogenschlange mit Hörnern; die Regenbogenschlange ist in der Gegend von Arnhem ein Hauptgegenstand der Mythen aus der Zeit der Träume, sowie Beschützerin des Wassers; Rinde

◀ **Lipundja**
(1912-1968)
Giant spider; eucalyptus bark
Riesenspinne; Eukalyptusrinde
Enorme spin; eucalyptusschors
Araña gigante; corteza de eucalipto
1963
Musée du quai Branly, Paris

Regenboogslang met horens, de Regenboogslang in Arnhem Land is de protagonist van de mythen van de droomtijd en beschermer van het water; schors
Serpiente arco iris con cuernos; la serpiente arco iris en la Tierra de Arnhem es protagonista de los mitos del Tiempo del Sueño y protectora de las aguas; corteza
Musée du quai Branly, Paris

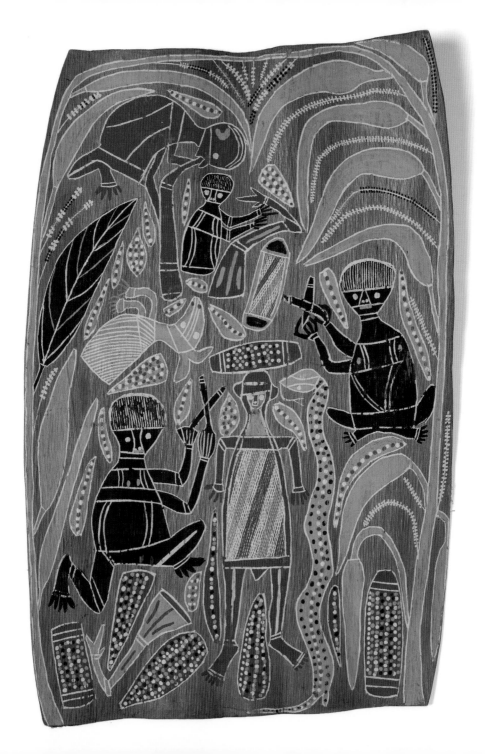

■ *The dozens of Aboriginal traditions have been able to make use of local resources with great effectiveness.*
■ *Viele Überlieferungen der Ureinwohner konnten mit großer Wirkung die lokalen Ressourcen verwerten.*
■ *Tientallen Aboriginaltradities hebben de lokale middelen weten te exploiteren, met zeer effectieve resultaten.*
■ *Las decenas de tradiciones aborígenes han sabido valorizar, obteniendo resultados de gran eficacia, los recursos locales.*

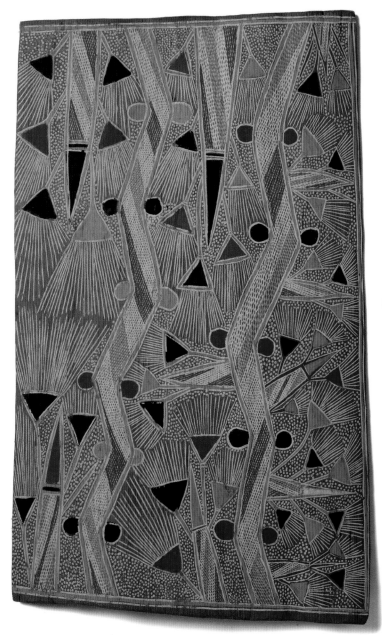

Bininiywui
(1921-1982)
Rivers and dwarf palms created by the passage of the sacred serpent, Yurlunggur; eucalyptus bark
Flüsse und Zwergpalmen, die an der Landschaft der heiligen Schlange Yurlunggur geschaffen wurden; Eukalyptusrinde
Rivieren en dwerg palmbomen gemaakt door de passage van de heilige slang Yurlunggur; eucalyptusschors
Ríos y palmeras enanas creadas en el paisaje por la serpiente sagrada Yurlunggur; corteza de eucalipto
1963
Musée du quai Branly, Paris

◄ David Malangi
(1927-2001)
Funerary ceremony; eucalyptus bark
Begräbniszeremonie; Eukalyptusrinde
Begrafenisceremonie; eucalyptusschors
Ceremonia funeraria; corteza de eucalipto
1963
Musée du quai Branly, Paris

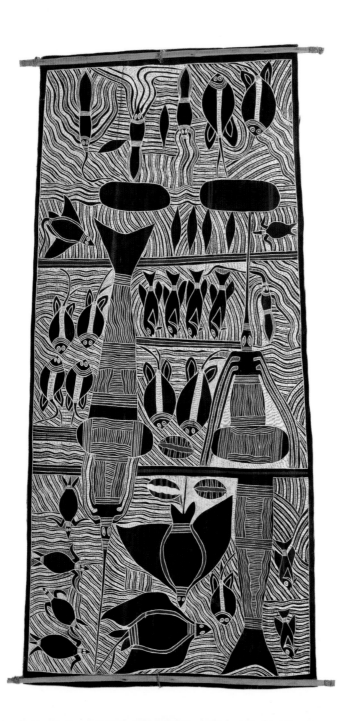

Maravili Bakulanay
Myth of the Munyuku tribal
group and detail; bark
Mythos der Stammesgruppe
Munyuku mit Detail; Rinde
Mythe van de tribale groep
Munyuku en detail; schors
Mito del grupo tribal
Munyuku y detalle; corteza
1900-2000
Musée du quai Branly, Paris

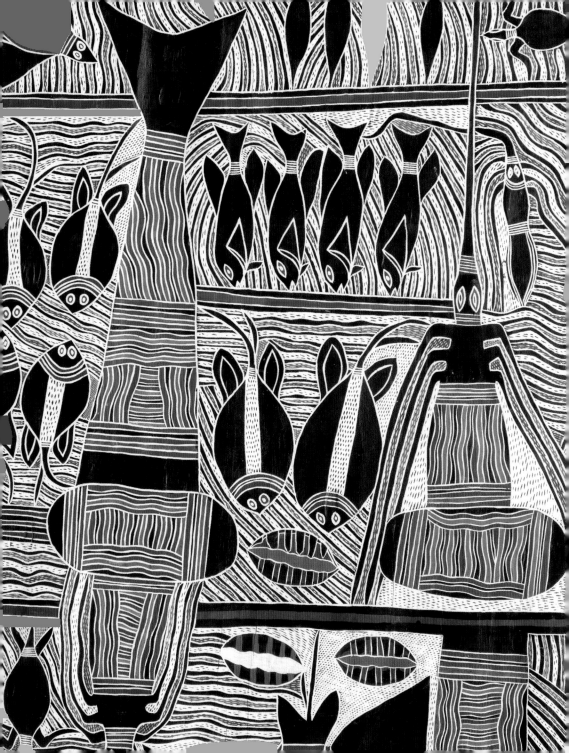

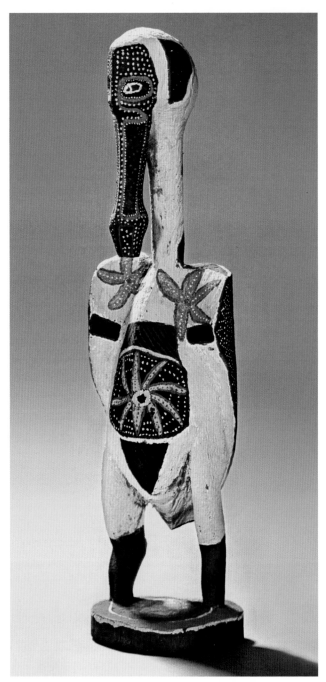

▌ *Sculpture is first and foremost
an interpretation of the specific
characteristics of each Aboriginal group,
with greater expressive strength.*
▌ *Die Skulptur eignet sich als besonders
ausdrucksstarke Interpretation der
spezifischen Charakteristiken jeder
Aborigine-Gruppe, mit größerer
Ausdruckskraft.*
▌ *Zelfs de beeldhouwkunst is vooral
een lezing van de specifieke kenmerken
van elke Aboriginal groep, met meer
expressieve kracht.*
▌ *También la escultura es, en primer
lugar, una lectura de las características
específicas de cada grupo aborigen, con
una gran fuerza expresiva.*

Depiction of marine bird, Bathurst
Island, Northern Territory; wood
Darstellung eines Seevogels, Bathurst-
Insel, Northern Territory; Holz
Afbeelding van zeevogels, Bathurst
eilanden, Northern Territory; hout
Representación de ave marina, isla
Bathurst, Northern Territory; madera

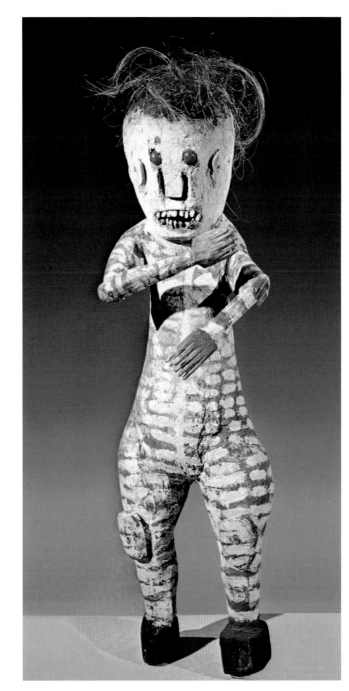

Anthropomorphic statue, Aurunkun,
Cape York Peninsula; wood
Anthropomorphe Statue, Aurunkun,
Cape York Halbinsel; Holz
Antropomorf standbeeld, Aurunkun,
Cape York schiereiland; hout
Estatua antropomorfa, Aurunkun,
Península del Cabo de York; madera

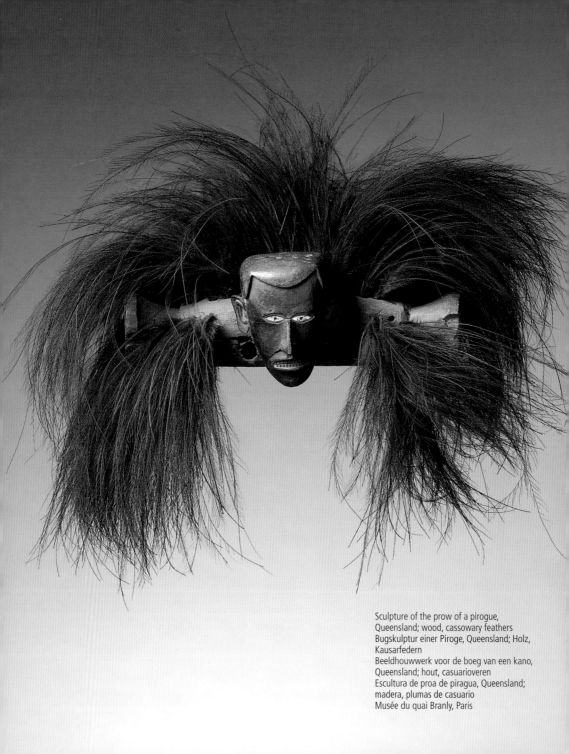

Sculpture of the prow of a pirogue,
Queensland; wood, cassowary feathers
Bugskulptur einer Piroge, Queensland; Holz,
Kausarfedern
Beeldhouwwerk voor de boeg van een kano,
Queensland; hout, casuarioveren
Escultura de proa de piragua, Queensland;
madera, plumas de casuario
Musée du quai Branly, Paris

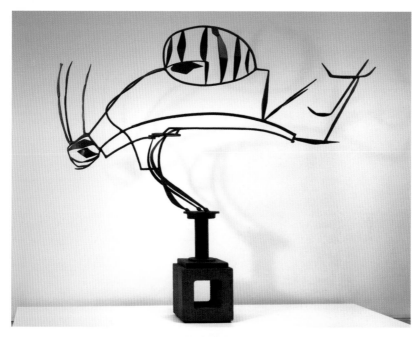

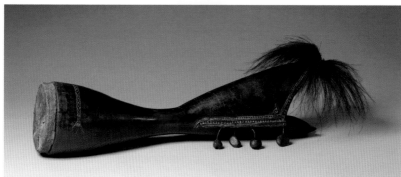

David Smith
(Decatur, Indiana 1906 -
Bennington, Vermont 1965)
Australia; steel
Australien; Stahl
Australië; acacia
Australia; acero
1951
Museum of Modern Art
(MoMA), New York

Drum in the shape of an hourglass for ritual use;
wood, crocodile skin and feathers
Tamburin in Form einer Sanduhr für den rituellen
Gebrauch; Holz, Krokodilhaut und Federn
Zandlopervormige trommel voor ritueel gebruik;
hout, krokodillenhuid en veren
Tambor en forma de clepsidra para uso ritual;
madera, piel de cocodrilo y plumas
1900-2000
Musée du quai Branly, Paris

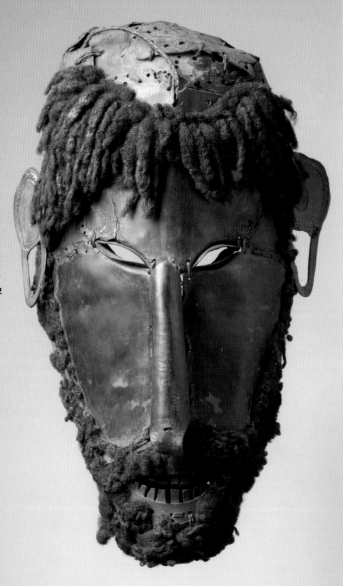

Mask that depicts an ancestor, Torres Strait
Islands; turtle shell, hair, fibres
Maske, einen Vorfahren darstellend, Torres-
Strait-Inseln; Schildkrötenpanzer, Haare und
Fasern
Masker dat een voorouder afbeeldt, Torres Strait
eilanden; schild van schildpad, haar en vezel
Máscara que representa un antepasado, islas
del estrecho de Torres; caparazón de tortuga,
cabellos, fibras
1850-1890
The Metropolitan Museum of Art, New York

▶ Mask with the appearance of a mythological
spirit used in funeral and initiation rites, Torres
Strait Islands; turtle shell, hair and fibres
Maske, die einem mythologischen Wesen ähnelt
und in den Begräbnis- sowie Initiationsriten
verwendet wird, Torres-Strait-Inseln;
Schildkrötenpanzer, Haare und Fasern
Masker met de verschijning van een
mythologisch wezen gebruikt in
begrafenisrituelen en initiatie, Torres Strait
eilanden; schild van schildpad, haar en vezel
Máscara con los rasgos de un ser mitológico
utilizada en los ritos fúnebres y de iniciación,
islas del estrecho de Torres; caparazón de
tortuga, cabellos, fibras
1800-1900
Musée du quai Branly, Paris

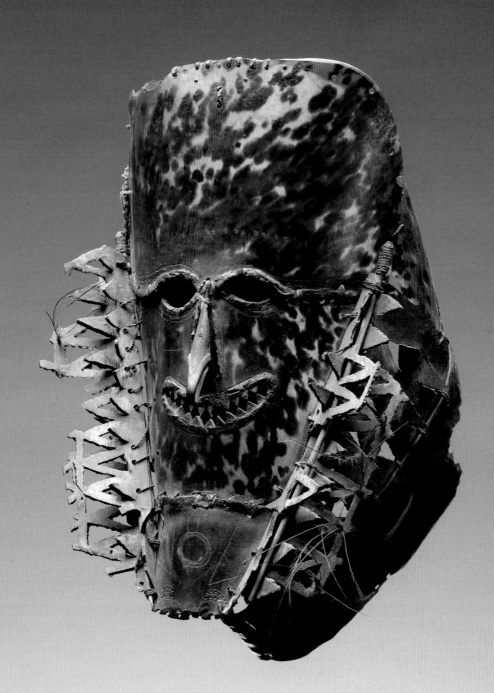

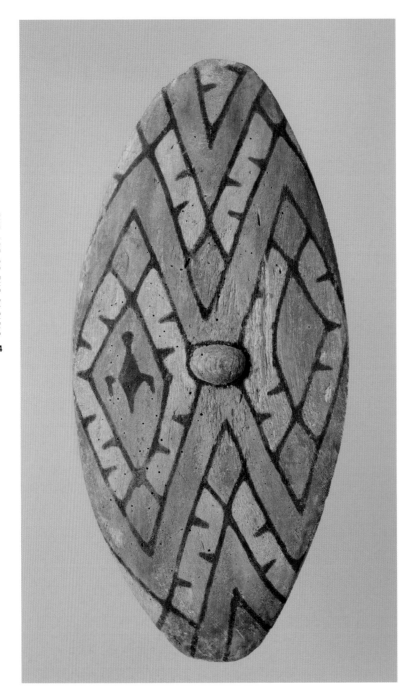

Shield of Queensland; wood
Schild aus Queensland; Holz
Schild van Queensland; hout
Escudo de Queensland; madera
1850-1890
The Metropolitan Museum
of Art, New York

Shield of Queensland with painted
motifs used for the initiation
of young boys; wood
Schild aus Queensland mit
aufgemalten Motiven für die
Initiation der Jugendlichen; Holz
Schild van Queensland patroon
schilderijen gebruikt voor de
inleiding van jongeren; hout
Escudo de Queensland con
motivos pintados utilizado para la
iniciación de los jóvenes; madera
ca. 1850
Musée du quai Branly, Paris

Sculpture of totemic dog, Cape York
Peninsula; wood and enamels
Skulptur eines Totemhunds, Cape York
Halbinsel; Holz und Email
Totempaal sculptuur van een hond,
Cape York schiereiland; hout en glas
Escultura de perro totémico, península
del Cabo de York; madera y esmaltes
1962

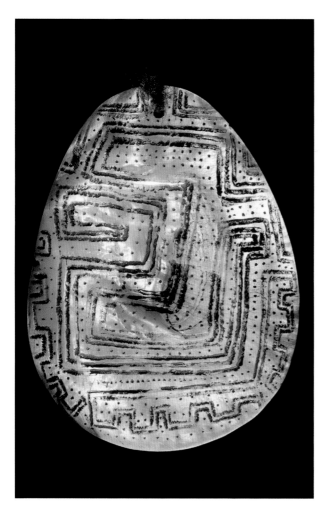

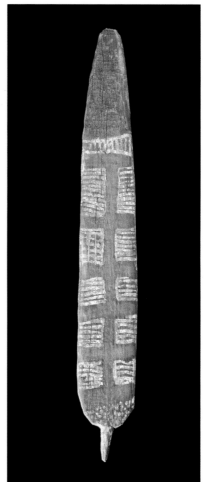

Pendant of Western Kimberley with shape and designs
connected with the water element; mother-of-pearl
Anhänger aus Western Kimberley mit Form
und Bemalung des Elements Wasser; Perlmutt
Hanger van Western Kimberley met vormen en
tekeningen in verband met het element water; parelmoer
Colgante de Western Kimberley con forma y dibujos
relacionados con el elemento acuático; nácar
1900-2000
Tara Collection, New York

Hair ornament used during ritual dances; wood
Haarschmuck für rituelle Tänze; Holz
Haarsieraden gebruikt tijdens rituele dansen; hout
Ornamento para cabellos usado durante las danzas
rituales; madera
1900-2000
Tara Collection, New York

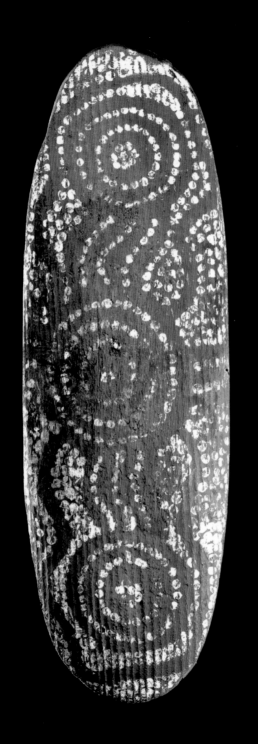

Shield with grooved surface, Central
Australia; wood and enamels
Schild mit gerillter Oberfläche;
Zentralaustralien; Holz und Email
Schild met gegroefd schild, Centraal-
Australië; hout en glas
Escudo con superficie estriada,
Australia central; madera y esmaltes

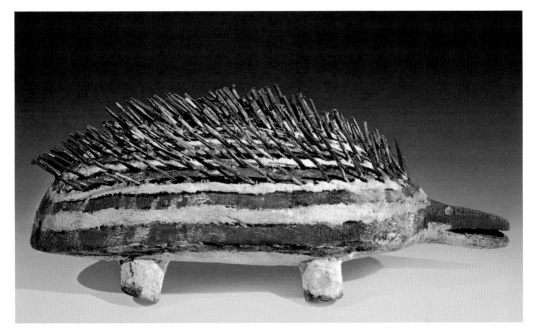

▌ *The ability to elaborate simple shapes with basic colors obtaining highly expressive results is surprising.*
▌ *Überraschend ist die Fähigkeit, einfache Formen mit Grundfarben in ausdrucksstarke Produkte zu verwandeln.*
▌ *Verrassend is de mogelijkheid om met het uitwerken van eenvoudige vormen en essentiële kleuren tot sterk expressieve resultaten te komen.*
▌ *Es sorprendente la capacidad de elaborar formas simples de colores básicos con resultados fuertemente expresivos.*

Wooden figure depicting an echidna, Aurunkun,
Cape York Peninsula; wood and enamels
Eine Echidna darstellende Holzskulptur, Aurunkun,
Cape York Halbinsel; Holz und Email
Houten sculptuur met een afbeelding van Echidna,
Aurunkun, Cape York schiereiland; hout en glas
Escultura de madera que representa un equidna,
Aurunkun, península del Cabo de York; madera
y esmaltes

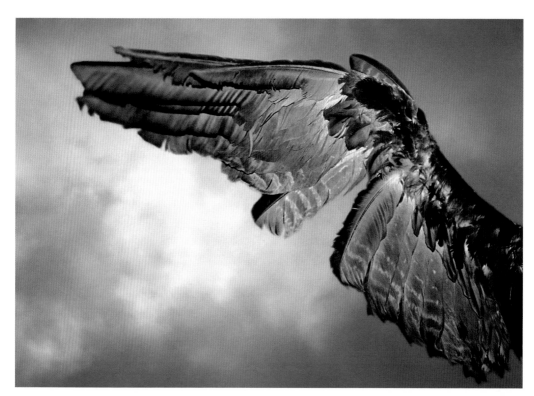

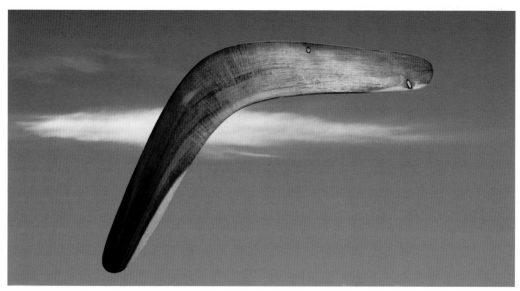

❚ Similar to the boomerang, today Australian Aboriginal art reconciles apparently simple forms with extremely complex content.
❚ Wie der Bumerang vereint die australische Kunst der Ureinwohner heute augenscheinliche Einfachheit der Formen mit extremer Komplexität der Inhalte.
❚ Zoals de boemerang, Australische Aboriginal kunst van vandaag, verenigt de schijnbare eenvoud van vorm de extreme complexiteit van de inhoud.
❚ Como sucedió con el boomerang, hoy el arte aborigen australiano concilia la aparente sencillez de sus formas con la extrema complejidad de sus contenidos.

◀ **Michael Riley**
(Dubbo, New South Wales 1960 - ? 2004)
Broken wing, image from the Clouds installation; photography on glass
Gebrochenener Flügel, Bild von der Installation Wolken; Fotografie auf Glas
Gebroken vleugel, beeld installatie Wolken; foto op glas
Ala rota, imagen de la instalación Nubes; fotografía sobre vidrio
2006
Musée du quai Branly, Paris

◀ **Michael Riley**
(Dubbo, New South Wales 1960 - ? 2004)
Boomerang, image of the Clouds installation; photography on glass
Bumerang, Bild von der Installation Wolken; Fotografie auf Glas
Boomerang, beeld-installatie Wolken; foto op glas
Boomerang, imagen de la instalación Nubes; fotografía sobre vidrio
2006
Musée du quai Branly, Paris

Boomerang, Western Kimberley; wood
Bumerang, Western Kimberley; Holz
Boomerang, Western Kimberley; hout
Boomerang, Western Kimberley; madera
1850-1900
The Metropolitan Museum of Art, New York

71

The art of Oceania in the museums of the world
Die Kunst Ozeaniens in den Museen der Welt
Kunst uit Oceanië in de musea wereldwijd
El arte de Oceanía en los museos del mundo

British Library, London

Rautenstrauch-Joest-Museum Köln

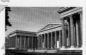

British Museum, London

Ethnologisches Museum, Berlin

Metropolitan Museum of Art, New York

Museum of Modern Art (MoMA), New York

Philip Goldman Collection, London

Stapleton Historical Collection, London

Museum für Völkerkunde, Berlin

Tara Collection, New York

Entwistle Gallery, London

Steinschneider Collection, Miami

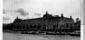

Museo di Antropologia ed Etnologia, Firenze

Musée d'Orsay, Paris

Musée Barbier-Müller, Genève

Museo Pedro Coronel, Zacatecas (México)

Rapa Nui National Park, Easter Island

Musée du quai Branly, Paris

State Hermitage Museum, St. Petersburg

Linden-Museum, Stuttgart

Museo Missionario-Etnologico, Città del Vaticano

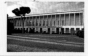

Museo Nazionale Preistorico ed Etnografico Luigi Pigorini, Roma

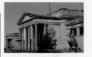

Art Gallery of New South Wales, Sydney

National Museum of Australia, Canberra

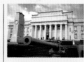

Auckland Institute and Museum, Auckland

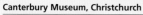

National Library of Australia, Canberra

Department of Anthropology, University of Auckland

National Museum of New Zealand, Wellington

Taranaki Museum, New Plymouth

Canterbury Museum, Christchurch

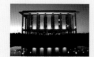

Otago Museum, Dunedin

Maori and Pioneer Museum, Okains Bay

Melanesia • Melanesien • Melanesië

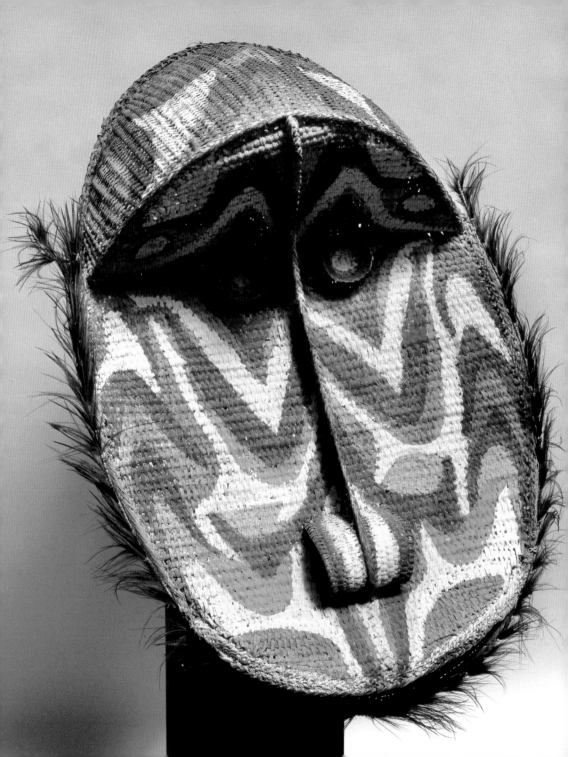

The civilization of rivers and forests

Melanesian culture is centered on the large island of New Guinea: high mountains, impervious forests crossed by majestic rivers, the restless ocean that moulds the coasts, and a constellation of islands and archipelagos separated by a sea that is difficult to navigate. The rhythm of life is dictated by an overwhelming nature that is a source of inspiration, but also fear. These elements can be found in the region's art, which is dominated by a strong ancestral spirituality.

Kultur der Flüsse und Wälder

Die Kultur Melanesiens hat ihren Mittelpunkt auf der großen Insel Papua-Neuguinea: hohe Berge, unwegsame von mächtigen Flüssen durchzogene Wälder, der unruhige Ozean, der die Küsten formt und die von einem schwerlich passierbaren Meer umgebenen Inseln und Inselgruppen. Der Rhythmus des Lebens wird von einer tobenden Natur diktiert, die sowohl Inspirationsquelle, als auch Gefahrenquelle ist. Diese Elemente finden wir in den von einer starken Spiritualität der Ahnen beherrschten künstlerischen Erscheinungen wieder.

3

Beschaving van rivieren en bossen

De Melanesische cultuur is gecentreerd op het grote eiland van Nieuw-Guinea: hoge bergen, ruige bossen doorstroomd door majestueuze rivieren, de rusteloze oceaan, die de kustlijnen vorm geeft, een constellatie van eilanden en eilandengroepen voor de kust, gescheiden door een zee waardoor moeilijk te navigeren valt. Het tempo van het leven wordt gedicteerd door een overweldigende natuur die inspirerend is, maar ook een bron van gevaar. Deze elementen vinden we in de kunst gedomineerd door een sterke voorouderlijke spiritualiteit.

Civilización de ríos y bosques

La cultura melanesia tiene como centro la gran isla de Nueva Guinea: altas montañas, bosques impenetrables atravesados por ríos majestuosos, el océano inquieto que esculpe las costas, una constelación de islas y archipiélagos alejados, separados por un mar difícil de navegar. El ritmo de vida está dictado por una naturaleza arrolladora que es fuente de inspiración, pero también fuente de peligro. Encontramos estos elementos en las manifestaciones artísticas dominadas por una fuerte espiritualidad ancestral.

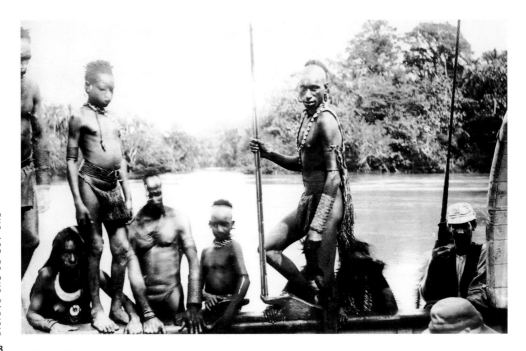

■ *New Guinea's sensational nature has deeply marked and divided the many groups of people that live there.*
■ *Die gewaltige Natur von Neuguinea hat die verschiedenen Völker, die es bewohnen, tief gekennzeichnet und geteilt.*
■ *Het ontwrichtende karakter van Nieuw-Guinea heeft de vele groepen van mensen die hier wonen aangeraakt en diep verdeeld.*
■ *La impresionante naturaleza de Nueva Guinea ha marcado y dividido profundamente los muchos grupos humanos que la habitan.*

New Guinea natives in canoe; the major Papuan cultures started along the rivers
Eingeborene aus Neuguinea im Kanu; entlang der Flüsse sind die größten Kulturen Papuas entstanden
Inboorlingen van Nieuw-Guinea in kano; langs de rivieren ontspringen de grote culturen Papoea
Nativos de Nueva Guinea en canoa; a la vera de los ríos han nacido las principales culturas papúas
1887

Print depicting the Dodinga River in New Guinea
Stich mit Darstellung des Flusses Dodinga in Neuguinea
Afbeelding van de Dodinga rivier in Nieuw-Guinea
Estampa que representa el río Dodinga en Nueva Guinea
Guinea
1877

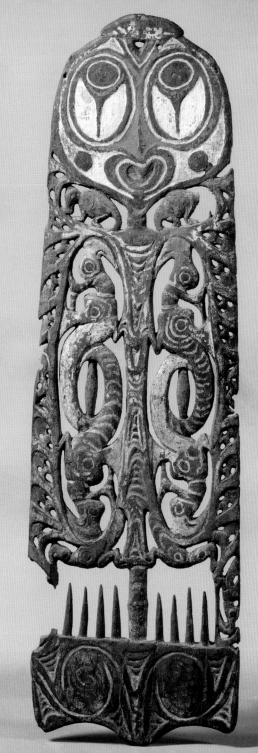

▶ Rear of a tablet sculpted with water gods,
Papua New Guinea; wood
Rückseite einer gemeißelten Tafel mit
Wassergottheiten, Papua-Neuguinea; Holz
Achterkant van een gebeeldhouwd tablet met
de watergoden, Papoea-Nieuw-Guinea; hout
Reverso de una tabla esculpida con divinidad
acuática, Papúa Nueva Guinea; madera
Museo Missionario-Etnologico, Città del Vaticano

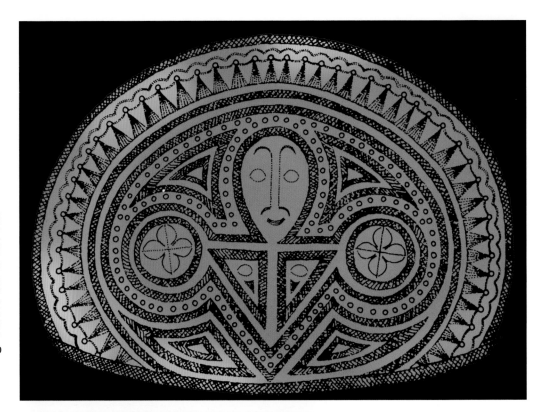

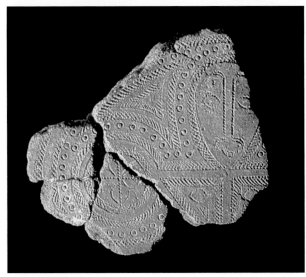

Reconstruction of anthropomorphic drawing from a
fragement found in the Nenumbo, Solomon Islands site
Rekonstruktion einer anthropomorphen Zeichnung
nach einem Fragment, das bei Nenumbo entdeckt
wurde, Salomon Inseln
Reconstructie van een antropomorfe tekening
fragmenten gevonden op de site van Nenumbo,
Salomonseilanden
Reconstrucción de dibujo antropomorfo de un
fragmento encontrado en Nenumbo, islas Salomón

Fragment with stylized human faces from Nenumbo,
Solomon Islands
Fragment mit stilisierten menschlichen Zügen aus
Nenumbo, Salomon Inseln
Fragment met gestileerde menselijke gezichten
uit Nenumbo, Salomonseilanden
Fragmento con rostros humanos estilizados
de Nenumbo, islas Salomón
ca. 1200-1000 BCE

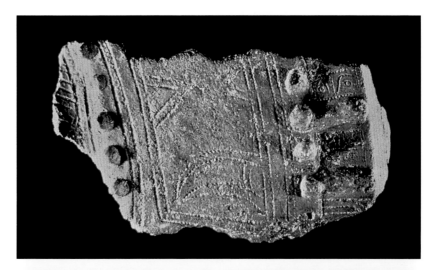

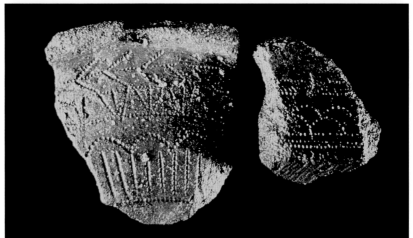

Lapita vase fragment from Natunuku, Fiji Islands
Fragment einer Lapita-Vase aus Natunuku, Fiji Inseln
Vaasfragment uit Lapita Natunuku, Fiji-eilanden
Fragmento de un vaso lapita de Natunuku, islas Fiji
ca. 1200-1000 BCE
Department of Anthropology, University of Auckland

Fragment of vase with geometric decorations;
Natunuku, Fiji Islands
Fragment einer Vase mit geometrischen
Verzierungen; Natunuku, Fiji Inseln
Vaasfragment met geometrische versieringen;
Natunuku, Fiji
Fragmento de un vaso con decoraciones
geométricas; Natunuku, islas Fiji
ca. 1000-900 BCE

Figure of bird, Papua New Guinea; stone
Vogelfigur, Papua-Neuguinea; Stein
Figuren van vogels, Papoea-Nieuw-Guinea; steen
Figura de ave, Papúa Nueva Guinea; piedra
The Metropolitan Museum of Art, New York

▶ Stone of Ambun, rare example of sculpture from
the territory of the clan of the Yambu; Ambun Valley,
Papua New Guinea
Ambun-Stein, seltenes Exemplar einer Statue,
die aus dem Territorium des Yambu-Clans stammt;
Ambun Valley, Papua-Neuguinea
Stone Ambun, een zeldzaam exemplaar van
de beeldhouwkunst vanaf het grondgebied van de
Yambú clan; Ambun Valley, Papoea-Nieuw-Guinea
Piedra de Ambun, raro ejemplar de escultura
proveniente del territorio del clan de los Yambu;
Ambun Valley, Papúa Nueva Guinea
National Museum of Australia, Canberra

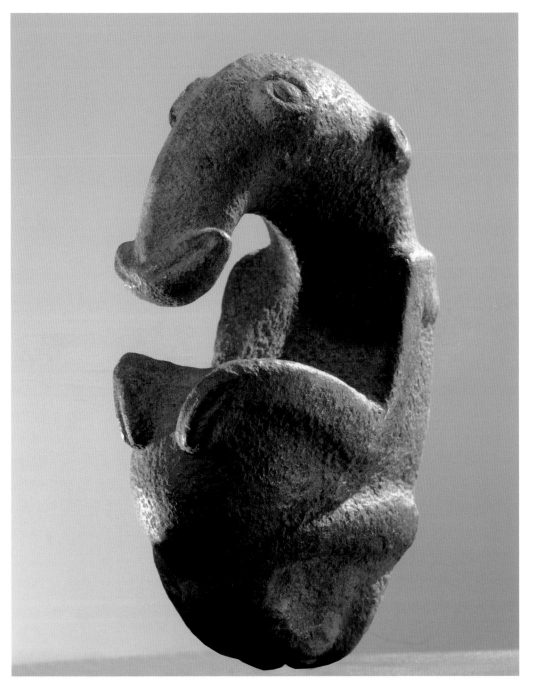

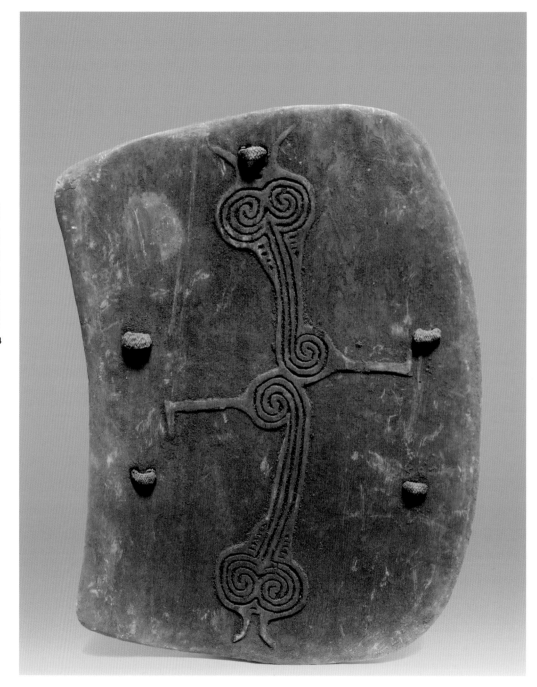

■ "Poor" materials are the basis of a type of art that can be described as both refined and "wild".
■ "Arme" Materialien sind die Grundlage einer raffinierten und gleichsam „wilden" Kunst.
■ "Arme" materialen zijn de basis van een kunst die zowel geraffineerd als "wild" is.
■ Los materiales "pobres" son la base de un arte que es al mismo tiempo refinado y "salvaje".

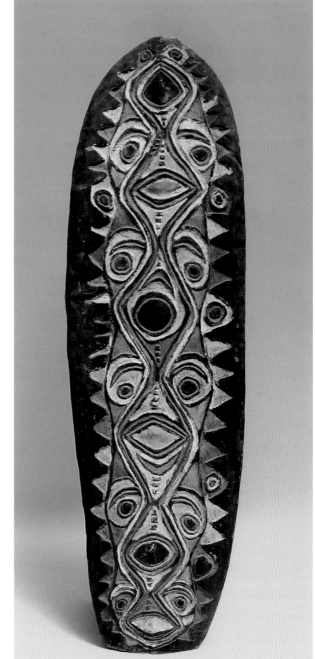

Shield, Papua New Guinea; wood
Schild, Papua-Neuguinea; Holz
Schild, Papoea-Nieuw-Guinea; hout
Escudo, Papúa Nueva Guinea; madera
1900-2000
Private collection / Private Sammlung
Privécollectie / Colección privada

◄ Shield with stylized drawing,
Papua New Guinea
Schild mit stilisierter Zeichnung,
Papua-Neuguinea
Schild met gestileerde afbeelding,
Papoea-Nieuw-Guinea
Escudo con dibujo estilizado,
Papúa Nueva Guinea
1900-2000
Philip Goldman Collection, London

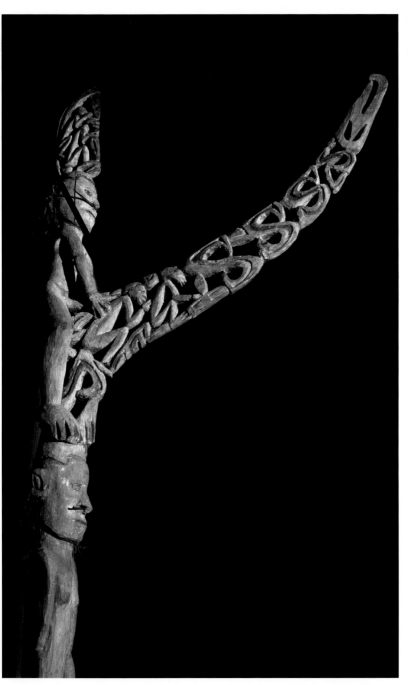

■ The Asmat people, who live in the Papua province of Indonesia, are masters of woodcarving.
■ Die Asmat leben auf dem indonesischen Teil der Insel Papua. Sie sind Meister der Schnitzarbeit.
■ De Asmat, die leven op het Indonesische gedeelte van Papoea, zijn meesters in de insnijdingen.
■ Los Asmat, que viven en la parte indonesia de la isla de Papúa, son maestros en el arte del tallado.

Pole of the Asmat ancestors with phallic figures in the end section, Papua New Guinea; wood
Pfahl der Asmat-Ahnen mit phallischen Figuren an der Spitze, Papua-Neuguinea; Holz
Palo van de Asmat-voorouders met fallische vormen in de terminal, Papoea-Nieuw-Guinea; hout
Palo de los antepasados Asmat con figuras fálicas en la parte terminal, Papúa Nueva Guinea; madera
1900-2000

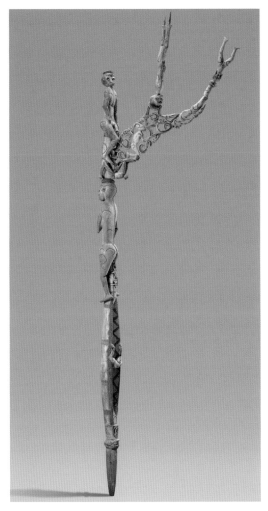

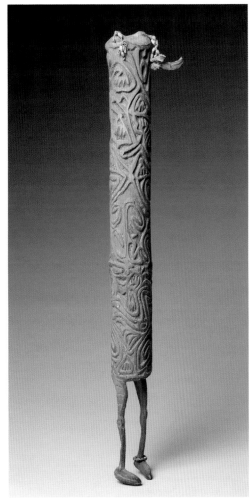

Pole of the Asmat ancestors for the rites of the dead,
Papua New Guinea; wood and fibres
Pfahl der Asmat-Ahnen für die Totenrituale,
Papua-Neuguinea; Holz und Fasern
Palo van de Asmat-voorouders riten voor de doden,
Papoea-Nieuw-Guinea; hout en vezels
Palo de los antepasados Asmat para los ritos
de los muertos, Papúa Nueva Guinea; madera y fibras
ca. 1950
The Metropolitan Museum of Art, New York

Asmat trumpet for head hunting; bamboo
Asmat-Trompete für die Kopfjagd; Bambus
Asmattrompet voor het jagen op hoofden; bamboe
Trompeta Asmat para la caza de cabezas; bambú
1900-2000
Musée du quai Branly, Paris

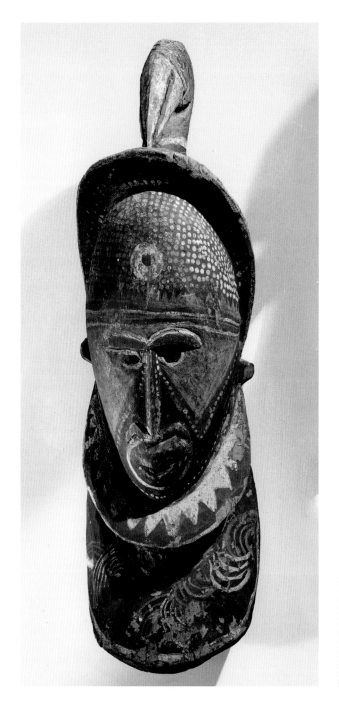

Male figure Abelam,
Papua New Guinea; wood
Männliche Abelam Figur,
Papua-Neuguinea; Holz
Man figuur Abelam,
Papoea-Nieuw-Guinea; hout
Figura masculina Abelam,
Papúa Nueva Guinea; madera
Museo Pedro Coronel, Zacatecas
(México)

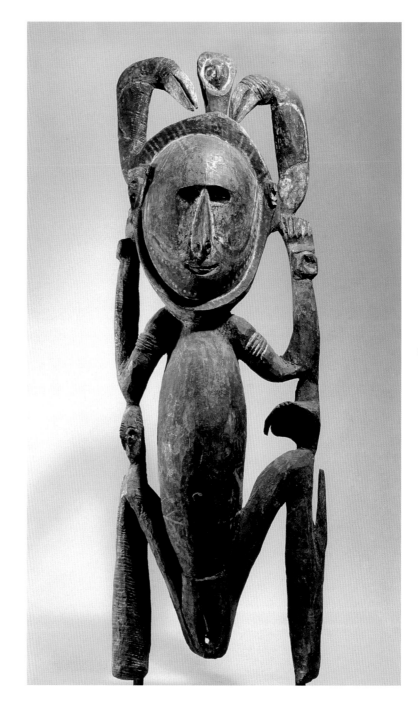

MELANESIA – THE CIVILIZATION OF RIVERS AND FORESTS

Squatting female figure,
Papua New Guinea; wood
Sitzende weibliche Figur,
Papua-Neuguinea; Holz
Vrouwenfiguur gehurkt,
Papoea-Nieuw-Guinea; hout
Figura femenina agazapada,
Papúa Nueva Guinea; madera
1900-2000
Philip Goldman Collection,
London

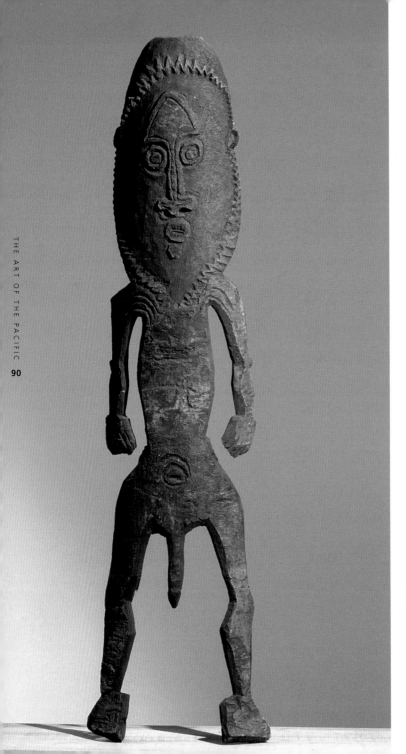

Two-dimensional male figure from
the Gulf of Papua; bark
Zweidimensionale männliche Figur
aus dem Golf von Papua; Rinde
Mannelijk beeldje tweedimensionaal
uit de Golf van Papoea; schors
Figurilla masculina bidimensional
del Golfo de Papúa; corteza
1900-2000
Private collection / Private Sammlung
Privécollectie / Colección privada

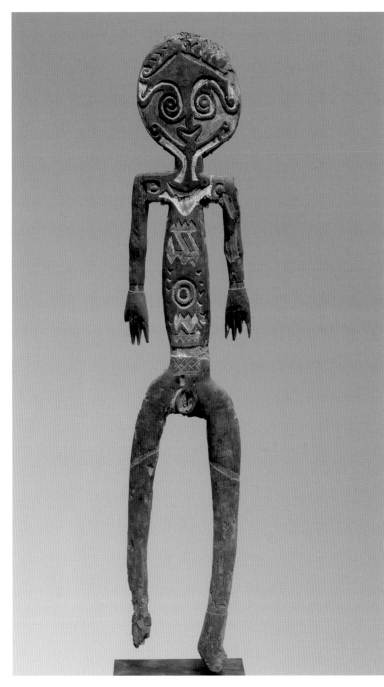

Two-dimensional female figure
from the Gulf of Papua; bark
Zweidimensionale weibliche Figur
aus dem Golf von Papua; Rinde
Vrouwenbeeldjes
tweedimensionaal uit de Golf
van Papoea; schors
Figurilla femenina bidimensional
del Golfo de Papúa; corteza
1900-2000
Philip Goldman Collection,
London

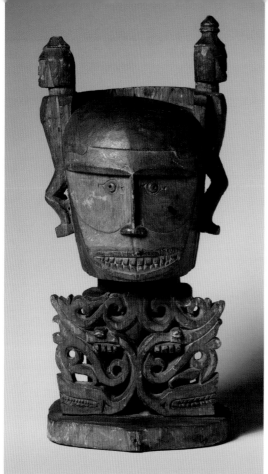

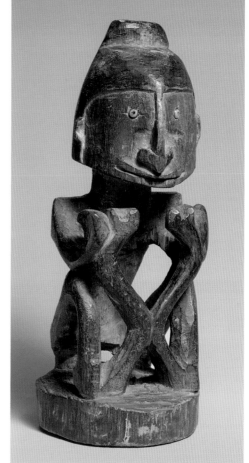

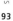

"Korwar" style sculpture, depiction for soothsaying or magical purposes; Cenderawasih Bay, New Guinea; wood and glass beads
Skulptur im „Korwar"-Stil, die für Wahrsagerei und Magie benutzt wird; Cenderawasih Bay, Neuguinea; Holz und Glasperlen
Sculptuur stijl "korwar", uitbeelding van waarzeggers of tovenaars; Cenderawasih Bay, Nieuw-Guinea; hout en parelmoer
Escultura de estilo "korwar", representación con fines adivinatorios o mágicos; Cenderawasih Bay, Nueva Guinea; madera y perlas de vidrio
1890-1910
Musée du quai Branly, Paris

◀ Figure of ancestor in the "Korwar" style; wood
Ahnenfigur im "Korwar"-Stil; Holz
Figuur van voorouder in "korwar" stijl; hout
Figura de antepasado en estilo "korwar"; madera
Private collection / Private Sammlung / Privécollectie / Colección privada

Figure of Korwar ancestor, Cenderawasih Bay, New Guinea; wood and glass beads
Korwar-Ahnenfigur, Cenderawasih Bay, Neuguinea; Holz und Glasperlen
Figuur van voorouder korwar, Cenderawasih Bay, Nieuw-Guinea; hout en parelmoer
Figura de antepasado korwar, Cenderawasih Bay, Nueva Guinea; madera y perlas de vidrio
1890-1910
The Metropolitan Museum of Art, New York

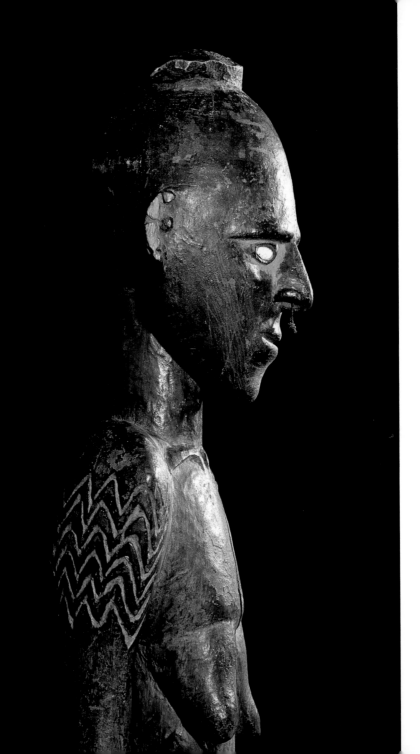

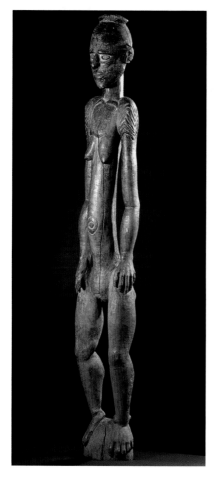
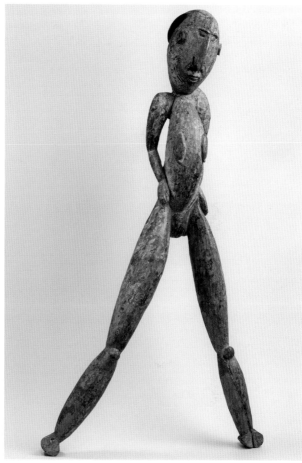

▌ *The tribes along the Sepik River developed a refined artistic tradition based on wood.*
▌ *Die am Fluss lebenden Stämme haben eine raffinierte Tradition der Holzbearbeitung entwickelt.*
▌ *De stammen langs de rivier de Sepik, hebben een geraffineerde houtkunst ontwikkeld.*
▌ *Las tribus ubicadas a lo largo del curso del río Sepik han desarrollado un refinado arte de la madera.*

Female statue that possibly represents an ancestor of
the clan and detail, Sepik, Papua New Guinea; wood
Frauenstatue, die vielleicht einen Ahnen des Clans
darstellt und Detail, Sepik, Papua-Neuguinea; Holz
Vrouwenbeeldje dat misschien een voorouder is van
de clan en detail, Sepik, Papoea-Nieuw-Guinea; hout
Estatuilla femenina que probablemente representa
una antepasada del clan y detalle, Sepik, Papúa Nueva
Guinea; madera
Entwistle Gallery, London

Female figure of probable ancestor of the clan,
East Sepik, Papua New Guinea; wood
Frauenfigur, wahrscheinlich von einem Vorfahren
des Clans, East Sepik, Papua-Neuguinea; Holz
Vrouwenfiguur, waarschijnlijk voorouder van de clan,
Oost Sepik, Papoea-Nieuw-Guinea; hout
Figura femenina de probable antepasada del clan,
Sepik Este, Papúa Nueva Guinea; madera
1800-1900
The Metropolitan Museum of Art, New York

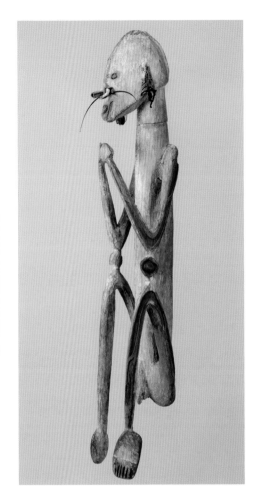

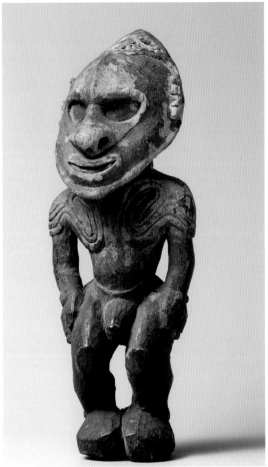

Figure of ancestor Asmat, Papua New Guinea; wood
Asmat-Ahnenfigur, Papua-Neuguinea; Holz
Figuur voorouder van de Asmat, Papoea-Nieuw-Guinea; hout
Figura de antepasado Asmat, Papúa Nueva Guinea; madera
1900-1950
The Metropolitan Museum of Art, New York

Male figure from the lower course of the Sepik, Papua New Guinea; wood
Männliche Figur, die aus dem unteren Lauf des Sepik stammt, Papua-Neuguinea; Holz
Mannenfiguur uit de benedenloop van de Sepik, Papoea-Nieuw-Guinea; hout
Figura masculina proveniente del curso inferior del río Sepik, Papúa Nueva Guinea; madera
1800-1910
The Metropolitan Museum of Art, New York

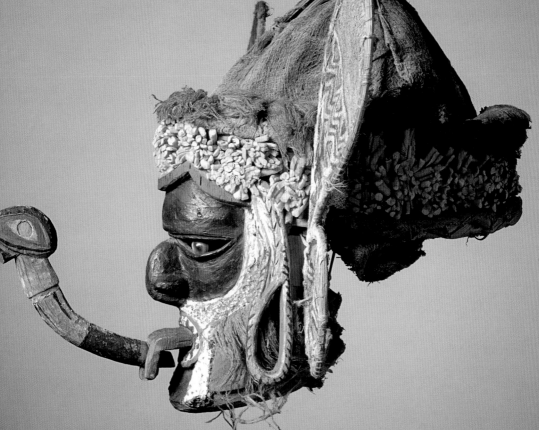

Mask for probable funeral use, worn by the relatives of the deceased, New Ireland; pounded bark
Maske, wahrscheinlich zur Verwendung bei Begräbnissen, wo sie von Verwandten des Verstorbenen getragen wird, Neuirland; geschlagene Rinde
Masker waarschijnlijk gebruikt bij begrafenis, gedragen door familieleden van de overledene, Nieuw-Ierland; geslagen schors
Máscara, probablemente de uso fúnebre, utilizada por los parientes del difunto, Nueva Irlanda; corteza tratada
1800-1900
Musée du quai Branly, Paris

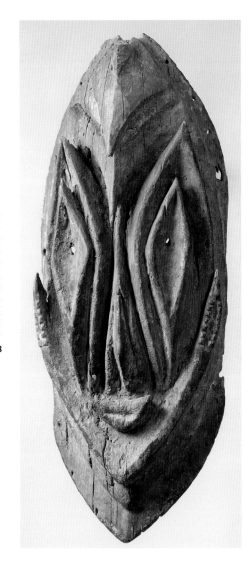

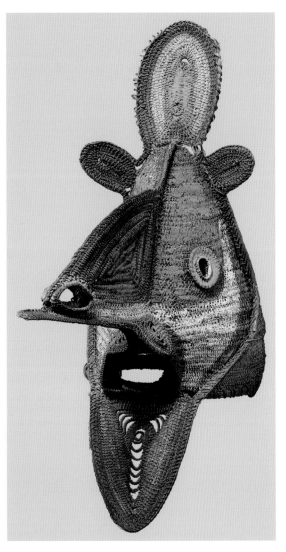

Mask, Lower Sepik, Papua New Guinea; wood
Maske, Lower Sepik, Papua-Neuguinea; Holz
Masker, Neder Sepik, Papoea-Nieuw-Guinea; hout
Máscara, Bajo Sepik, Papúa Nueva Guinea; madera
1800-1900
The Metropolitan Museum of Art, New York

Mask, Papua New Guinea; woven reeds
Maske, Papua-Neuguinea; geflochtenes Schilfgras
Masker, Papoea-Nieuw-Guinea; geweven riet
Máscara, Papúa Nueva Guinea; cañas trenzadas
Museo Missionario-Etnologico, Città del Vaticano

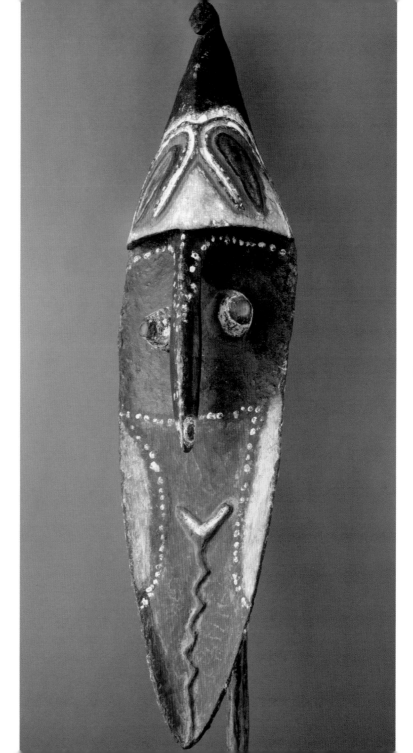

■ Masks have a highly
important cultural role among
populations with a strong
sense of the supernatural.
■ Die Masken spielen eine
enorm wichtige kulturelle
Rolle bei Völkern, die einen
besonders ausgeprägten Hang
zum Übernatürlichen besitzen.
■ De maskers hebben een
vooraanstaande culturele
rol bij populaties met
een sterk gevoel voor het
bovennatuurlijke.
■ Las máscaras tienen un rol
cultural fundamental entre los
pueblos con un fuerte sentido
de lo sobrenatural.

Mask relative to the cult
of the yam (Yena),
Papua New Guinea; wood
Maske für den
Jamswurzelkult (Yena),
Papua-Neuguinea; Holz
Masker behorend
bij de yam cult (Yena),
Papoea-Nieuw-Guinea; hout
Máscara inherente al culto
del ñame (Yena),
Papúa Nueva Guinea; madera
1800-1910
The Metropolitan Museum
of Art, New York

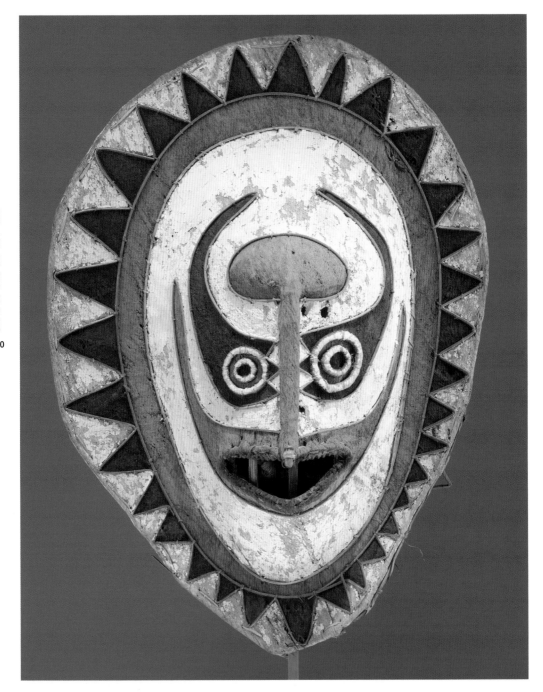

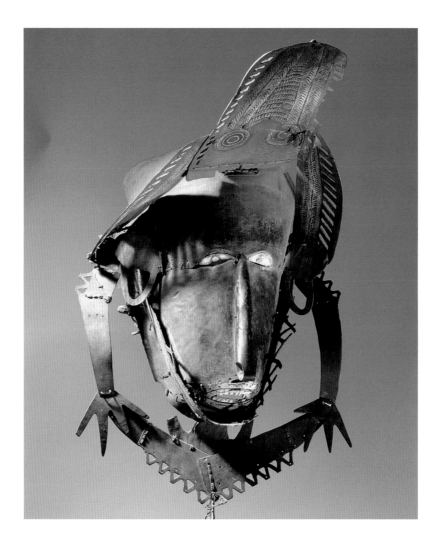

◀ Eharo mask generally used for entertainment purposes, Papua New Guinea; bark, bamboo cane, dried grasses, sago palm leaves
Eharo-Maske, eigentlich zu Unterhaltungszwecken hergestellt wird, Papua-Neuguinea; Rinde, Bambusgras, getrocknete Kräuter, Blätter der Sagopalme
Masker Ehara in het algemeen geproduceerd voor entertainment, Papoea-Nieuw-Guinea; schors, bamboe, gedroogde kruiden, bladeren van sago palm
Máscara Eharo, generalmente producida con fines de entretenimiento, Papúa Nueva Guinea; corteza, caña de bambú, hierbas disecadas, hojas de palmera sago
ca. 1900-1920
The Metropolitan Museum of Art, New York

Dance mask; sheets of turtle shell, palm fibres
Tanzmaske; Schildkrötenpanzerplatten, Palmenfasern
Dansmasker; platen van schildpad schelp, palm vezel
Máscara de danza; láminas de caparazón de tortuga, fibras de palmera
Entwistle Gallery, London

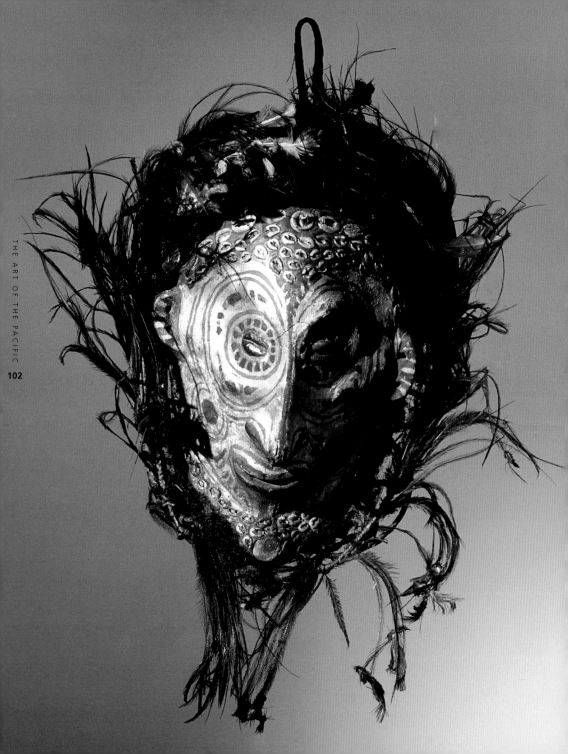

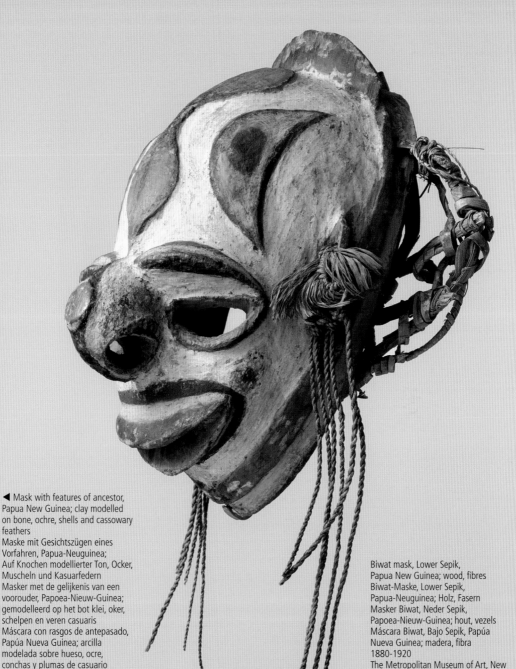

◄ Mask with features of ancestor,
Papua New Guinea; clay modelled
on bone, ochre, shells and cassowary
feathers
Maske mit Gesichtszügen eines
Vorfahren, Papua-Neuguinea;
Auf Knochen modellierter Ton, Ocker,
Muscheln und Kasuarfedern
Masker met de gelijkenis van een
voorouder, Papoea-Nieuw-Guinea;
gemodelleerd op het bot klei, oker,
schelpen en veren casuaris
Máscara con rasgos de antepasado,
Papúa Nueva Guinea; arcilla
modelada sobre hueso, ocre,
conchas y plumas de casuario
Steinschneider Collection, Miami

Biwat mask, Lower Sepik,
Papua New Guinea; wood, fibres
Biwat-Maske, Lower Sepik,
Papua-Neuguinea; Holz, Fasern
Masker Biwat, Neder Sepik,
Papoea-Nieuw-Guinea; hout, vezels
Máscara Biwat, Bajo Sepik, Papúa
Nueva Guinea; madera, fibra
1880-1920
The Metropolitan Museum of Art, New
York

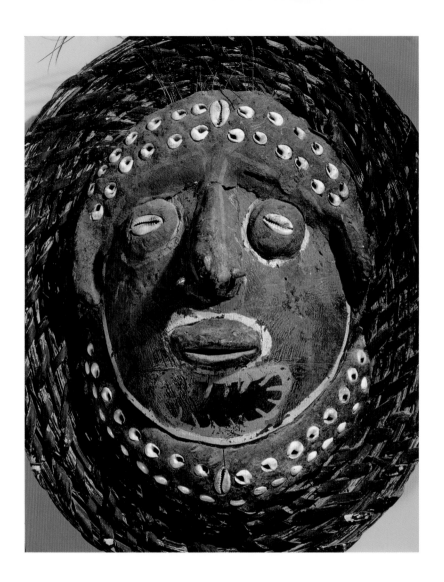

Mask, Sepik, Papua New Guinea; wood and shells
Maske, Sepik, Papua-Neuguinea; Holz und Muscheln
Masker, Sepik, Papoea-Nieuw-Guinea; hout en schelpen
Máscara, Sepik, Papúa Nueva Guinea; madera y conchas
Museo Pedro Coronel, Zacatecas (México)

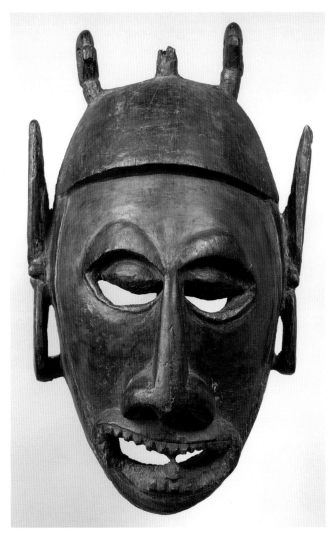

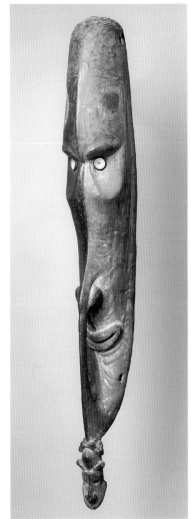

Mask of probable provenance of the Umboi or Siassi
Islands, Papua New Guinea; wood
Maske, die wahrscheinlich von den Inseln Umboi oder
Siassi stammt, Papua-Neuguinea; Holz
Masker van waarschijnlijk de eilanden Umboi of Siassi,
Papoea-Nieuw-Guinea; hout
Máscara, probablemente originaria de las islas Umboi
o Siassi, Papúa Nueva Guinea; madera
1800-1900
The Metropolitan Museum of Art, New York

Latmul mask used in initiation rites; Middle Sepik,
Papua New Guinea; painted wood
Latmul-Maske, die bei Initiationsriten verwendet
wird; Middle Sepik, Papua-Neuguinea; bemaltes
Holz
Latmul masker gebruikt in initiatieriten, Midden
Sepik, Papoea-Nieuw-Guinea; beschilderd hout
Máscara Iatmul utilizada en los ritos de iniciación;
Medio Sepik, Papúa Nueva Guinea; madera
pintada
1800-1900
The Metropolitan Museum of Art, New York

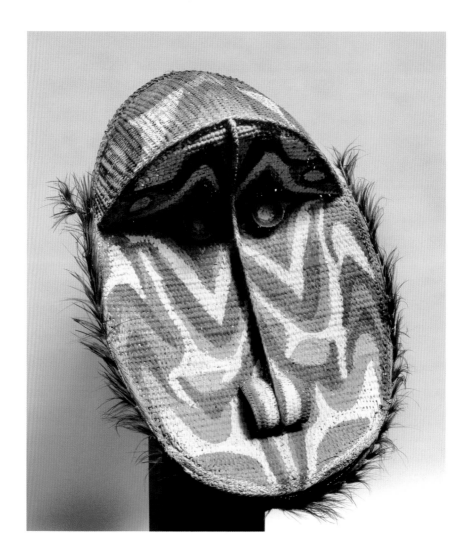

Circular mask that represents female spirits
specific to the clan; woven reed
Rundmaske, die die weiblichen Geister eines
Clans verkörpert; geflochtene Binsen
Rond masker dat hun eigen vrouwelijke geesten
van de clan vertegenwoordigt; gescheurde rotan
Máscara circular que representa espíritus
femeninos del clan; junco trenzado
1900-2000
Private collection / Private Sammlung
Privécollectie / Colección privada

▶ Magical anthropomorphic hook shown in times
of war, Papua New Guinea; wood and Indian reed
Anthropomorpher, magischer Haken, der in
Kriegszeiten ausgestellt wird, Papua-Neuguinea;
Holz und indianische Binsen
Antropomorfe magische haak onthuld in tijd van
oorlog, Papoea-Nieuw-Guinea; hout en Indiase rotan
Gancho antropomorfo mágico expuesto en tiempo
de guerra, Papúa Nueva Guinea; madera y junco indio
ca. 1950
Musée du quai Branly, Paris

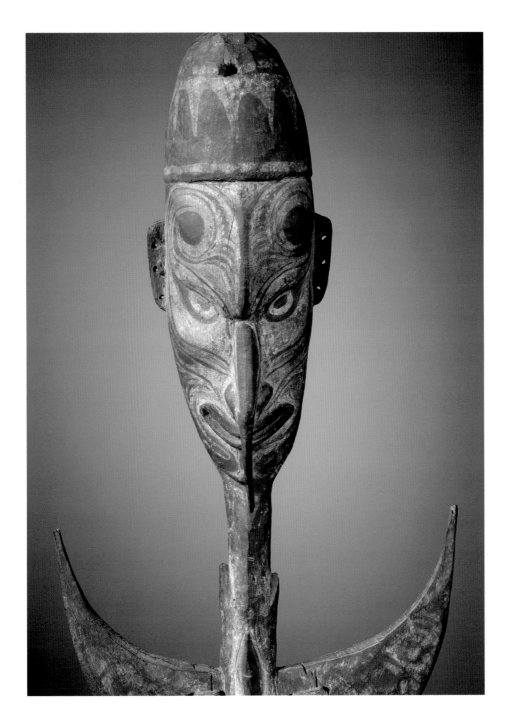

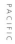
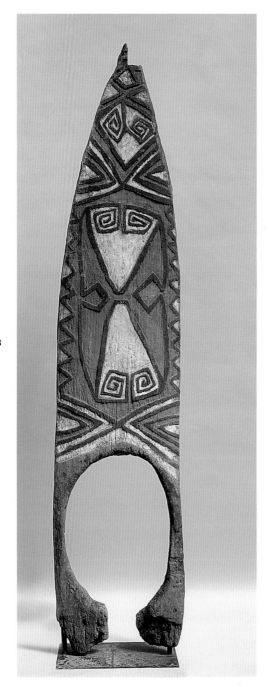

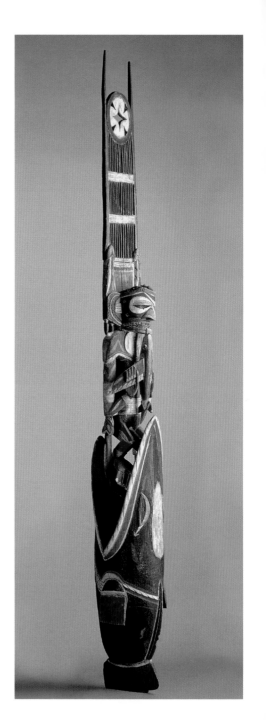

▌ *The slender sculptures and many daily tools are strongly influenced by the archetypal image of the canoe.*
▌ *Die langgezogene Form von Skulpturen und vielen Gebrauchsgegenständen ist stark vom archetypischen Bild der Einbäume geprägt.*
▌ *De slanke vorm van de beelden en veel gebruikte hulpmiddelen is sterk beïnvloed door het archetypische beeld van de kano's.*
▌ *La forma esbelta de las esculturas y de muchas herramientas de uso común está fuertemente influenciada por la imagen arquetípica de las piraguas.*

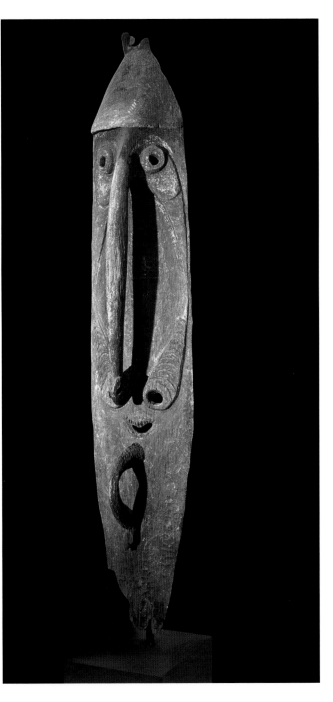

Sculpture from a meeting house of the men depicting an elongated face with phallic-shaped nose, Sepik, Papua New Guinea
Skulptur aus einer Versammlungsstätte für Männer, mit langgezogenem Gesicht und phallusartiger Nase, Sepik, Papua-Neuguinea
Sculptuur van een bijeenkomsthuis voor mannen afbeelding van een lang gezicht en een fallische neus, Sepik, Papoea-Nieuw-Guinea
Escultura de una casa de reunión de los hombres representando una cara alargada con nariz de forma fálica, Sepik, Papúa Nueva Guinea
1900-1920

◀ Decorated panel from a meeting house (*Haus Tambaran*), Sepik, Papua New Guinea; wood
Dekorierte Tafel aus einer Versammlungsstätte (*Haus Tambaran*), Sepik, Papua-Neuguinea; Holz
Paneel versierd met een huis van vergaderingen (*Haus Tambaran*), Sepik, Papoea-Nieuw-Guinea; hout
Panel decorado de una casa de reuniones (*Haus Tambaran*), Sepik, Papúa Nueva Guinea; madera
Private collection / Private Sammlung
Privécollectie / Colección privada

◀ Funerary sculpture, New Ireland; wood, operculum shell and fur
Grabplastik, Neuirland; Holz, Operculum-Muschel und Pelz
Funeraire beeldhouwkunst, Nieuw-Ierland; hout, opercula schelp en haren
Escultura funeraria, Nueva Irlanda; madera, concha de opérculo y pelo
1900-2000
The Metropolitan Museum of Art, New York

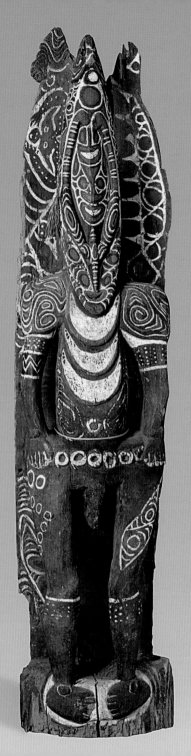

Riser of a ceremonial house Kambot, Lower Sepik, Papua New Guinea; wood and fibre
Pfeiler eines Kambot-Zeremonienzimmers, Lower Sepik, Papua-Neuguinea; Holz und Fasern
Bovendeel van een Kambot ceremoniëel huis, Neder Sepik, Papoea-Nieuw-Guinea; hout en vezels
Mástil de una casa ceremonial Kambot, Bajo Sepik, Papúa Nueva Guinea; madera y fibra
1800-1900
The Metropolitan Museum of Art, New York

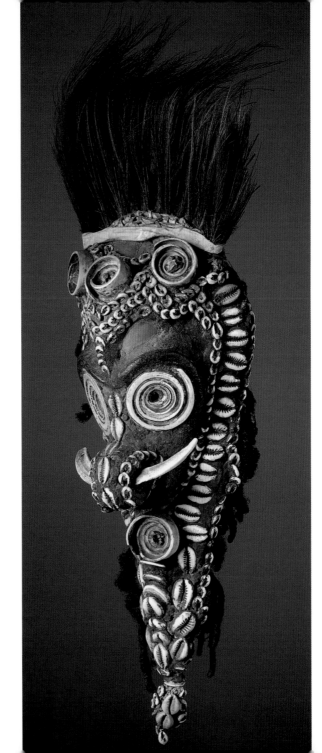

Effigy of ritual flute, East Sepik, Papua
New Guinea; wicker, inserts of shells
and cassowary feathers
Abbild einer ritualen Flöte, East
Sepik, Papua-Neuguinea; Weide,
Muscheleinfassungen und Kasuarfedern
Effigy fluit ritueel, Oost Sepik,
Papoea-Nieuw-Guinea; riet, schelpen
inzetstukken en veren van casuario
Efigie de flauta ritual, Sepik del
Este, Papúa Nueva Guinea; mimbre,
inserciones de conchas y plumas de
casuario
1800-1900
Musée du quai Branly, Paris

Multiple and original expressions

The substantial and multi-faceted art of Melanesia reflects the thousands of years of history in this area, where since the distant past, alternating groups and cultures have existed. Through the use of colors and elaborate decorations, art forms convey a dynamism and expressive quality that stresses the relationship with the existential cycle and spiritual dimension. The formal and decorative richness of these expressions associated with the religious world is equally seen in secular objects.

Mannigfaltige und traditionsreiche Formen

Die gewaltige und reichhaltige künstlerische Produktion Melanesiens spiegelt auf sehr eindrucksvolle Weise die jahrtausendelange Geschichte dieses Gebiets wieder, in dem seit langer Zeit verschiedene Gruppen und Kulturen aufeinanderfolgten. Durch Verwendung von Farben und komplexen Ornamenten besitzen diese Kunstformen Dynamik und Ausdruckskraft, die ihre Bindung an den Kreislauf des Lebens und die geistige Dimension betonen. Der formale und dekorative Reichtum dieser Ausdrucksformen wird eigentlich mit der religiösen Dimension in Verbindung gebracht, macht sich aber ebenso an weltlichen Gegenständen bemerkbar.

4

Verschillende en originele expressies

De grote en gevarieerde artistieke productie van Melanesië weerspiegelt de geschiedenis van dit gebied, waarin ze zijn veranderd, ongeacht leeftijd, groepen en oorspronkelijke cultuur. Kunstvormen drukken, door het gebruik van kleuren en uitgebreide versiering, een dynamiek en expressiviteit uit, die de relatie met de cyclus van het bestaan en de spirituele dimensie onderstrepen. De formele en decoratieve rijkdom van de uitdrukkingen met betrekking tot de religieuze sfeer wordt opnieuw gepresenteerd op eenzelfde manier als objecten voor werelds gebruik.

Expresiones múltiples y originales

La ingente y multiforme producción artística de la Melanesia es un buen reflejo de la historia milenaria de esta región, en la cual se han sucedido, desde tiempos remotos, grupos y culturas originales. Las formas artísticas expresan, mediante el empleo de colores y ornamentaciones elaboradas, un dinamismo y una expresividad que resaltan su relación con el ciclo existencial y la dimensión espiritual. La riqueza formal y decorativa de las expresiones ligadas a la esfera religiosa se reformula de igual modo en los objetos de uso profano.

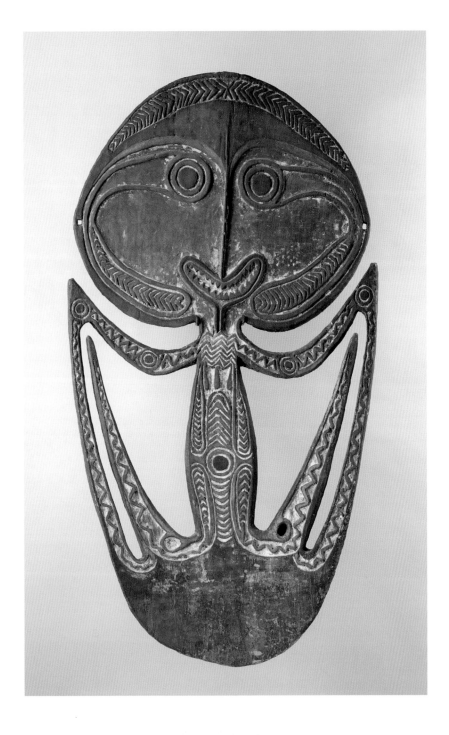

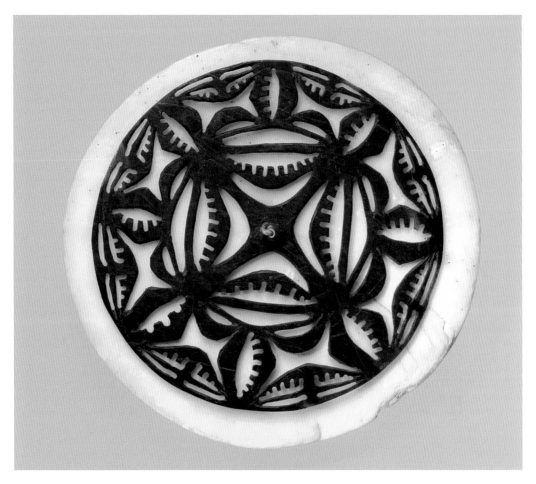

▎*The island universe is populated by supernatural beings, frequently hostile, which are exorcised with images and amulets.*
▎*Diese Insel ist ein von übernatürlichen, meist feindlich gesinnten Wesen bevölkertes Universum. Mit Bildern und Amuletten werden sie vertrieben.*
▎*Deze eilanden is een universum bevolkt door bovennatuurlijke wezens, vaak vijandig, die bezworen moeten worden met beelden en amuletten.*
▎*El universo isleño está poblado por seres sobrenaturales, a menudo hostiles, que se deben exorcizar a través de imágenes y amuletos.*

◀ Hook in shape of skull (*Agiba*), Papua New
Guinea; wood
Haken in Form eines Totenkopfs (*Agiba*),
Papua-Neuguinea; Holz
Haakvormige schedel (*Agiba*), Papoea-
Nieuw-Guinea; hout
Gancho en forma de calavera (*Agiba*),
Papúa Nueva Guinea; madera
1800-1910
The Metropolitan Museum of Art, New York

Hair ornament, Admiralty Islands, Papua
New Guinea; shell, turtle shell
Haarschmuck, Admiralitätsinseln, Papua-Neuguinea;
Muschel, Schildkrötenpanzer
Haarsieraden, Admiralty-eilanden, Papoea-
Nieuw-Guinea; schelp, schild van schildpad
Ornamento para tocado, islas del Almirantazgo,
Papúa Nueva Guinea; concha, caparazón de tortuga
1890-1910
The Metropolitan Museum of Art, New York

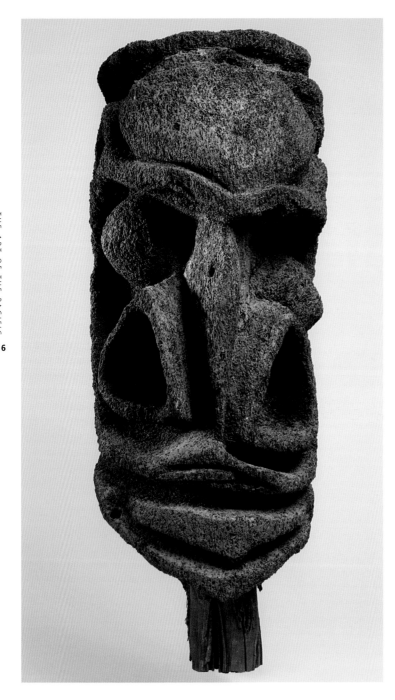

Tympanum ornament (*P'naret*) of
the house of ceremonies, Malekula
Island, Vanuatu; bark of fern
Tympanonornament (*P'naret*) des
Zeremonienhauses, Malekula Island,
Vanuatu; Farnschale
Ornament van het trommelvlies
(*P'naret*) van het huis van de
ceremoniën, Malekula Island,
Vanuatu; varenschors
Ornamento del tímpano (*P'naret*)
de la casa de ceremonias, Malekula
Island, Vanuatu; corteza de helecho
ca. 1950
The Metropolitan Museum of Art,
New York

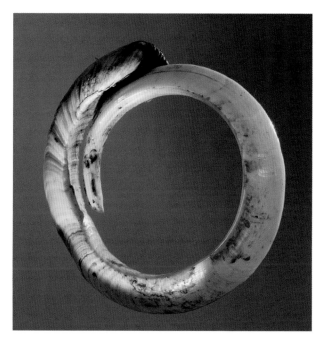

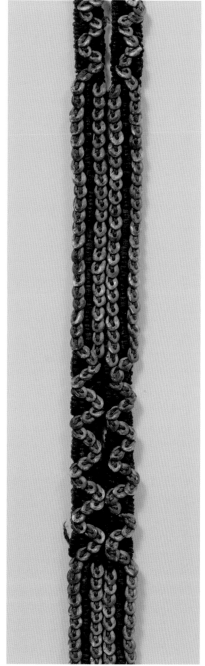

Armband, Papua New Guinea; boar tusk
Armband, Papua-Neuguinea; Wildschweinhauer
Armband, Papoea-Nieuw-Guinea; slagtand van zwijn
Pulsera, Papúa Nueva Guinea; colmillo de jabalí
1900-2000
Private collection / Private Sammlung / Privécollectie / Colección privada

Bracelet; esparto grass, shells, plant fibres
Armband; Esparto, Muscheln, pflanzliche Fasern
Armband; esparto, schelpen en vezels
Brazalete; esparto, conchas, fibras vegetales
1900-2000
Musée du quai Branly, Paris

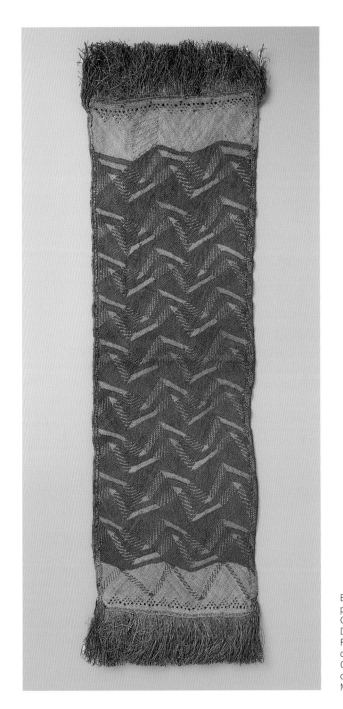

Belt with geometric designs, Vanuatu; plant fibres
Gürtel mit geometrischen Formen und Detail, Vanuatu; pflanzliche Fasern
Riem met geometrische motieven en detail, Vanuatu; plantaardige vezels
Cinturón con motivos geométricos y detalle, Vanuatu; fibras vegetales
Musée du quai Branly, Paris

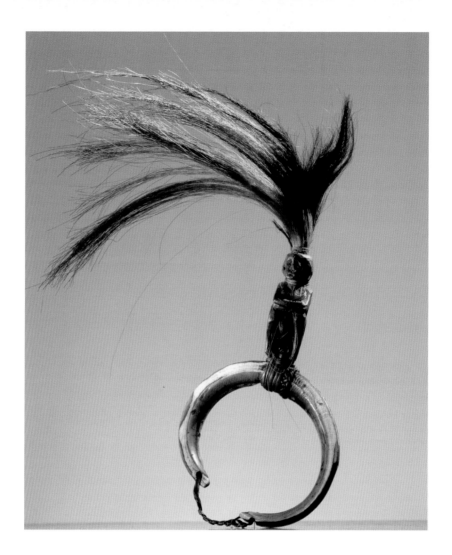

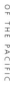

Warrior breast ornament, Papua New Guinea
Brustschmuck eines Kriegers, Papua-Neuguinea
Ornament voor de borst van een krijger, Papoea-Nieuw-Guinea
Ornamento para el pecho de un guerrero, Papúa Nueva Guinea
1900-2000
Private collection / Private Sammlung
Privécollectie / Colección privada

▶ Dance mask, Aoba Island, Vanuatu; plant fibres, wood, bark
Tänzermaske, Aoba Island, Vanuatu; pflanzliche Fasern, Holz, Rinde
Dansmasker, Aoba Island, Vanuatu; plantaardige vezels, hout
en schors
Máscara de danza, Aoba Island, Vanuatu; fibras vegetales, madera,
corteza
ca. 1880-1900
Musée du quai Branly, Paris

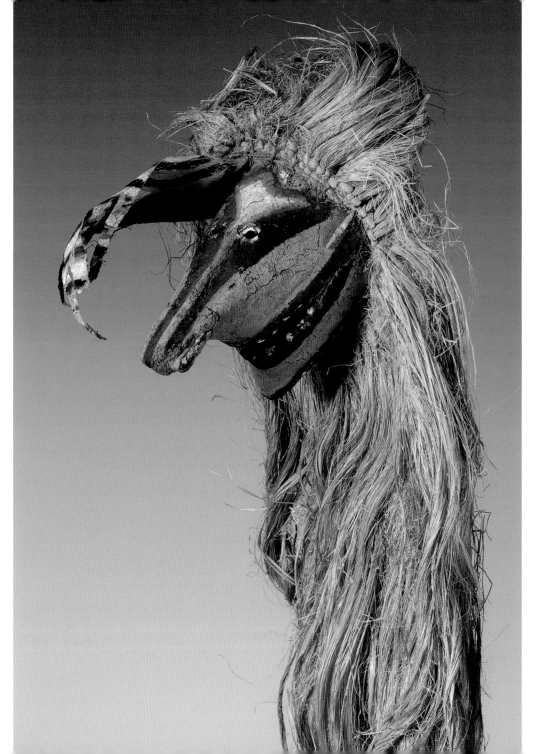

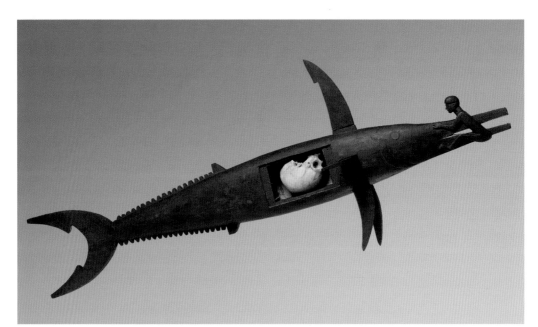

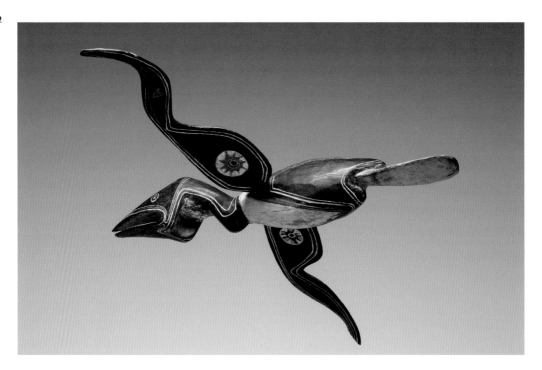

▌ *Animals are part of the cognitive reality of the Melanesians, but also support in their supernatural experiences.*
▌ *Tiere sind Teil des kognitiven Bewusstseins der Melanesier, aber sie spielen ebenso eine Rolle bei ihren übernatürlichen Erfahrungen.*
▌ *De dieren zijn onderdeel van de realiteit van Melanesiërs, maar ondersteunen ook hun bovennatuurlijke ervaringen.*
▌ *Los animales son parte de la realidad cognitiva de los melanesios, pero también el sustento de sus experiencias sobrenaturales.*

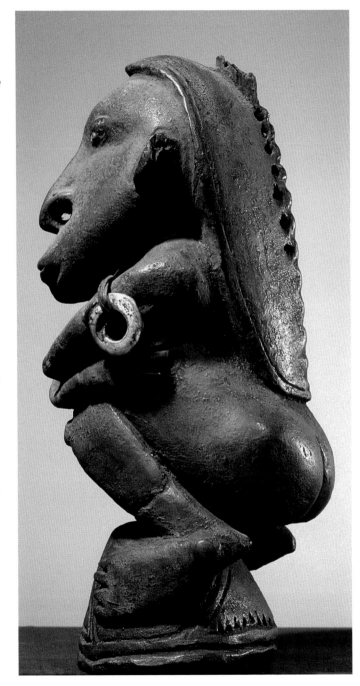

123

Cover for ritual offers in the shape of a squatting woman, Papua New Guinea; wood
Deckel für Opfergaben mit der Gestalt einer kauernden Frau, Papua-Neuguinea; Holz
Deksel voor rituele offers in de vorm van een gehurkte vrouw, Papoea-Nieuw-Guinea; hout
Tapa para ofrendas rituales en forma de mujer agazapada, Papúa Nueva Guinea; madera
1900-2000
British Museum, London

◀ Zoomorphic reliquary to hold the skull of the deceased, Solomon Islands; wood
Zoomorpher Heiligenschrein zur Aufbewahrung eines Totenschädels, Salomon Inseln; Holz
Zoomorf heiligdom bedoeld om de schedel van de overledene te herbergen, de Salomonseilanden; hout
Relicario zoomorfo destinado a albergar el cráneo del difunto, islas Salomón; madera
1900-1910
Musée du quai Branly, Paris

◀ Sculpture of bird, Solomon Islands; wood
Vogelskulptur, Salomon Inseln; Holz
Sculptuur van een vogel, Salomonseilanden; hout
Escultura de pájaro, islas Salomón; madera
1900-1910
Musée du quai Branly, Paris

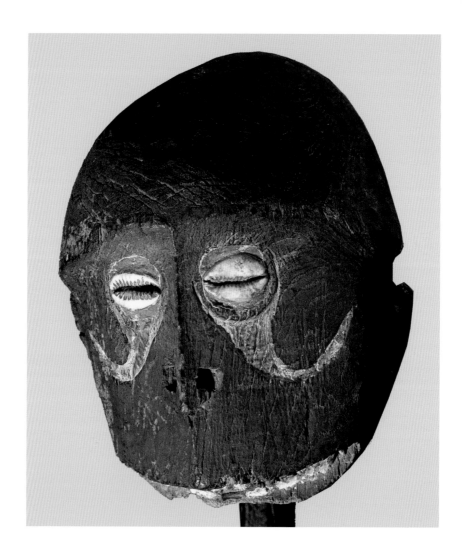

Head with eyes of shell inserted; wood, shell
Kopf mit eingesetzten Muschelaugen; Holz, Muschel
Hoofd met ogen van ingevoegde schelpen; hout, schelpen
Cabeza con ojos de concha insertados; madera, conchas
1900-2000
Sainsbury Centre for Visual Arts, Norwich

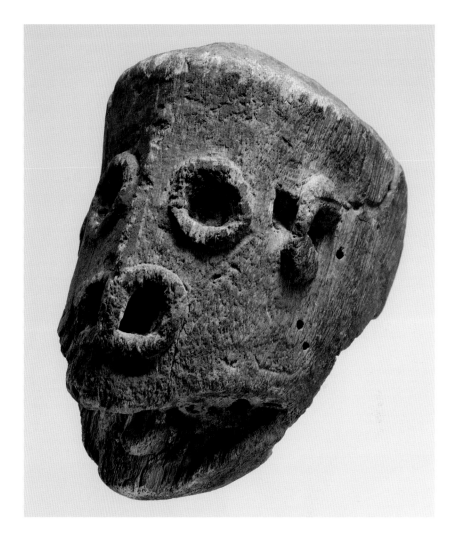

Head used to prevent diseases, Wapo Creek, Papua
New Guinea; carved wood
Kopf zur Vorbeugung von Krankheiten, Wapo Creek,
Papua-Neuguinea; gemeißeltes Holz
Hoofd gebruikt om ziekte te voorkomen, Wapo Creek,
Papoea-Nieuw-Guinea; uitgesneden hout
Cabeza utilizada para prevenir enfermedades, Wapo
Creek, Papúa Nueva Guinea; madera esculpida
1800-1900
The Metropolitan Museum of Art, New York

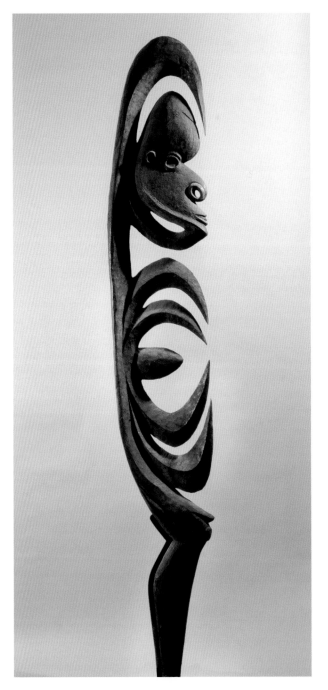

▌ *Archaic and disconcerting modern aspects coexist in the artistic tradition of Papua New Guinea.*
▌ *Archaische und befremdend moderne Aspekte charakterisieren in gleichem Maße die künstlerische Tradition Papua-Neuguineas.*
▌ *Archaïsche en onthutsende moderniteit bestaan naast elkaar in de artistieke tradities van Papoea-Nieuw-Guinea.*
▌ *Arcaicidad y desconcertante modernidad conviven en la tradición artística de Papúa Nueva Guinea.*

Styled figure (*Yipwon*) of spirit protector of the hunt, Sepik, Papua New Guinea; wood
Stilisierte Figur (*Yipwon*) eines Schutzgeistes der Jagd, Sepik, Papua-Neuguinea; Holz
Stick figuur (*Yipwon*) de beschermgeest van de jacht, Sepik, Papoea-Nieuw-Guinea; hout
Figura estilizada (*Yipwon*) de espíritu protector de la caza, Sepik, Papúa Nueva Guinea; madera
1900-2000
Philip Goldman Collection, London

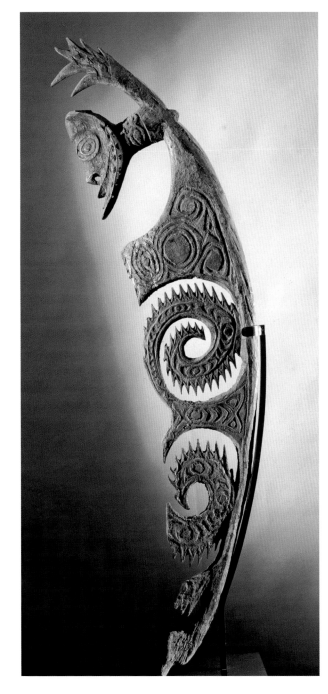

Styled figure (*Yipwon*) that assists men during
hunting, Sepik, New Guinea; wood
Stilisierte Figur (*Yipwon*) zum Beistand während
der Jagd, Sepik, Papua-Neuguinea; Holz
Gestileerd figuur (*Yipwon*) voor bijstand tijdens
de jacht, Sepik, Papoea-Nieuw-Guinea; hout
Figura estilizada (*Yipwon*) que ayuda a los hombres
durante la caza, Sepik, Papúa Nueva Guinea; madera
1900-2000
Philip Goldman Collection, London

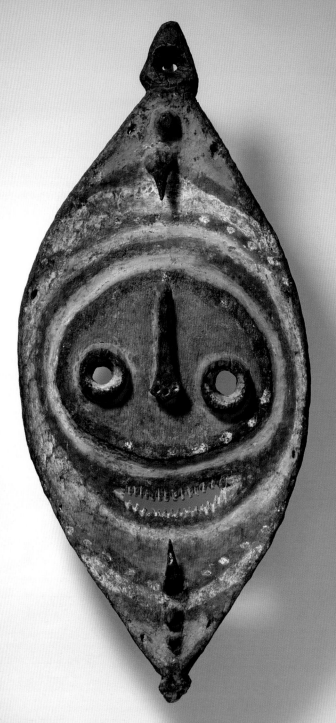

Gra or Garra mask, Middle
Sepik, Papua New Guinea;
wood
Gra oder Garra-Maske,
Middle Sepik, Papua-
Neuguinea; Holz
Masker van Gra of Garra,
Midden Sepik, Papoea-
Nieuw-Guinea; hout
Máscara Gra o Garra, Sepik
Medio, Papúa Nueva Guinea;
madera
ca. 1890-1910
The Metropolitan Museum of
Art, New York

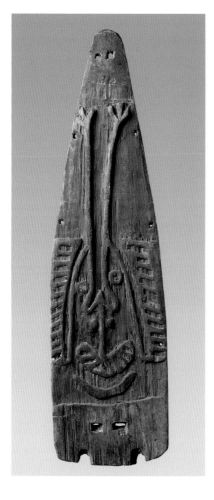

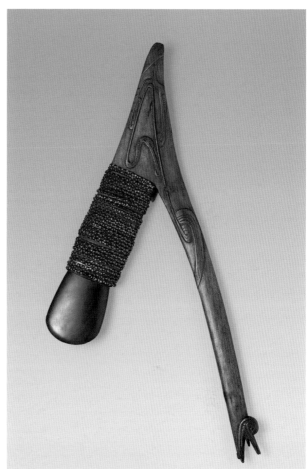

Canoe board (*Gope*) for initiation or as prize for the warriors, Papua New Guinea; wood
Brett-Kanus (*Gope*) für die Initiation oder als Preis für die Krieger, Papua-Neuguinea; Holz
Tafekkano (*Gope*) voor aanvang of als beloning voor de krijgers, Papoea-Nieuw-Guinea; hout
Mesas-canoa (*Gope*) para iniciación o como premio para los guerreros, Papúa Nueva Guinea; madera
ca. 1890-1910
The Metropolitan Museum of Art, New York

Ceremonial axe of Massim region, Papua New Guinea; wood, stone, plant fibres
Zeremonienaxt aus der Gegend von Massim, Papua-Neuguinea; Holz, Stein, pflanzliche Fasern
Ceremoniële bijl uit de regio Massim, Papoea-Nieuw-Guinea; hout, steen, plantaardige vezels
Hacha ceremonial de la región de Massim, Papúa Nueva Guinea; madera, piedra, fibras vegetales
1850-1900
The Metropolitan Museum of Art, New York

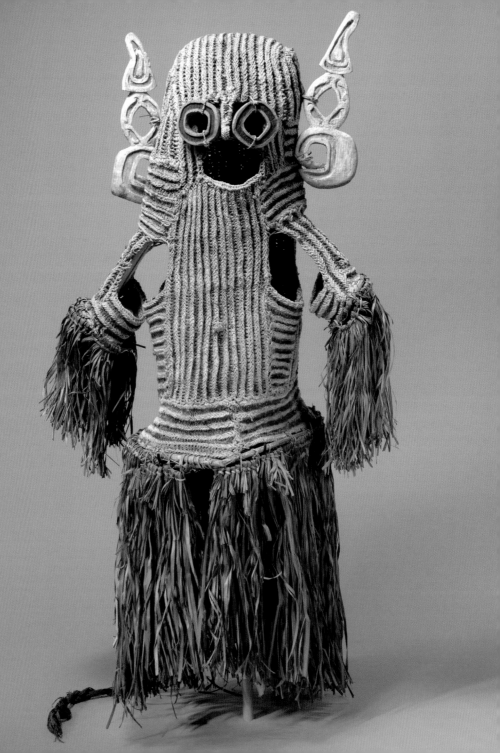

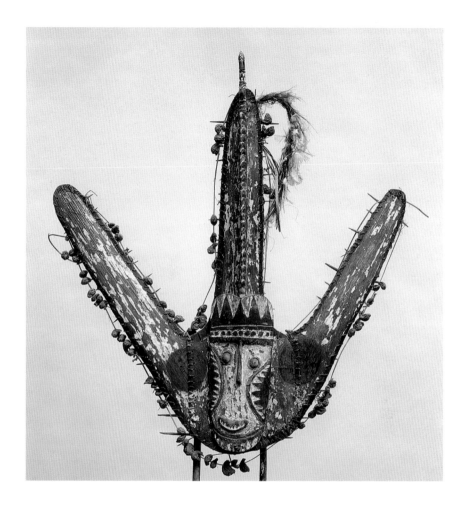

◄ Body mask essential for the cult of the dead Asmat;
Papua New Guinea; plant fibres, wood and palm leaves
Maske für den Körper, die vor allem dem Asmat-
Ahnenkult dient; Papua-Neuguinea; pflanzliche Fasern,
Holz und Palmblätter
Lichaamsmasker is essentieel voor de cultus van de
overleden Asmat; Papoea-Nieuw-Guinea; plantaardige
vezels, hout en palmbladeren
Máscara para el cuerpo esencial para el culto de los
difuntos Asmat; Papúa Nueva Guinea; fibras vegetales,
madera y hojas de palmera
ca. 1950
The Metropolitan Museum of Art, New York

Emblem from a war canoe, Papua New Guinea
Emblem eines Kriegskanus, Papua-Neuguinea
Embleem van een oorlogskano, Papoea-Nieuw-
Guinea
Emblema de una canoa de guerra, Papúa Nueva Guinea
1900-2000
Philip Goldman Collection, London

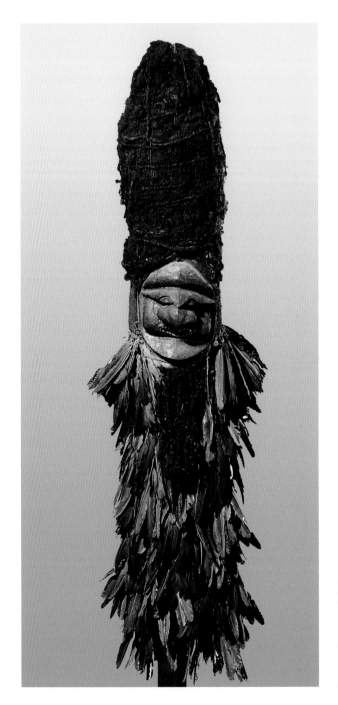

Costume, Papua New Guinea; plant fibres,
wood, hair and feathers
Tracht, Papua-Neuguinea; pflanzliche Fasern,
Holz, Haare und Federn
Kostuum, Papoea-Nieuw-Guinea;
plantaardige vezels, hout, haren en veren
Traje, Papúa Nueva Guinea; fibras vegetales,
madera, cabellos y plumas
1800-1900
Australian Museum, Sydney

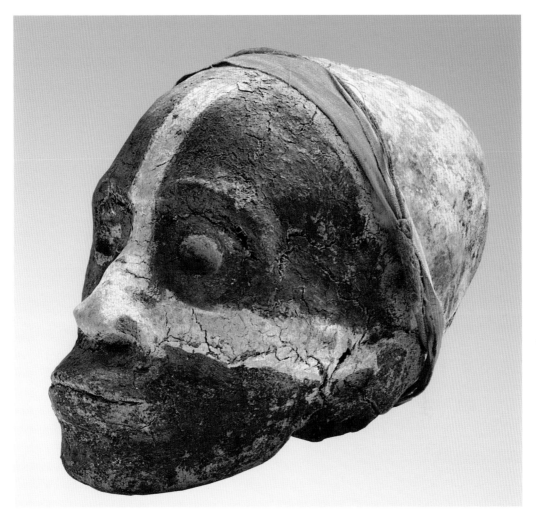

Reshaped skull of a high ranking deceased
individual, Malekula Island, Vanuatu
Nachgebildeter Schädel eines Verstorbenen
von hohem Rang, Malekula Island, Vanuatu
Verbouwde schedel van een overleden persoon
van hoge rang, Malekula Island, Vanuatu
Cráneo remodelado de un difunto de alto rango,
Malekula Island, Vanuatu

▌ *A tiny minority today in the archipelago of Vanuatu, animist religions
are practiced by about ten small cultural groups.*
▌ *Eine verschwindend geringe, aus vielleicht zehn kleinen kulturellen
Gruppen bestehende Minderheit praktiziert auf dem Vanatu-Archipel
noch den animistischen Glauben.*
▌ *Tegenwoordig behoren onbeduidende minderheden in de archipel van
Vanuatu, de animistische religies tot tientallen kleine culturele groepen.*
▌ *Minoritarios hoy día en el archipiélago de Vanuatu, los cultos
animistas son practicados por decenas de minúsculos grupos culturales.*

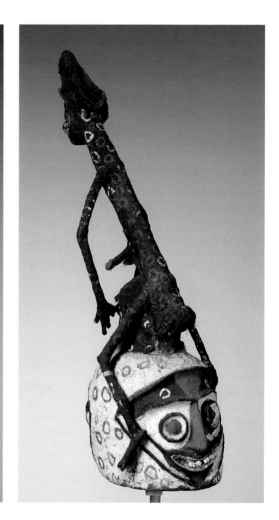

Two views of the mask that represents the ogress, Nevimbubao, dominated by the son, Sasndaliep, or the husband, Ambat Malondr; Malekula Island, Vanuatu; plant fibres
Zwei Ansichten der Maske, die die Riesin Nevimbubao darstellt, welche von ihrem Sohn Sasndaliep oder vom Ehemann Ambat Malondr überragt wird; Malekula Island, Vanuatu; pflanzliche Fasern
Twee standpunten van het masker dat de menseneetster Nevimbubao gedomineerd door de echtgenoot of de zoon Sasndaliep Ambato Malondr, Malekula Island, Vanuatu vertegenwoordigt; plantaardige vezels
Dos vistas de la máscara que representa la ogresa Nevimbubao montada por su hijo Sasndaliep o su esposo Ambat Malondr; Malekula Island, Vanuatu; fibras vegetales
Musée du quai Branly, Paris

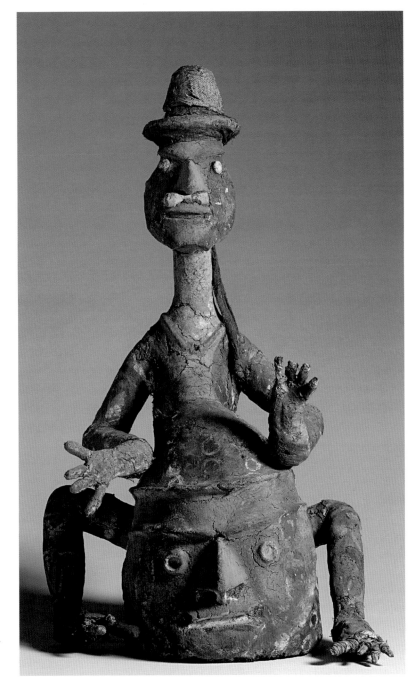

Mask, Malekula Island,
Vanuatu; plant fibres
Maske, Malekula Island,
Vanuatu; pflanzliche Fasern
Masker, Malekula Island,
Vanuatu; plantaardige vezels
Máscara, Malekula Island,
Vanuatu; fibras vegetales
Musée du quai Branly, Paris

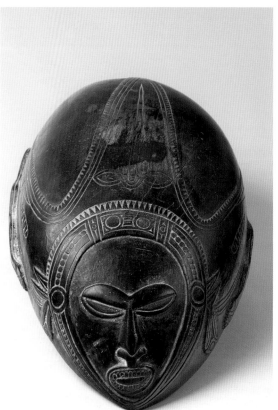

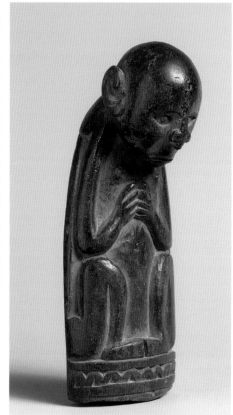

Ceremonial bowl, Tami Islands, Papua New Guinea; wood
Zeremonienschale, Tami-Inseln, Papua-Neuguinea; Holz
Ceremoniële kom, Tami eilanden, Papoea-Nieuw-Guinea; hout
Cuenco ceremonial, islas Tami, Papúa Nueva Guinea; madera
1800-1910
The Metropolitan Museum of Art, New York

Top of a ritual stick from Massim region, Papua New Guinea; wood
Spitze eines rituellen Stabs aus der Region von Massim, Papua-Neuguinea; Holz
Begin van een rituele stok ritueel uit de regio Massim, Papoea-Nieuw-Guinea; hout
Parte superior de un bastón ritual de la región de Massim, Papúa Nueva Guinea; madera
1800-1910
The Metropolitan Museum of Art, New York

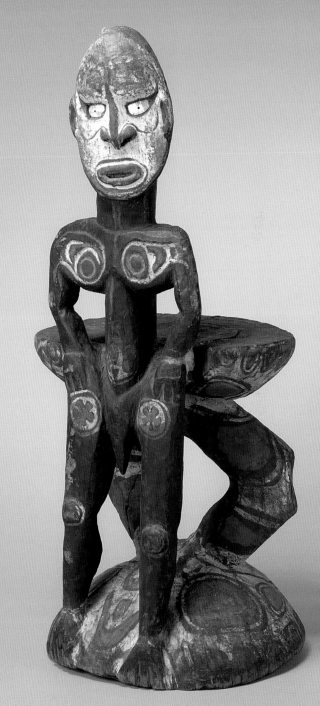

Ritual Latmul seat used in public debates
for symbolic purposes, Papua New Guinea;
wood and shell
Ritueller Latmulsitz, der während der
öffentlichen Debatten zu symbolischen
Zwecken benutzt wird, Papua-Neuguinea;
Holz und Muschel
Latmul zetel, ritueel gebruikt in publieke
debatten met een symbolisch doel,
Papoea-Nieuw-Guinea; hout en schelpen
Asiento ritual latmul utilizado en los
debates públicos con fines simbólicos,
Papúa Nueva Guinea; madera y concha
1800-1900
The Metropolitan Museum of Art, New York

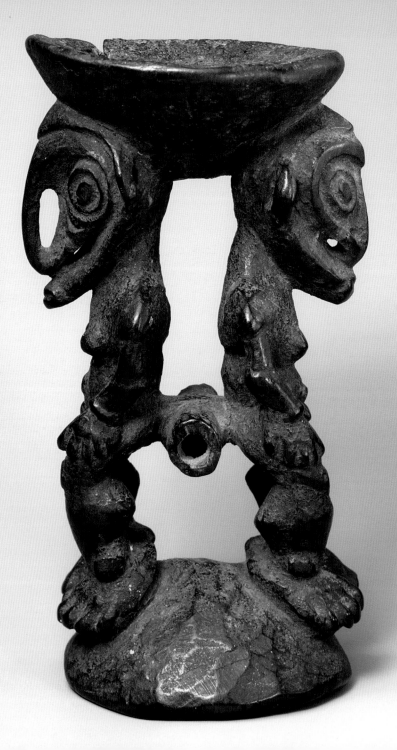

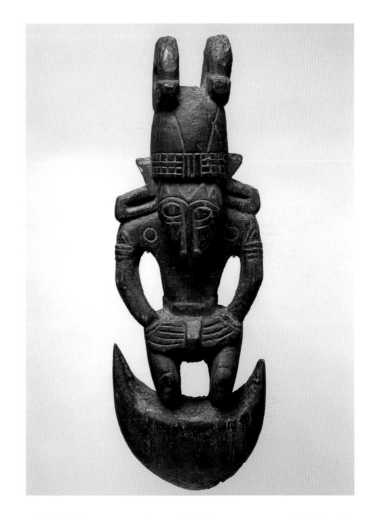

Ritual hook, Tami Islands, Papua
New Guinea; wood
Ritueller Haken, Tami-Inseln,
Papua-Neuguinea; Holz
Rituele haak, Tami eilanden,
Papoea-Nieuw-Guinea; hout
Gancho ritual, islas Tami,
Papúa Nueva Guinea; madera
1800-1900
The Metropolitan Museum of Art,
New York

Ritual bowl, Admiralty Islands, Papua
New Guinea; wood
Rituelle Schüssel, Admiralitätsinseln,
Papua-Neuguinea; Holz
Rituele schaal, Admiralty-eilanden,
Papoea-Nieuw-Guinea; hout
Tazón ritual, islas del Almirantazgo,
Papúa Nueva Guinea; madera
ca. 1890-1910
The Metropolitan Museum of Art,
New York

◀ Mortar for crushing betel nuts,
Papua New Guinea; wood
Mörser zum zerkleinern von
Betelnüssen, Papua-Neuguinea; Holz
Mortel om de betel noten te
verpletteren, Papoea-Nieuw-Guinea; hout
Mortero para moler las nueces de la
palmera Areca Catechu, Papúa Nueva
Guinea; madera
1800-1910
The Metropolitan Museum of Art,
New York

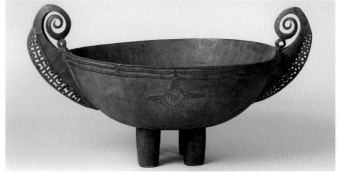

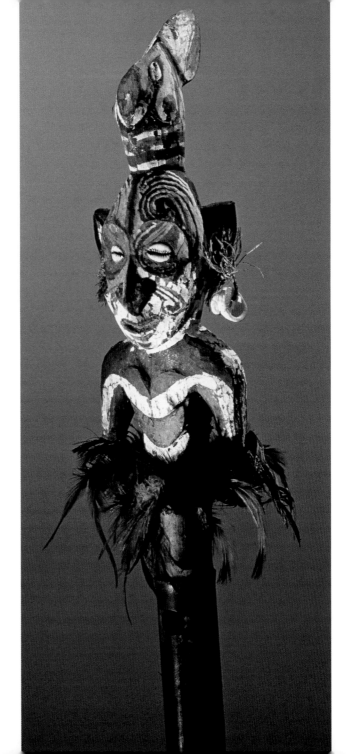

■ *Terrifying forms express both ancestral and imaginary forces of craftsmen-artists.*
■ *Entsetzen erregende Formen drücken gleichsam die Mächte der Vorfahren und die Vorstellungskraft der Handwerker/ Künstler aus.*
■ *Angstaanjagende vormen zijn uiting van zowel voorouderlijke krachten als van de verbeelding van ambachtslieden/ kunstenaars*
■ *Las formas aterradoras son la expresión conjunta de fuerzas ancestrales y del imaginario de los artesanos-artistas.*

Flute with carved valve, Papua New Guinea; wood and feathers
Flöte mit figürlichem Verschluss, Papua-Neuguinea; Holz und Federn
Fluit met figuren op de luiken, Papoea-Nieuw-Guinea; hout en veren
Flauta con obturador tallado, Papúa Nueva Guinea; madera y plumas
1900-2000
Philip Goldman Collection, London

◀ Flute with carved valve, Papua New Guinea; wood and feathers
Flöte mit figürlichem Verschluss, Papua-Neuguinea; Holz und Federn
Fluit met figuren op de luiken, Papoea-Nieuw-Guinea; hout en veren
Flauta con obturador tallado, Papúa Nueva Guinea; madera y plumas
1900-2000
Philip Goldman Collection, London

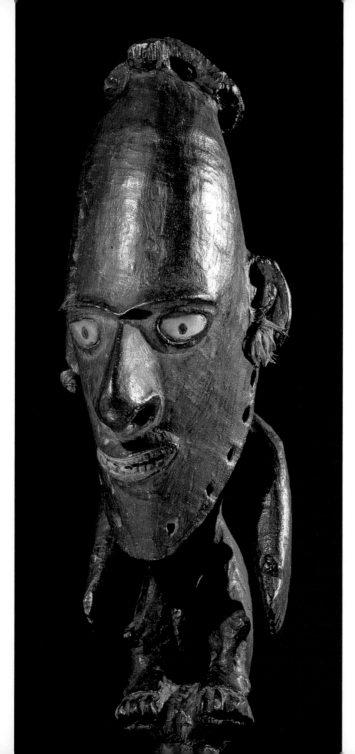

Two views of flute with carved
valve, Papua New Guinea
Zwei Ansichten einer Flöte mit
figürlichem Verschluss, Papua-
Neuguinea
Twee standpunten van fluit
met figuren op de luiken,
Papoea-Nieuw-Guinea
Dos vistas de flauta con
obturador tallado, Papúa
Nueva Guinea
1900-2000
Philip Goldman Collection,
London

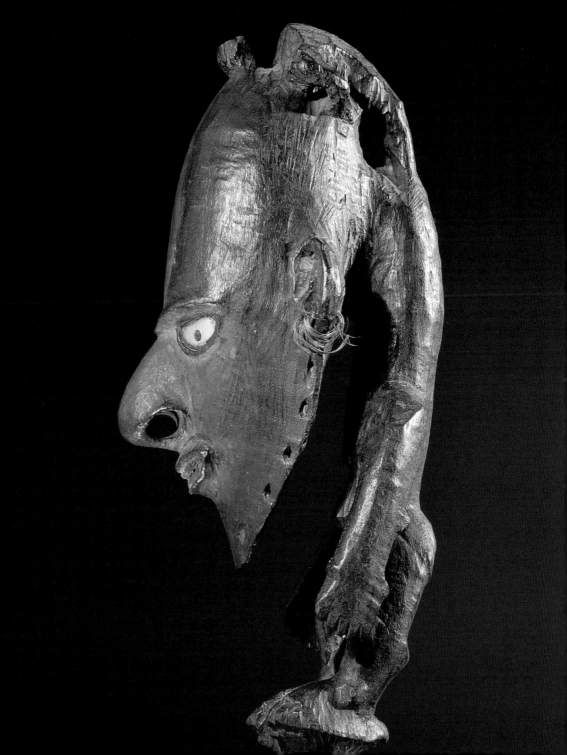

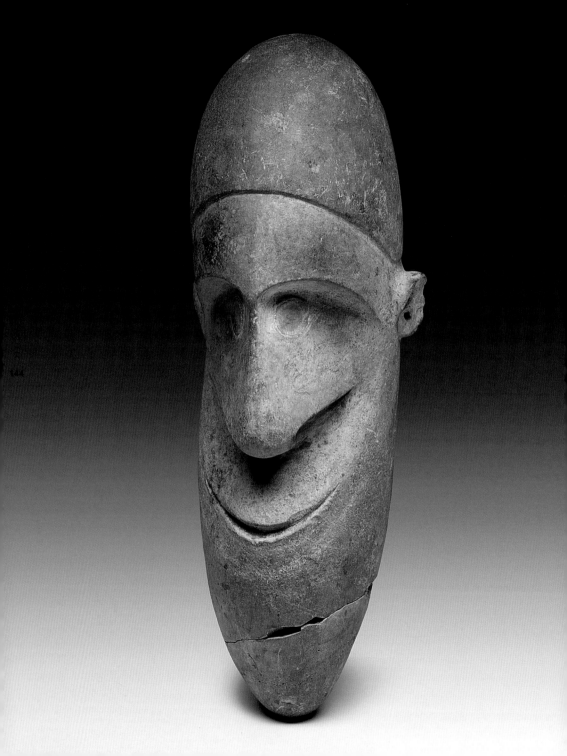

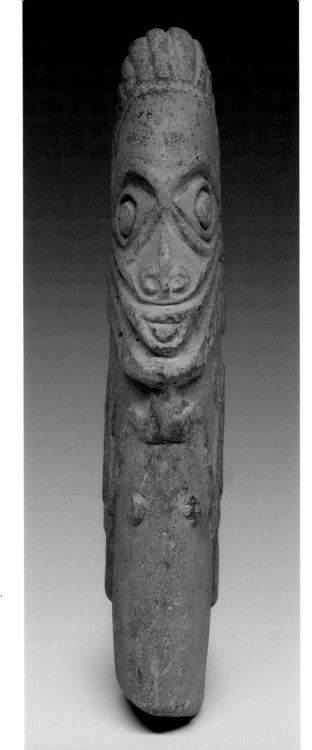

Magic stone depicting two styled heads
Magischer Stein mit Darstellung von zwei stilisierten Köpfen
Magische stenen van twee gestileerde hoofden
Piedra mágica que representa dos cabezas estilizadas
1900-1910
Musée du quai Branly, Paris

◀ Magic stone, used for raising pigs and regulating the rains, Ambrym Island, Vanuatu; volcanic tufa
Magischer Stein, der zur Schweinezucht und zur Regulierung des Regens verwendet wird, Ambrym Island, Vanuatu; Vulkansandstein
Magische steen, gebruikt voor het fokken van varkens en de regulatie van de regens, Ambrym Island, Vanuatu; vulkanisch gesteente
Piedra mágica, utilizada para la cría de cerdos y en el control de las lluvias, Ambrym Island, Vanuatu; toba volcánica
ca. 1950
Musée du quai Branly, Paris

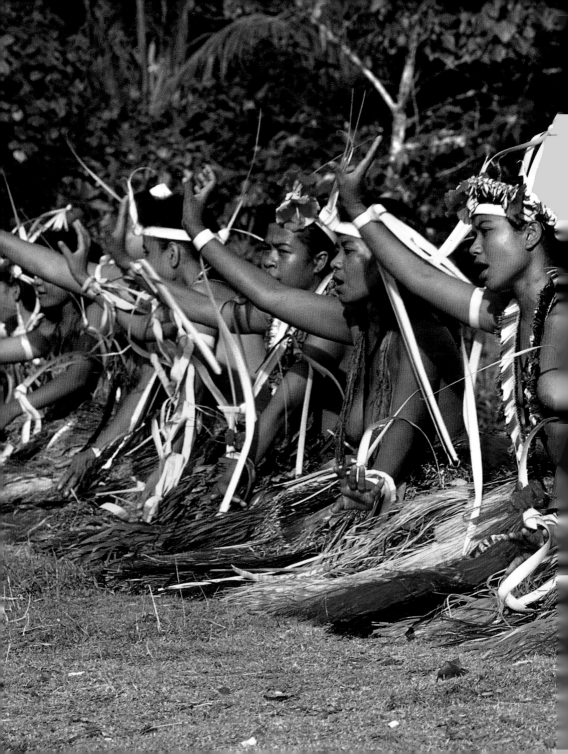

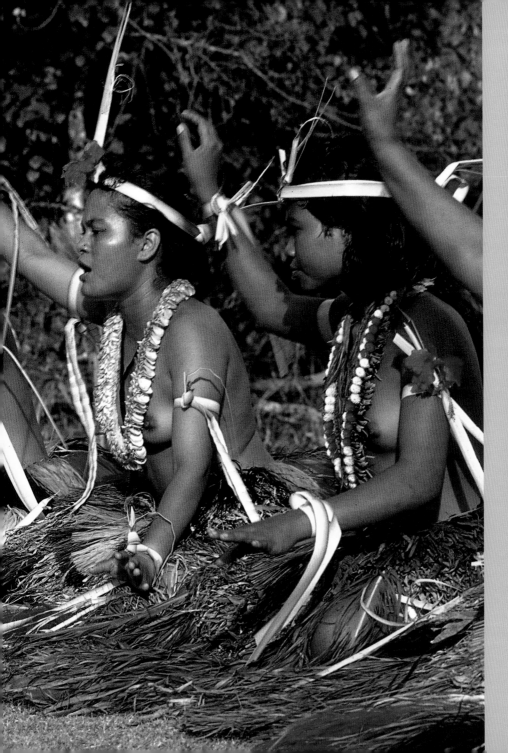

Micronesia • Mikronesien • Micronesie

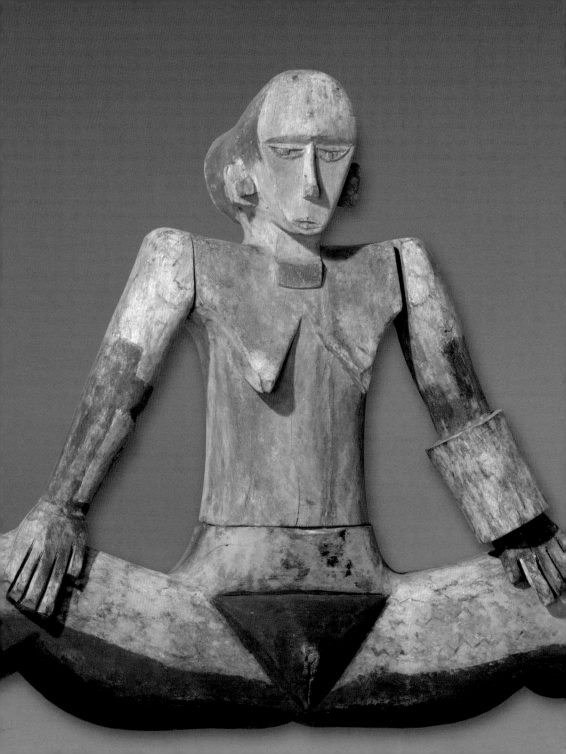

Art dictated by the Ocean

Micronesian culture, similar to other communities of the Pacific, is influenced by the awareness of an existence linked to the ocean, and the dangers and privileges associated with it. When this is compared to other areas in Oceania, Micronesia's visual arts are generally seen as having inferior value, due to its basic nature. Undoubtedly, the limits associated with Micronesian art are linked to environmental factors, the rarity of suitable materials, such as wood or rocks, or the insufficiency of pigments for painting.

Kunst im Zeichen des Ozeans

Die Kultur Mikronesiens ist, ähnlich wie die anderer Gemeinschaften im Pazifik, geprägt von der Gewissheit, dass man von einem Ozean abhängig ist, der gleichsam Gefahren und Privilegien verbirgt. Doch im Gegensatz zu anderen Bereichen Ozeaniens gilt die bildende Kunst Mikronesiens aufgrund ihrer Einfachheit gemeinhin als minderwertig. Zweifelsohne ist diese augenscheinliche Beschränktheit der mikronesischen Kunst auf Umweltbedingungen, auf den Mangel an geeigneten Materialien wie Holz oder Stein, sowie auf die Unzulänglichkeit der Farbpigmente zurückzuführen.

5

De kunst gedicteerd door de Oceaan

De Micronesische cultuur, is net als andere gemeenschappen in de Stille Oceaan, beïnvloed door het besef van een leven gebonden aan de oceaan met de gevaren en de privileges die daaruit voortvloeien. Echter, wanneer het wordt vergeleken met andere gebieden van Oceanië, wordt de beeldende kunst van Micronesië algemeen beschouwd als minderwaardige kunst, door de essentie van de vormen. Aan de beperkte consistentie van het micronesische repertoire hebben zonder twijfel de omgevingsfactoren bijgedragen, zoals de zeldzaamheid van geschikte materialen, hout of stenen, of de ontoereikendheid van pigmenten voor verf.

El arte dictado por el Océano

La cultura micronesia, como sucede con otras comunidades del Pacífico, está influenciada por la conciencia de una existencia ligada al océano, con los peligros y privilegios que esto ocasiona. Sin embargo, cuando se compara con otras regiones de Oceanía, el arte visual de la Micronesia es considerado por lo general un arte de valor inferior, debido a lo esencial de sus formas. A la consistencia limitada del repertorio micronesio han contribuido indudablemente factores ambientales, como la escasez de materiales adecuados, madera o rocas, o la insuficiencia de pigmentos para las pinturas.

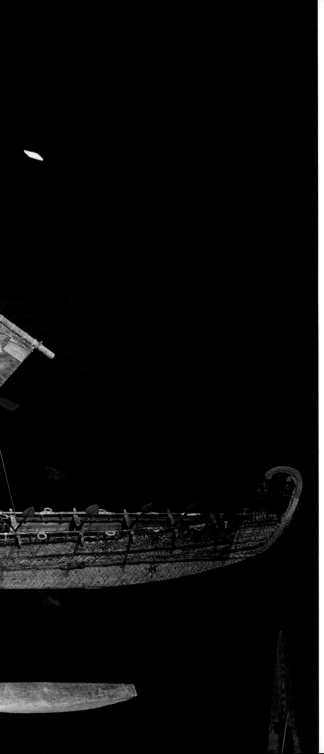

❚ *Frequent conflicts on an immense territory contributed both to the development of navigation techniques and imposing defensive structures.*
❚ *Die häufigen Konflikte in einem immensen Territorium haben zur Verfeinerung der Navigationstechniken und der Verteidigungsstrukturen beigetragen.*
❚ *De veelvuldige conflicten over een uitgestrekte regio hebben bijgedragen aan de ontwikkeling van technieken van de scheepvaart en indrukwekkende defensieve structuren.*
❚ *Los frecuentes conflictos en un territorio inmenso han contribuido al desarrollo de las técnicas de la navegación y de imponentes estructuras defensivas.*

Pirogue of the high seas with stabilizer, Bismarck Archipelago; wood, coconut fibres, palm leaves, canes of bamboo
Hochseepiroge mit Stabilisator, Bismarck Archipel; Holz, Kokosfasern, Palmenblätter, Bambusrohre
Kano volle zee met stabilisator, Bismarck Archipel; hout, kokosvezels, palmbladeren, bamboestokken
Piragua de alta mar con estabilizador, Achipiélago Bismarck; madera, fibras de coco, hojas de palmera, cañas de bambú
1800-1900
Ethnologisches Museum, Staatliche Museen, Berlin

Navigational chart (*rebbilib*), Marshall Islands; coconut fibres
Navigationsdiagramm (*rebbilib*), Marshallinseln; Kokosfasern
Navigatiediagram (*rebbilib*), Marshalleilanden; kokosvezels
Diagrama de navegación (*rebbilib*), islas Marshall; fibra de coco
1800-1910
The Metropolitan Museum of Art, New York

Navigational chart, Marshall Islands; wood, coconut and plant fibres
Navigationskarte, Marshallinseln; Holz, Kokos und pflanzliche Fasern
Navigatiekaart, Marshalleilanden; hout, kokos en plantaardige vezels
Mapa de navegación, islas Marshall; madera, coco y fibras vegetales
Musée du quai Branly, Paris

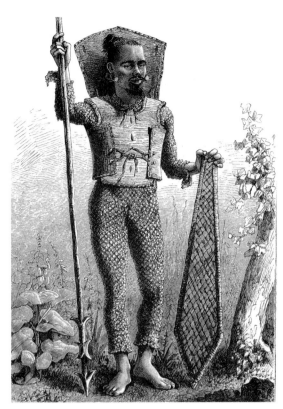

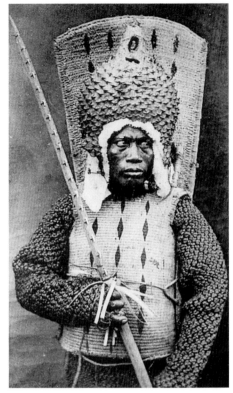

R. Pasquino
Warrior in battle clothes, Kiribati
Krieger in Rüstung, Kiribati
Krijger in de strijd, Kiribati
Guerrero con uniforme de combate, Kiribati
Musée du quai Branly, Paris

▶ Cuirass in coconut fibre, Kiribati
Brustpanzer aus Kokosfasern, Kiribati
Schild in kokosvezel, Kiribati
Coraza en fibra de coco, Kiribati
Musée du quai Branly, Paris

Battle clothes of the natives of the Caroline Islands
Kampfesuniform der Eingeborenen der Karolinen-Inseln
Strijd tegen de inboorlingen van de Caroline eilanden
Uniforme de combate de los nativos de las islas Carolinas
1877

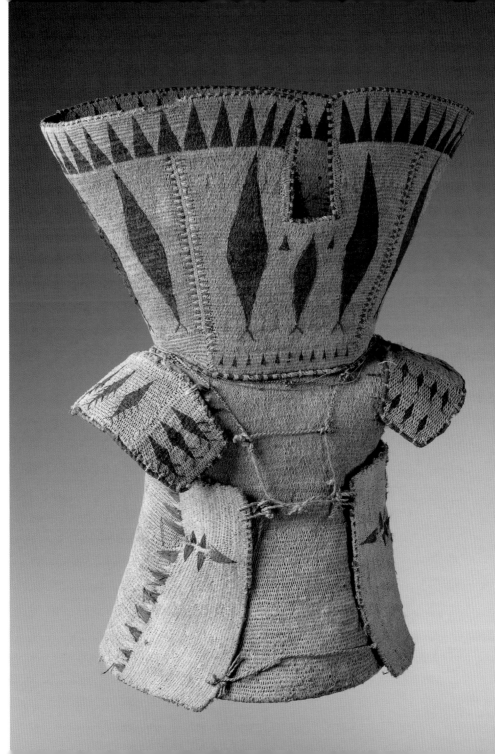

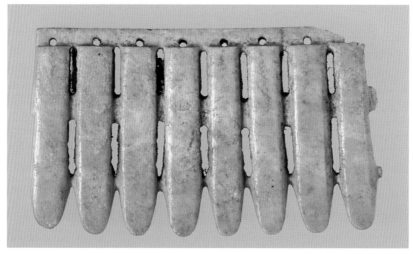

Valuable included in the female dowry and used as currency (*toluk*),
Caroline Islands; turtle shell
Wertgegenstand, der Bestandteil der Mitgift ist und als Währung dient
(*toluk*), Karolinen-Inseln; Schildkrötenpanzer
Waardeobject opgenomen in de bruidsschat van vrouwen en ook
gebruikt als betaalmiddel (*toluk*), Caroline eilanden; schild van schildpad
Objeto de valor incluido en la dote femenina y utilizado también como
moneda (*toluk*), islas Carolinas; caparazón de tortuga
ca. 1890-1910
The Metropolitan Museum of Art, New York

Fragment of a pendant, Marshall Islands; tridacna shell
Fragment eines Anhängers, Marshallinseln; Riesenmuschel
Fragment van hanger, Marshalleilanden; tridacna schelp
Fragmento de colgante, islas Marshall; concha de tridacna
ca. 1800-1900
The Metropolitan Museum of Art, New York

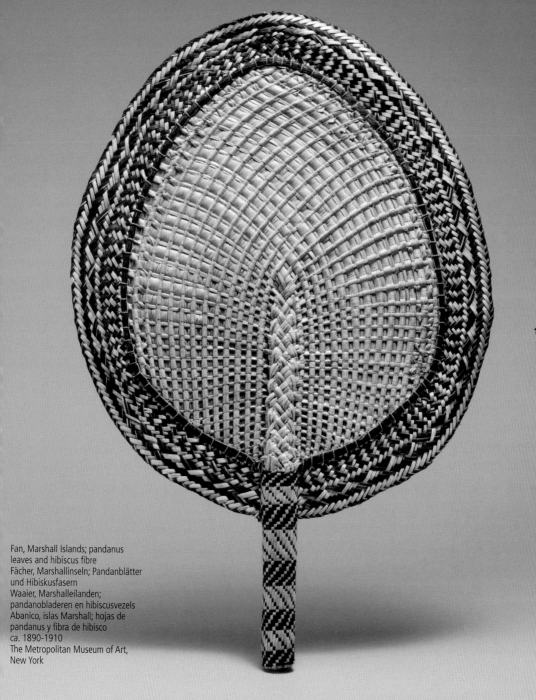

Fan, Marshall Islands; pandanus
leaves and hibiscus fibre
Fächer, Marshallinseln; Pandanblätter
und Hibiskusfasern
Waaier, Marshalleilanden;
pandanobladeren en hibiscusvezels
Abanico, islas Marshall; hojas de
pandanus y fibra de hibisco
ca. 1890-1910
The Metropolitan Museum of Art,
New York

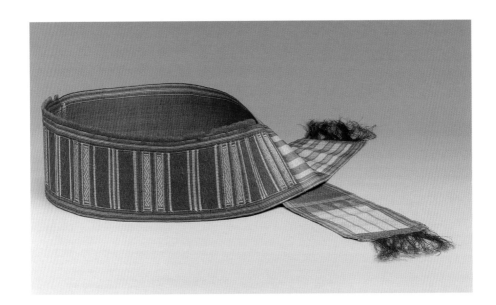

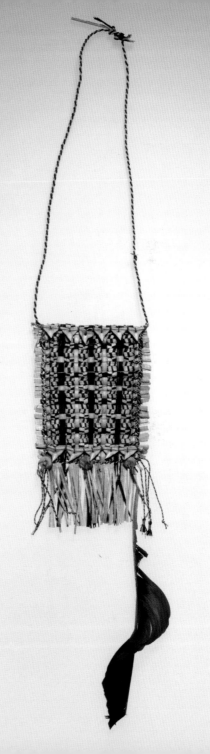

Maternity mat, Nauru Island; pandan leaves,
feathers, shells, shark teeth
Mutterschaftsmatte, Insel Nauru; Pandanblätter,
Gefieder, Muschel, Haifischzähne
Mat moederschap, eiland Nauru; pandanobladeren,
pen, schelpen, haaientanden
Esterilla de la maternidad, isla Nauru; hojas de
pandanus, plumas, conchas, dientes de tiburón
ca. 1890-1910
The Metropolitan Museum of Art, New York

◀ Man's belt (*tor*), Caroline Islands; banana tree fibres
Männergürtel (*tor*), Karolinen-Inseln; Bananenfasern
Mannenriem (*tor*), Caroline eilanden; vezels
van bananen
Cinturón masculino (*tor*), islas Carolinas; fibra
de plátano
ca. 1890-1910
The Metropolitan Museum of Art, New York

◀ Example of Micronesian fabric; plant fibre
Beispiel eines handgewebten Tuches aus
Mikronesien; pflanzliche Faser
Voorbeeld van ambachtelijk weefsel, Micronesië;
plantaardige vezels
Ejemplar de tejido de artesanía micronesia;
fibra vegetal

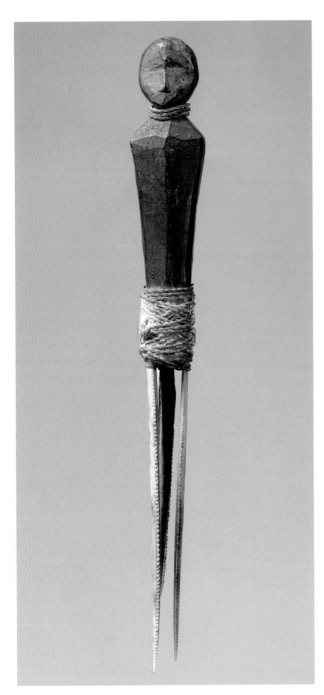

■ *Abstraction and essentiality are the characteristics of Micronesian sculpture.*
■ *Abstraktion und Einfachheit sind Merkmale der mikronesischen Bildhauerkunst.*
■ *Abstractie, essentie zijn kenmerken van het beeldhouwwerk van de Micronesiërs.*
■ *Abstracción y esencialidad son características de las estatuas micronesias.*

Amulet against weather adversity, Caroline Islands; wood, spines of skates, plant fibres
Amulett gegen ungünstige Wetterbedingungen, Karolinen-Inseln; Holz, Rochengräten, pflanzliche Fasern
Amulet tegen slecht weer, Caroline eilanden; hout, raspluggen, plantaardige vezels
Amuleto contra las adversidades atmosféricas, islas Carolinas; madera, espinas de raya, fibras vegetales
ca. 1890-1910
The Metropolitan Museum of Art, New York

▶ Views of anthropomorphic sculpture, possible depiction of the god Sope, Caroline Islands; wood
Ansichten einer anthropomorphen Skulptur, vielleicht Darstellung des Gottes Sope, Karolinen-Inseln; Holz
Zicht op antropomorfe sculptuur, misschien de god Sope, Caroline eilanden; hout
Vistas de escultura antropomorfa, probablemente representación del dios Sope, islas Carolinas; madera
1700-1900
Entwistle Gallery, London

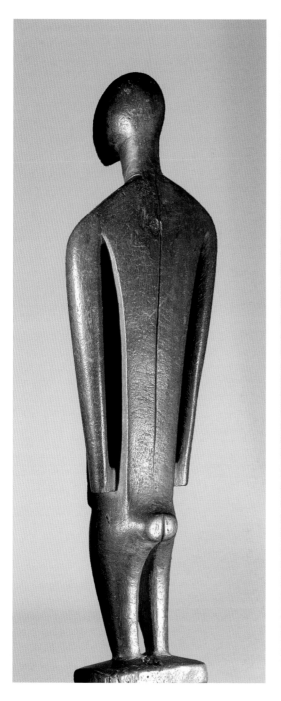
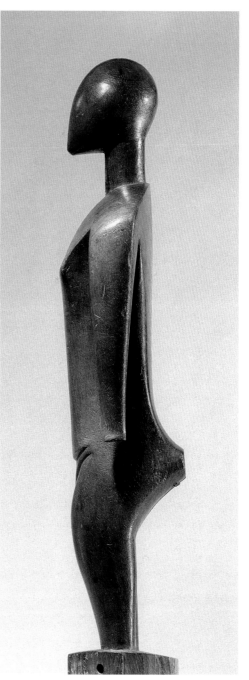

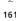

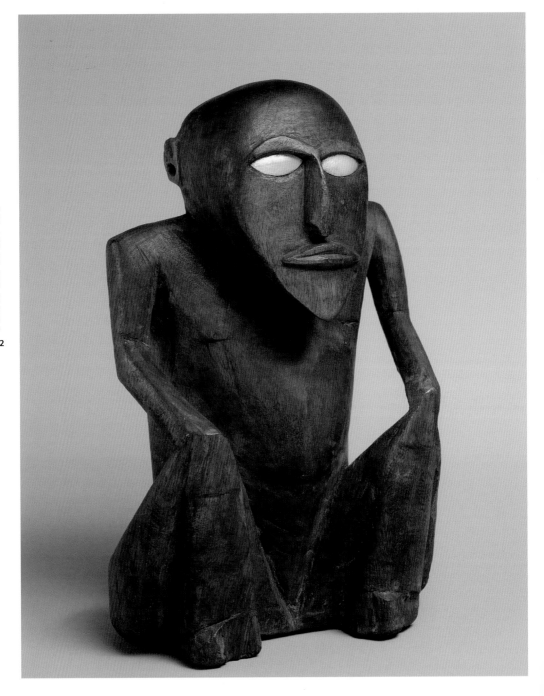

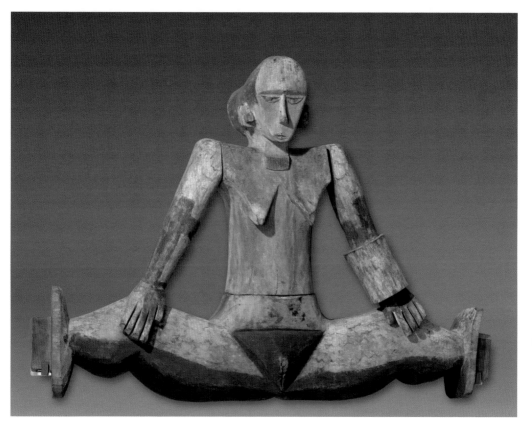

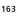

◀ Seated figure of probable ancestor, Caroline
Islands; wood and shell
Sitzende Figur wahrscheinlich eines Vorfahren,
Karolinen-Inseln; Holz und Muschel
Zittende figuur van de waarschijnlijke voorouder,
Caroline eilanden; hout en schelpen
Figura sentada de posible antepasado, islas
Carolinas; madera y concha
ca. 1890-1910
The Metropolitan Museum of Art, New York

Female figure, decoration of the tympanum of
a ceremonial hut, Palau, Caroline Islands; wood
Weibliche Figur, Tympanondekoration einer
Zeremonienhütte, Palau, Karolinen-Inseln; Holz
Vrouwenfiguur, decoratie van het timpaan van een
ceremoniële hut, Palau, Caroline eilanden; hout
Figura femenina, decoración del tímpano de una
choza ceremonial, Palau, islas Carolinas; madera
ca. 1890-1910
The Metropolitan Museum of Art, New York

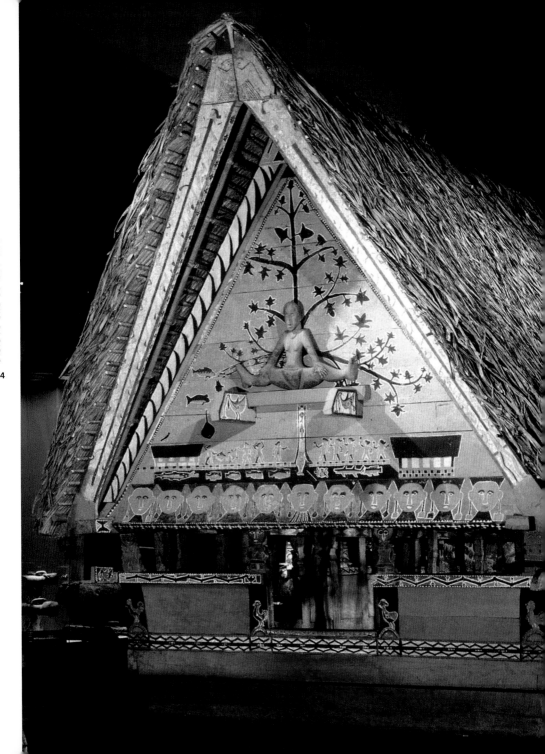

■ *Large huts used for ceremonies include a large number of art forms and objects for sacred use.*
■ *Die großen Hütten werden für Zeremonien verwendet. Sie enthalten zahlreiche Kunstformen und Objekte zur sakralen Nutzung.*
■ *De grote hutten voor ceremonieel gebruik bevatten een groot aantal artistieke vormen en voorwerpen voor heilig gebruik.*
■ *Las grandes chozas de uso ceremonial albergan un gran número de formas artísticas y de objetos de uso sagrado.*

Men's ceremonial hut (*bai*), Palau, Caroline Islands; wood and straw
Zeremonienhütte für Männer (*bai*), Palau, Karolinen-Inseln; Holz und Stroh
Hut voor ceremonieel gebruik van de man (*bai*), Palau, Caroline eilanden, hout en stro
Choza ceremonial de uso masculino (*bai*) Palau, islas Carolinas; madera y paja
1907
Ethnologisches Museum, Staatliche Museen, Berlin

Print depicting house of the ancestors
on the Island of Tinian, Mariana Islands
Stich mit der Darstellung eines Ahnenhauses
auf der Insel Tinian, Mariana Islands
Afbeelding van het huis van de voorouders
op het eiland Tinian, Mariana Islands
Estampa que representa la casa de los
antepasados en la isla de Tinian, Mariana
Islands
ca. 1820-1839

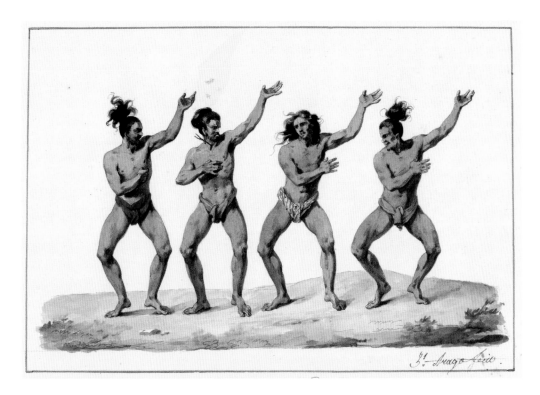

Jacques Étienne Victor Arago
(1790-1855)
Representation of dances of the Caroline Islands
Darstellung von Tänzen auf den Karolinen-Inseln
Uitbeelding van dansen van de Caroline eilanden
Representación de danzas de las islas Carolinas
1800-1900
Musée du quai Branly, Paris

▍ *European colonization resulted in Micronesian traditions
and costumes portrayed in paintings, prints and photographs.*
▍ *Mit der europäischen Kolonialisierung wurden mikronesische Traditionen
und Bräuche in Malereien, Drucken und Fotografien festgehalten.*
▍ *De Europese kolonisatie heeft ertoe geleid dat Micronesische gewoonten
en tradities werden vastgelegd in schilderijen, prenten en foto's.*
▍ *La colonización europea ha llevado a fijar en pinturas, estampas
y fotografías las costumbres y tradiciones micronesias.*

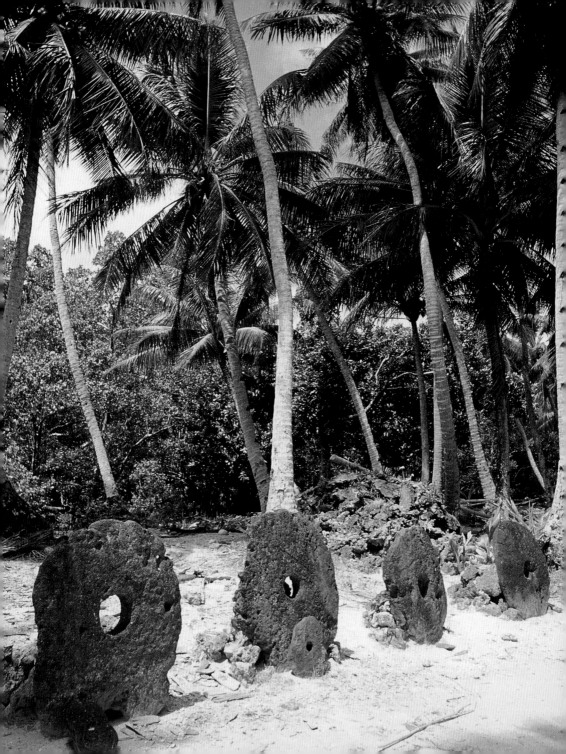

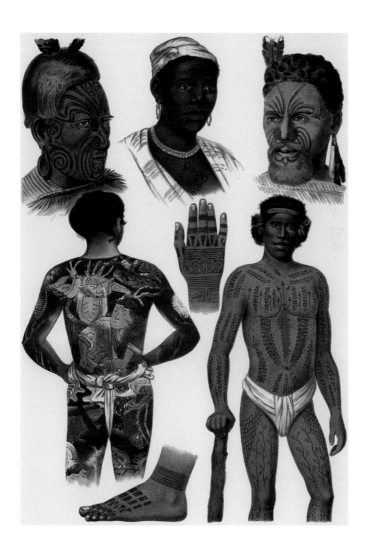

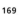

◄ Ancient stone coins (*rai*) of the Island
of Yap, Caroline Islands
Antike Steinmünzen (*rai*) auf der Insel Yap,
Karolinen-Inseln
Oude munten van steen (*rai*) op het
eiland Yap, Caroline eilanden
Antiguas monedas de piedra (*rai*)
de la isla de Yap, islas Carolinas

Illustrated print showing tattoos of various
parts of the world
Illustrierter Druck mit Tätowierungen aus
allen Teilen der Welt
Geïllustreerde print met tatoeages uit
verschillende delen van de wereld
Estampa ilustrada que representa tatuajes
de distintas partes del mundo
1800-1900

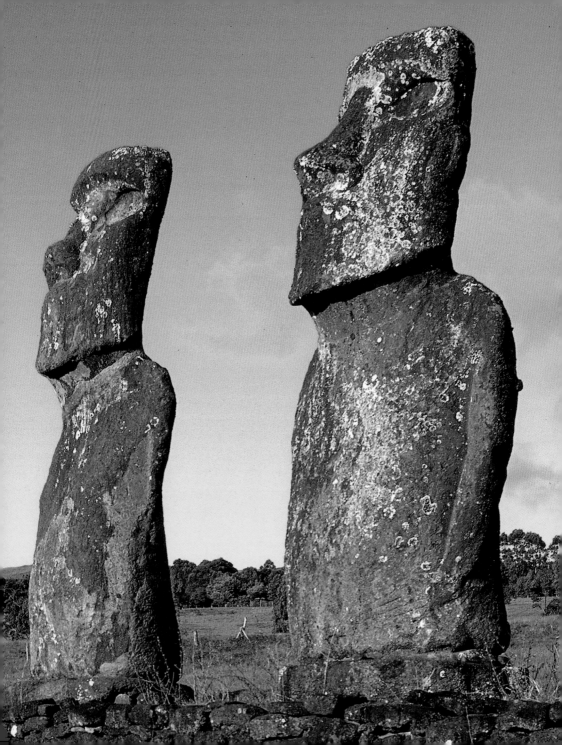

The mysteries
of Easter Island

*Easter Island represents a unique
cultural microcosm in the context of
Oceania, where the Moai, large statues
with their backs to the sea, are the most
well known example.
According to recent studies, the statues
represent the deceased former chiefs
of the indigenous tribes, capable of
putting the living in contact with the
world of the dead. The isolation, which
since the beginning of the second
millennium has allowed for their
preservation, also represented the
condemnation of the local civilization.
Today, the island-museum, with its
unique culture, is one of the most
beautiful places in the world.*

Die Mysterien
der Osterinsel

*Die Osterinsel stellt einen einzigartigen
kulturellen Mikrokosmos in Ozeanien dar,
für den die Moai, die riesigen mit dem
Rücken zum Meer gewandten Statuen als
bekanntestes Exempel gelten.
Jüngsten Studien zufolge sollen
die Statuen verstorbene indigene
Stammeshäuptlinge darstellen, die in der
Lage sind, für die Lebenden in Verbindung
mit der Welt der Toten zu treten. Die mit
dem zweiten Jahrtausend einsetzende
Isolation ermöglichte zwar die Bewahrung
der Statuen, allerdings war sie gleichfalls
das Todesurteil der lokalen Zivilisation.
Heute ist diese Museums-Insel mit ihrer
eigentümlichen Kultur einer der schönsten
Plätze auf der Welt.*

6

De mysteries
van Paaseiland

*Paaseiland vertegenwoordigt een
microkosmos van een unieke cultuur
in de context van de oceaan, waarvan
de Moai, grote standbeelden met de
rug naar de zee, het meest bekende
voorbeeld zijn. Volgens recente studies
zouden de beelden inheemse, dode
stamhoofden vertegenwoordigen, in
staat om de levenden in contact te
brengen met de wereld van de doden.
Het isolement dat vanaf het begin van
het tweede millennium hun behoud
heeft mogelijk gemaakt, was ook de
veroordeling van de lokale beschaving.
Tegenwoordig is het eiland-museum,
met zijn unieke cultuur, een van de
mooiste plekken in de wereld.*

Los misterios
de la Isla de Pascua

*La isla de Pascua representa un
microcosmos cultural único en el
contexto del continente oceánico, de
la cual los Moáis, las grandes estatuas
erigidas de espaldas al mar, son el
ejemplo más conocido. Según estudios
recientes, las estatuas representarían
jefes tribales indígenas fallecidos,
capaces de poner en contacto a los
vivos con el mundo de los muertos. El
aislamiento que desde el comienzo
del segundo milenio ha permitido su
conservación, ha representado también
la condena de la civilización local. Hoy
la isla-museo, con su peculiar cultura,
representa uno de los lugares más
atractivos del mundo.*

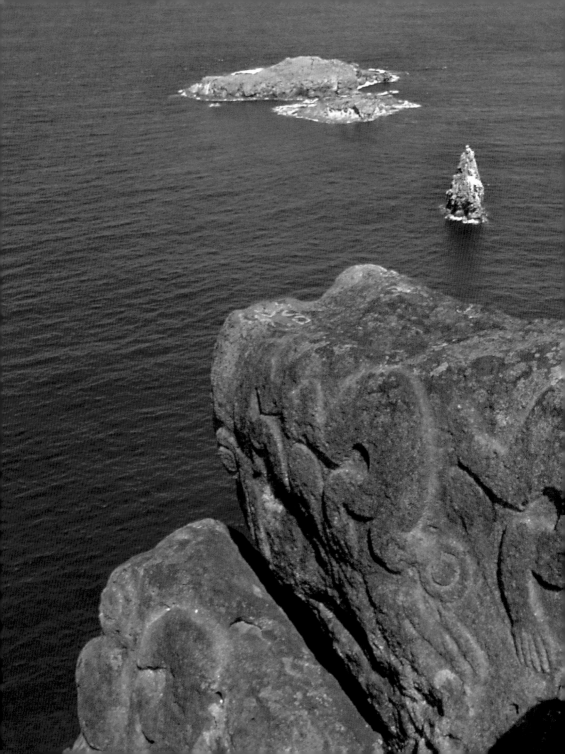

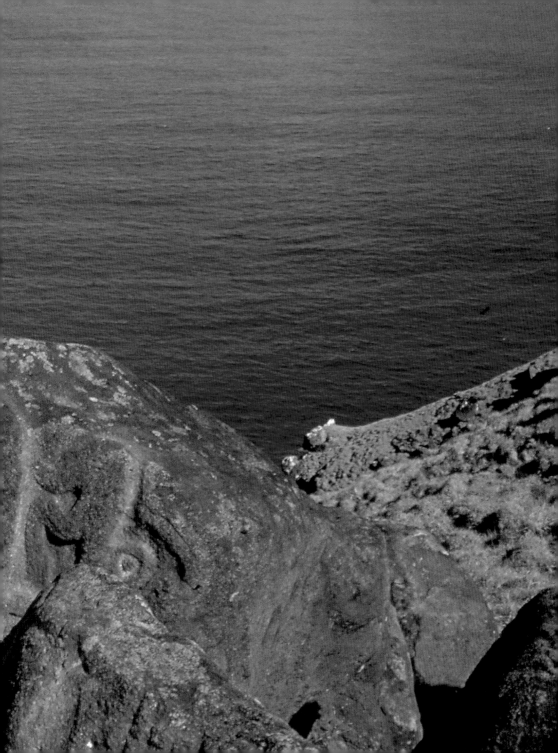

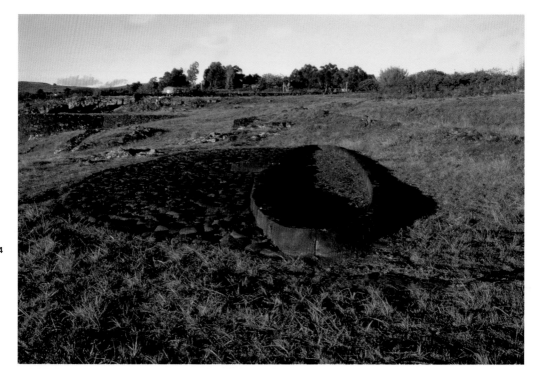

◀ **Rapa Nui National Park, Easter Island**
Rock carvings with "man-bird" in the village
for ceremonial use of Orongo
Felseinritzungen mit dem "Menschen-Vogel"
in der Siedlung, zum Zwecke der Orongo-
Zeremonienzwecke
Rotstekeningen met "man-vogel" in het
dorp voor gebruik van ceremoniële Orongo
Petroglifos con el "hombre pájaro" en la aldea
de uso ceremonial de Orongo

Rapa Nui National Park, Easter Island
Remains of a hut in the shape of a boat
Überbleibsel einer bootsförmigen Hütte
Overblijfselen van een bootvormige hut
Restos de una choza en forma de embarcación

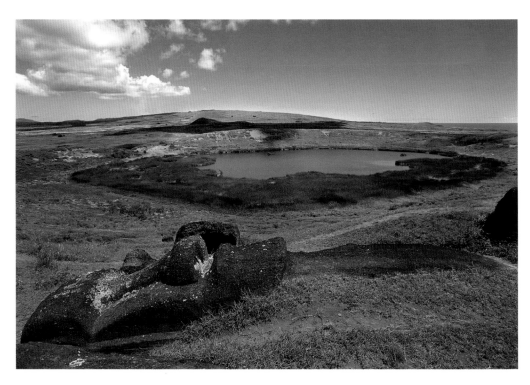

Rapa Nui National Park, Easter Island
Moai unfinished on the inside slope of the Rano Raraku volcano
Unvollendeter *Moai* auf den inneren Abhängen des Vulkans Rano Raraku
Onvoltooide *moai* op de interne hellingen van de vulkaan Rano Raraku
Moái inacabado sobre las laderas internas del volcán Rano Raraku

❚ *The mystery of the Moai, associated mainly with their ritual purpose, has persisted since the discovery of the island on Easter Sunday in 1722.*
❚ *Das Mysterium der Moai wird meist mit rituellen Zwecken in Verbindung gebracht. Es überlebte bis zur Entdeckung der Insel, zu Ostern des Jahres 1722.*
❚ *Het mysterie van de Moai, voornamelijk gerelateerd aan hun rituele doel, houdt vast aan de ontdekking van het eiland, op Paasdag van 1722.*
❚ *El misterio de los Moáis, vinculado sobre todo a su finalidad ritual, persiste desde el descubrimiento de la isla, el día de Pascua de 1722.*

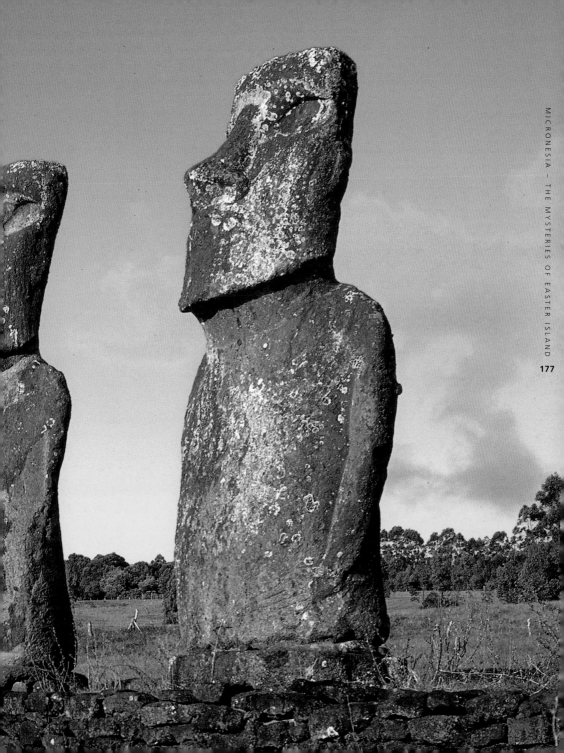

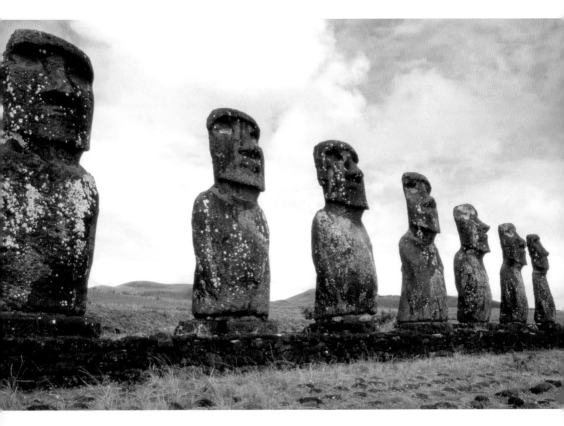

▌ *The statues, positioned with their backs to the sea, are stereotypical images of ancestors.*
▌ *Die mit dem Rücken zum Meer aufgestellten Statuen sind typisierte Darstellungen von Ahnen.*
▌ *Beelden, geplaatst met hun rug naar de zee, zijn stereotiepe beelden van voorouders.*
▌ *Las estatuas, colocadas de espaldas al mar, son imágenes estereotipadas de antepasados.*

◀ ▲ **Rapa Nui National Park, Easter Island**
View of the *moai* of Ahu Akivi
Ansicht der *Moai* von Ahu Akivi
Uitzicht op de *moai* van Ahu Akiva
Vista de los *moáis* de Ahu Akivi

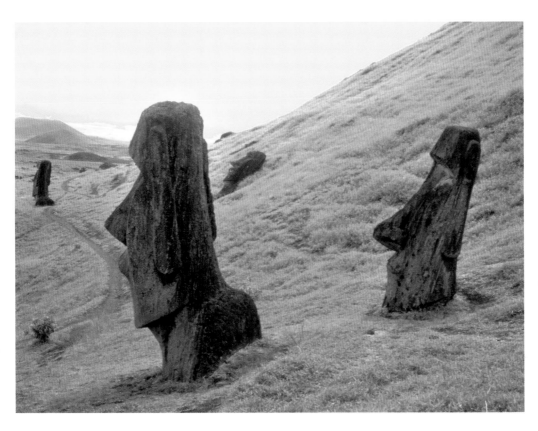

Rapa Nui National Park, Easter Island
Moai buried or unfinished in the quarries of Rano Raraku
Eingegrabene oder unvollendete *Moai* in den Steinbrüchen von Rano Raraku
Moai begraven of onvoltooid in de steengroeven van Rano Raraku
Moáis enterrados o inacabados en las canteras del volcán Rano Raraku

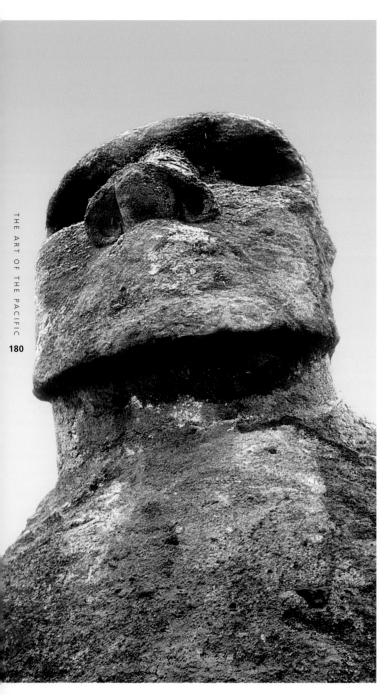

Rapa Nui National Park, Easter Island
View of the colossal *moai* weighing 86 tons,
part of the group of Ahu Tongariki
Ansicht des 86 Tonnen schweren kolossalen
Moai, der zu der Ahu Tongariki-Gruppe gehört.
Gezicht op kolossale *moai* met een gewicht
van 86 ton, de groep van Ahu Tongariki
Vista del colosal *moái* de 86 toneladas
de peso, parte del grupo de Ahu Tongariki

▶ **Rapa Nui National Park, Easter Island**
View of the 15 *moai* of Ahu Tongariki before
the restoration
Ansicht der 15 *Moai* von Ahu Tongariki
vor ihrer Restaurierung
Uitzicht op de 15 *moai* van de Ahu Tongariki
voor de restauratie
Vista de los 15 *moáis* del Ahu Tongariki
antes de la restauración

▶ **Rapa Nui National Park, Easter Island**
Statue of unfinished *moai* in the quarry
of the Rano Raraku volcano
Unvollendete *Moai*-Statue im Steinbruch
des Vulkans Rano Raraku
Moai standbeeld onafgewerkt in de
steengroeve van de vulkaan Rano Raraku
Estatua de *moái* inacabada en la cantera
del volcán Rano Raraku

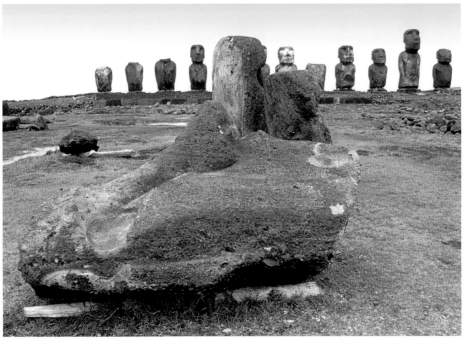

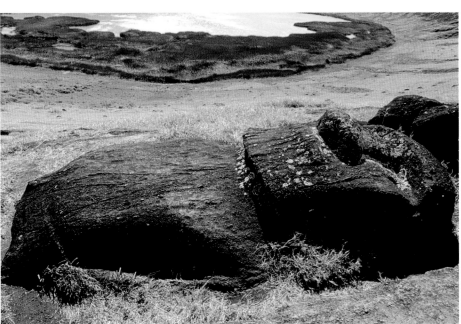

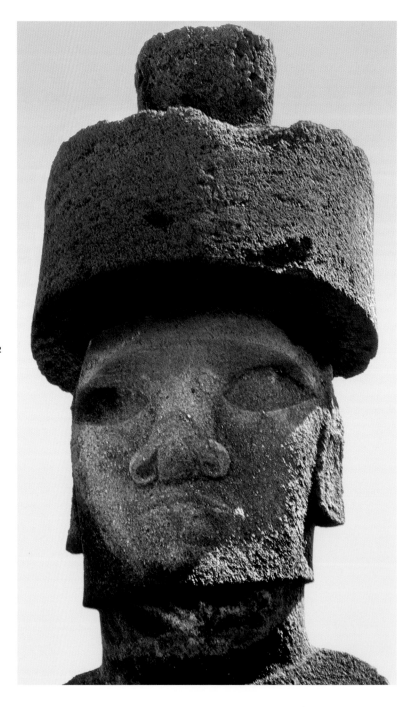

▌ The Moai, which in some cases date back to the 12th century, have been heavily restored over the last 20 years.
▌ Die Moai reichen in einigen Fällen bis ins 12. Jahrhundert zurück. In den letzten 20 Jahren wurden sie stark restauriert.
▌ Uitgebreide renovaties zijn in de afgelopen twee decennia uitgevoerd bij de Moai, die in sommige gevallen teruggaan tot de twaalfde eeuw.
▌ En los últimos veinte años, se han realizado importantes trabajos de restauración en los Moáis, que en algunos casos datan del siglo XII.

Rapa Nui National Park, Easter Island
Detail of a *moai* in the Ahu Nau Nau of Anakena
Detail eines *Moai* im Ahu Nau Nau von Anakena
Detail van een *moai* in de Ahu Nau Nau van Anakena
Detalle de un *moái* en el Ahu Nau Nau de Anakena

**Rapa Nui National Park,
Easter Island**
Rear view of *moai* in the
Ahu Nau Nau of Anakena
Rückansicht einiger *Moai* im
Ahu Nau Nau von Anakena
Achterzijde van een moai in
de Ahu Nau Nau van Anakena
Vista posterior de *moái* en
el Ahu Nau Nau de Anakena

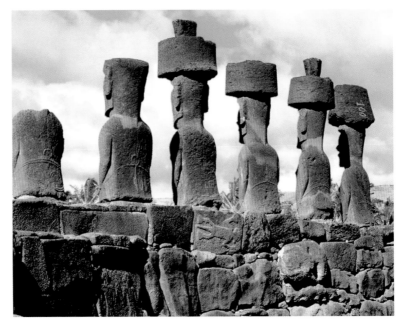

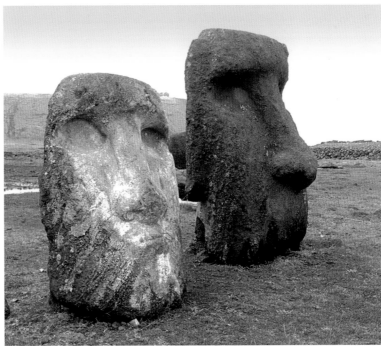

**Rapa Nui National Park,
Easter Island**
Two heads of *moai* fallen
from the Ahu Tongariki
Zwei Köpfe der vom Ahu
Tongariki gestürzten *Moai*
Twee hoofden van gevallen
moai van de Ahu Tongariki
Dos cabezas de *moái* caídas
del Ahu Tongariki

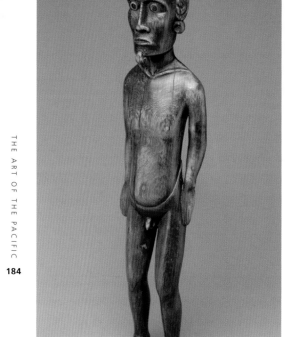
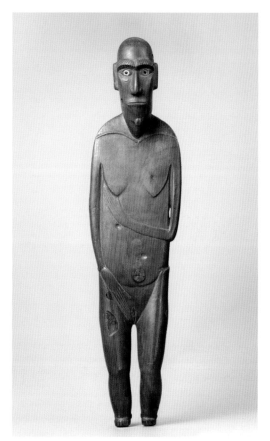

▌ *An expressive form of sculpture, part of Polynesian tradition, is part of the artistic heritage of Easter Island.*
▌ *Expressive Skulptur, eigentlich ein Teil der polynesischen Tradition, hat das künstlerische Erbe der Osterinsel bereichert.*
▌ *Een expressieve beeldhouwkunst, een deel van de Polynesische traditie, maakt deel uit van het erfgoed van Paaseiland.*
▌ *Una escultura expresiva, parte de la tradición polinesia, forma parte del patrimonio de la isla de Pascua.*

Male figurine (*Moai Tangata*); wood, obsidian, bone
Männliche Statue (*Moai Tangata*); Holz, Obsidian, Knochen
Mannelijk beeld (*Moai Tangata*); hout, bot, obsidiaan
Estatuilla masculina (*Moái Tangata*); madera, osidiana, hueso
ca. 1790-1810
The Metropolitan Museum of Art, New York

Female figurine (*Moai Papa*); wood, glass
Weibliche Statue (*Moai Papa*); Holz, Glas
Vrouwelijk beeldje (*Moai Papa*); hout, glas
Estatuilla femenina (*Moái Papa*); madera, vidrio
1800-1900
The Metropolitan Museum of Art, New York

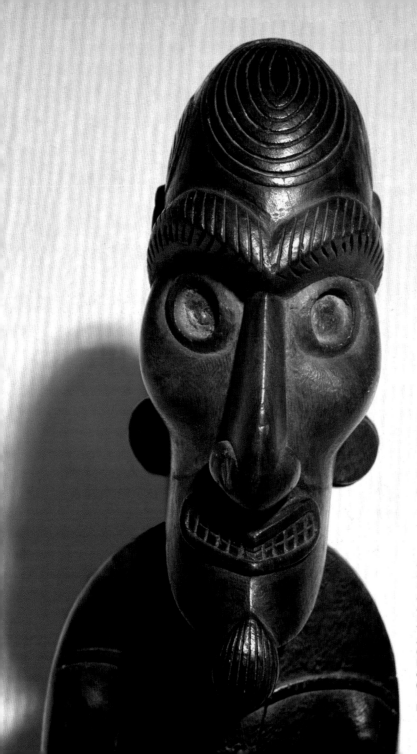

Ancestral figure known as
Moai Kavakava (emaciated
man); wood
Als *Moai Kavakava* bekannte
Ahnenfigur (abgemagerter
Mann); Holz
Voorouderfiguur bekend
als de *Moai Kavakava*
(uitgehongerde man); hout
Figura ancestral conocida
como *Moái Kavakava*
(hombre demacrado); madera
1800-1900
British Museum, London

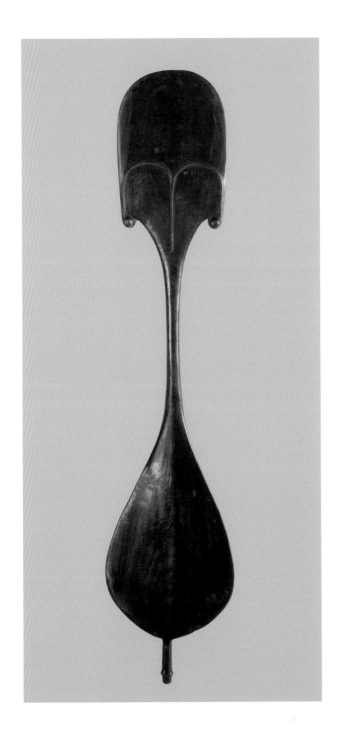

Dance emblem in the shape
of a paddle (*Rapa*); wood
Zeichen des Tanzes in Form
eines Paddels (*Rapa*); Holz
Dansembleem in de vorm van een
peddel (*Rapa*); hout
Enseña de danza en forma
de pagaia (*Rapa*); madera
ca. 1800-1820
The Metropolitan Museum of Art,
New York

▶ Statuette from Easter Island that
depicts a woman in labour; wood
Statue einer Gebährenden von der
Osterinsel; Holz
Standbeeld op Paaseiland van een
vrouw die bevalt; hout
Estatuilla de la isla de Pascua que
representa una parturienta; madera
Museo Nazionale Preistorico ed
Etnografico Luigi Pigorini, Roma

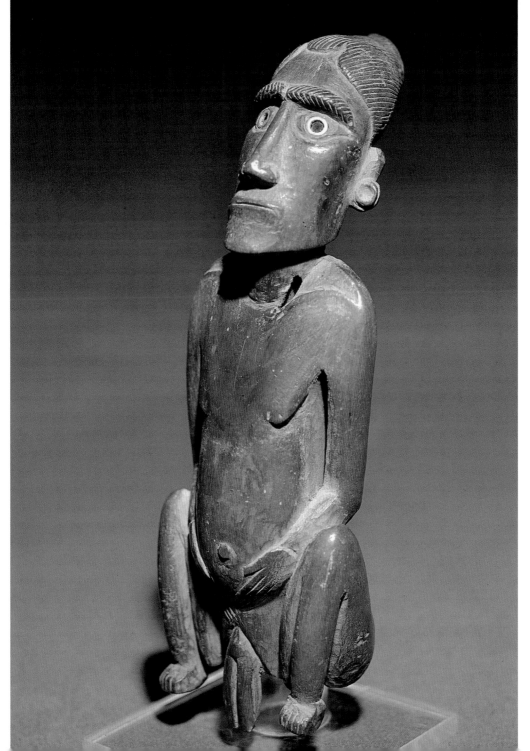

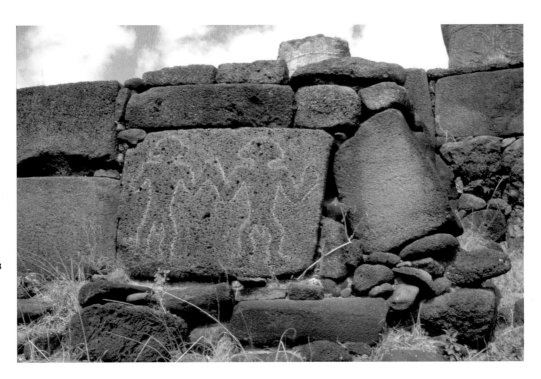

Rapa Nui National Park, Easter Island
Carving on the platform supporting the *moai* depicting
two men, Anakena Bay
Einritzungen in Form von zwei Männern an der Basis, auf
der die *Moai* stehen, Anakena Bay
Gravure op het platform ter ondersteuning van de *moai*
afbeelding van twee mannen, Anakena Bay
Grabado sobre la plataforma de sostén de los *moáis*
que representa dos hombres, Anakena Bay

❚ *The Island of the Moai also contains many examples of rupestrian
graffiti, among the most remarkable in the Pacific region.*
❚ *Die Insel der Moai enthält viele Beispiele an Felsenmalereien, die
zu den bemerkenswertesten der gesamten Pazifikregion gehören.*
❚ *Het eiland van de Moai biedt huis aan uitgebreide steengraffiti's,
onder de meest waardevolle rustige gebieden.*
❚ *La isla de los Moáis conserva grandes pinturas rupestres,
que se encuentran entre las más valiosas del área del Pacífico.*

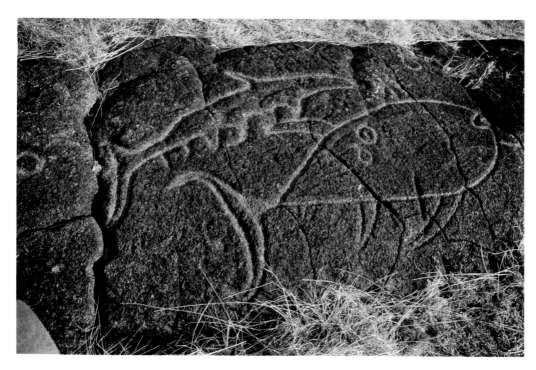

Rapa Nui National Park, Easter Island
Petroglyph in the site of Tongariki depicting two fish,
one of which looks like a shark
Petroglyphe bei Tongariki mit der Darstellung von zwei
Fischen, einer davon zeigt einen Hai zu deuten
Petroglyph op de site Tongariki, afbeelding van twee vissen,
waarvan er een is toe te schrijven aan een haai
Petroglifo en el sitio de Tongariki que representa dos peces,
uno de los cuales se puede identificar como un tiburón

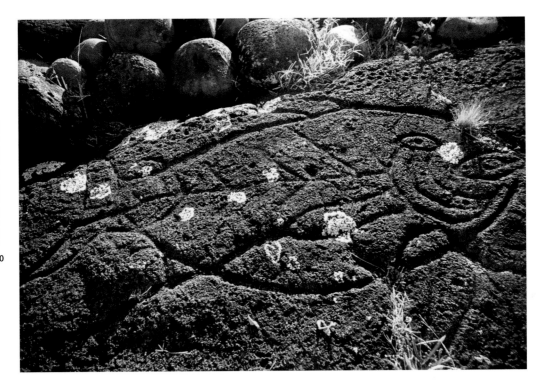

Rapa Nui National Park, Easter Island
Petroglyph of Tongariki depicting a tuna
Petroglyphe bei Tongariki in Form eines Thunfischs
Tongariki-petroglyph van afbeelding van een tonijn
Petroglifo de Tongariki que representa un atún

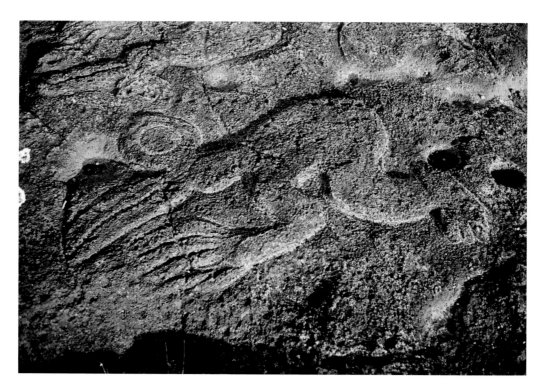

Rapa Nui National Park, Easter Island
Detail of the man-bird carved on the stone in the Tongariki site
Detail des Vogelmenschen, der Stein von Tongariki eingeritzt ist
Bijzondere man-vogel gegraveerd op de steen op de site van Tongariki
Detalle del hombre pájaro grabado sobre piedra en el sitio de Tongariki

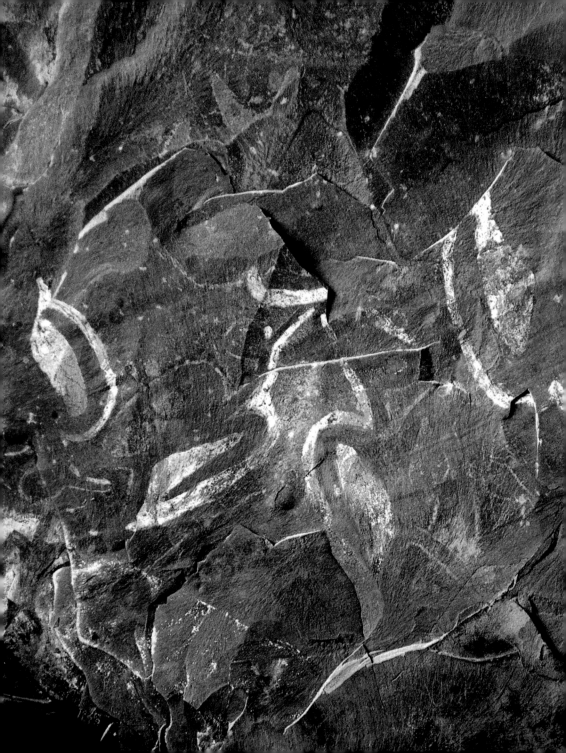

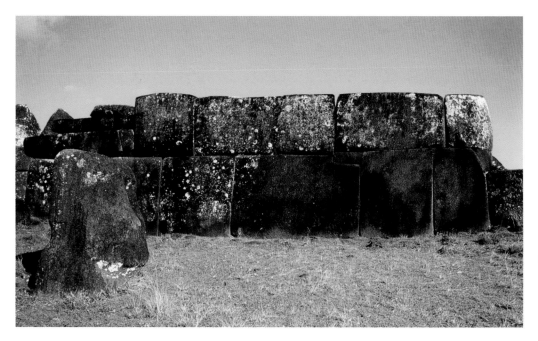

◄ Rapa Nui National Park, Easter Island
Interior of the Ana Kai Tangata cave; the vault
is decorated with painted birds
Innenansicht der Grotte Ana Kai Tangata;
die Decke ist mit Vögeln bemalt
Binnenaanzicht van de grot Ana Kai Tangata.
Het gewelf is versierd met geschilderde vogels
Interior de la gruta Ana Kai Tangata; la bóveda
está decorada con pájaros pintados

Rapa Nui National Park, Easter Island
Detail of the monolithic blocks of the Ahu Vinapu site
Detail der monolithischen Blöcke in Ahu Vinapu
Detail van monolithische blokken van de site van Ahu Vinapu
Detalle de los bloques monolíticos del sitio de Ahu Vinapu

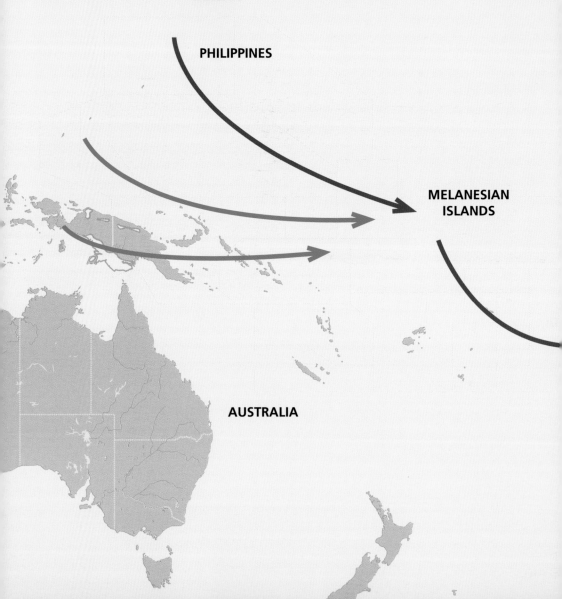

Migratory flows in the Pacific
Einwanderungsströme im Pazifik
Migratiegolven in de Pacific
Flujos migratorios en el Pacífico

TAIWAN

PHILIPPINES

MELANESIAN
ISLANDS

AUSTRALIA

The map shows two migration waves which colonized the Pacific starting from Southeast Asia. The oldest, the one with light-coloured arrows, towards Papua and Melanesia. The second towards Micronesia and Polynesia, down to New Zealand, passing through Melanesia.

Die Karte zeigt die beiden Migrationsströme, die vom Südosten Asiens aus den Pazifik bevölkert haben. Die älteste, mit hellen Pfeilen gekennzeichnete. Welle geht in Richtung Papua und Melanesien, die zweite in Richtung Mikronesien und Polynesien über Melanesien bis nach Neuseeland.

De kaart laat twee migratiegolven zien die de Stille Zuidzee vanuit Zuidoost-Azië gekoloniseerd hebben. De eerste, aangeduid met de lichte pijlen, ging richting Papoea-Nieuw-Guinea en Melanesië. De tweede via Melanesië richting Micronesië en Polynesië tot aan Nieuw-Zeeland.

El mapa muestra las dos oleadas migratorias que han colonizado el Pacífico partiendo desde el sudeste de Asia. La más antigua, la de las flechas claras, hacia Papúa y Melanesia. La segunda, hacia Micronesia y Polinesia, hasta Nueva Zelanda, pasando por Melanesia.

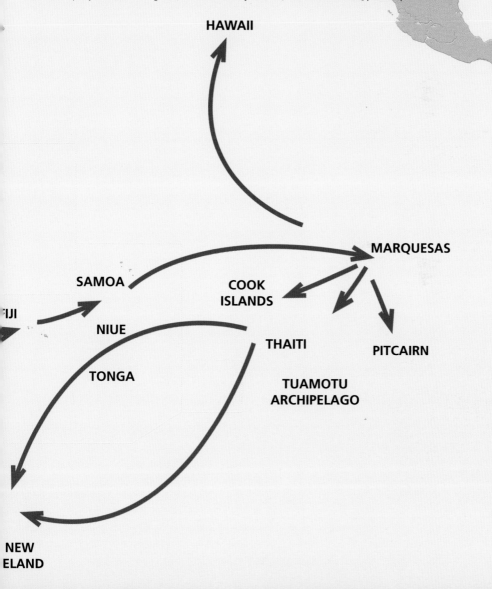

HAWAII

MARQUESAS

SAMOA

COOK
ISLANDS

FIJI

NIUE

THAITI

PITCAIRN

TONGA

TUAMOTU
ARCHIPELAGO

NEW
ZEALAND

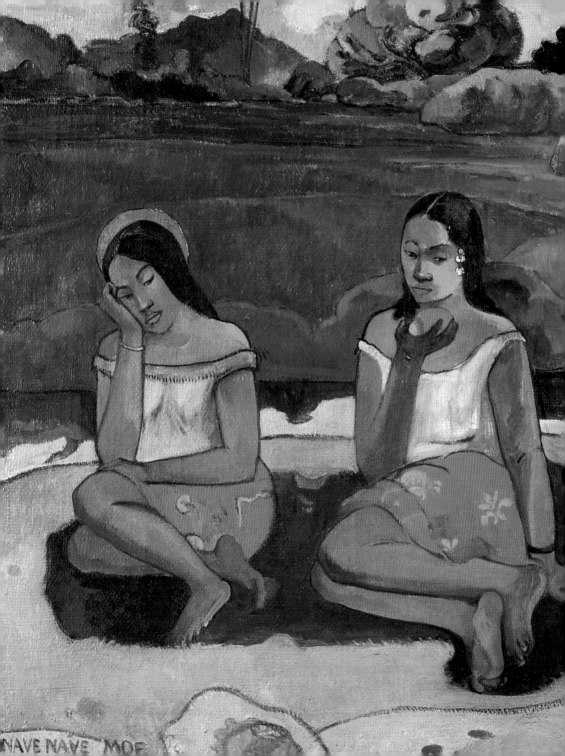

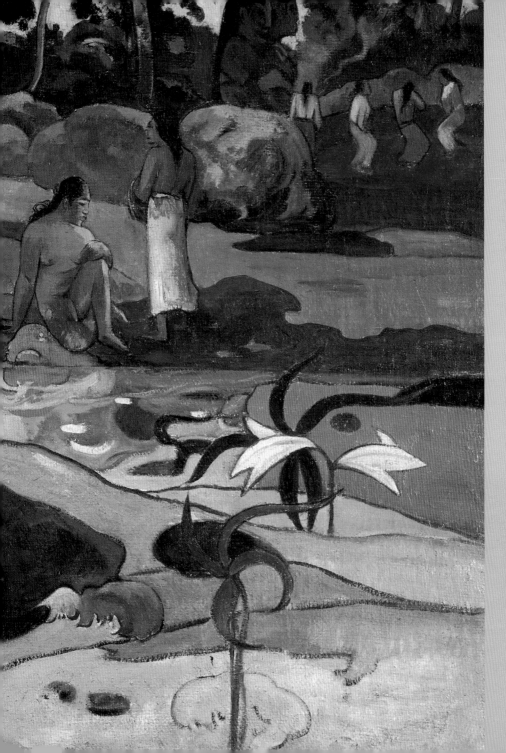

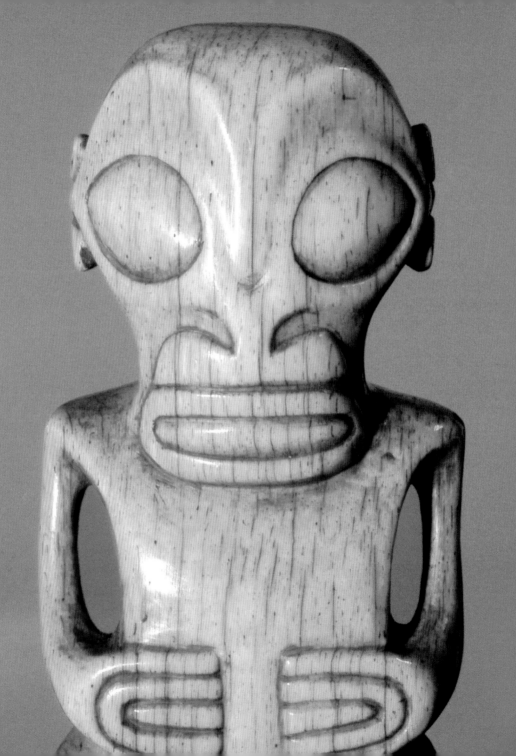

The atolls
of creativity

*Differently from the Melanesian
area, the art of Polynesia
is characterized by a more
homogeneous style, due to the
common cultural foundations of the
Polynesian people. The distance that
separates the major archipelagos
and the islands in the region
nonetheless favored the birth of
unique, highly specialized traditions,
which resulted in artistic expressions
focused on celebrating the sacred
role of the divinities and ancestors
and pointing out the privileged
position of the
elite classes.*

Atolle
der Kreativität

*Im Gegensatz zum melanesichen
Gebiet, besitzt die Kunst Polynesiens
eine viel stärkere stilistische
Homogeneität, was auf die
gemeinsame kulturelle Basis aller
polynesischen Völker zurückzuführen
ist. Trotzdem hat die zwischen den
Haupt-Archipelen und den Inseln
der Region liegende Distanz die
Entstehung von eigenen, hoch
spezialisierten Traditionen begünstigt.
Das Resultat sind künstlerische
Ausdrucksformen, in denen die heilige
Rolle der Götter und Ahnen ebenso
wie die privilegierte Position der Eliten
hervorgehoben werden.*

7

Atollen
van creativiteit

*In tegenstelling tot het Melanesische
gebied, tonen de kunsten van Polynesië
een grotere consistentie van stijl,
een eigenschap als gevolg van het
gemeenschappelijke culturele substraat
van de Polynesische volkeren. De
afstand die de belangrijkste archipels
scheidt van de eilanden heeft in ieder
geval geholpen bij het ontstaan van
eigenaardige en zeer gespecialiseerde
tradities, die vorm hebben gegeven aan
artistieke expressies, gemaakt om de
heilige rol van de goden en voorouders
te vieren en om de bevoorrechte positie
van de elitaire klassen te benadrukken.*

Los atolones
de la creatividad

*A diferencia de la región melanesia, las
manifestaciones artísticas de la Polinesia
muestran una mayor homogeneidad
estilística, un rasgo atribuible al
sustrato cultural común de los pueblos
polinesios. La distancia que separa los
archipiélagos principales y las islas de
la región ha favorecido, sin embargo,
el nacimiento de tradiciones peculiares,
altamente especializadas, que han
dado forma a expresiones artísticas
destinadas a celebrar el rol sagrado de
divinidades y antepasados, y a remarcar
socialmente la posición privilegiada de
las clases de élite.*

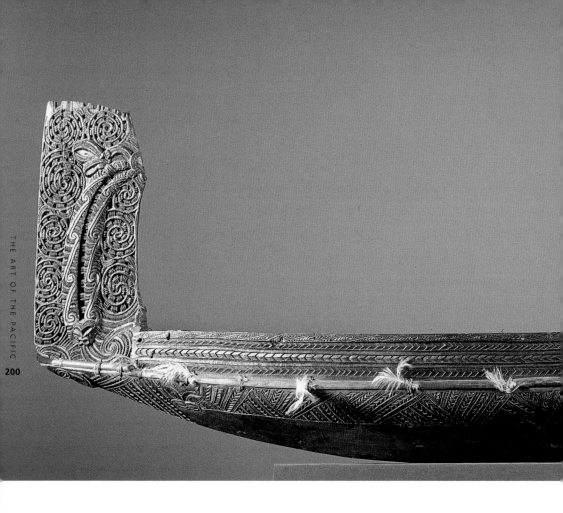

Model of war canoe from the area of Gisborne, New Zealand
Modell eines Kriegskanus aus dem Gebiet von Gisborne, Neuseeland
Model van oorlogskano afkomstig uit de omgeving van Gisborne, Nieuw-Zeeland
Modelo de canoa de guerra proveniente de la región de Gisborne, Nueva Zelanda
ca. 1850
Museum für Völkerkunde, Staatliche Museen, Berlin

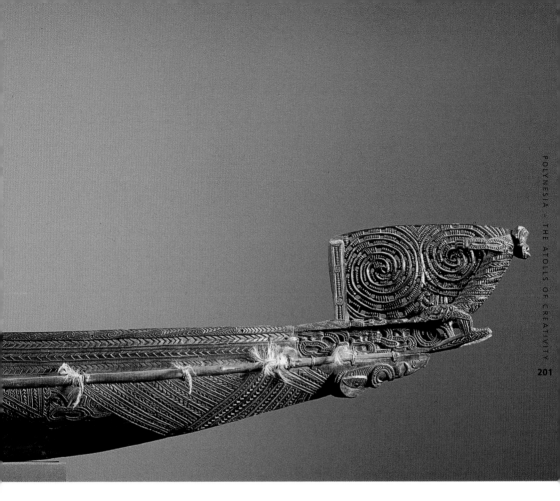

▌ *The subject of innumerable depictions, the large Polynesian canoes are the apex of a pre-eminent maritime tradition.*
▌ *Als Gegenstand unzähliger Darstellungen sind die großen polynesischen Pirogen der Gipfel einer frühreifen, exzellenten maritimen Tradition.*
▌ *Onderwerp van talloze voorstellingen, de grote Polynesische kano's zijn het hoogtepunt van een uitmuntende zeevarende traditie.*
▌ *Objeto de innumerables representaciones, las grandes piraguas polinesias son el ápice de una tradición marinera por excelencia.*

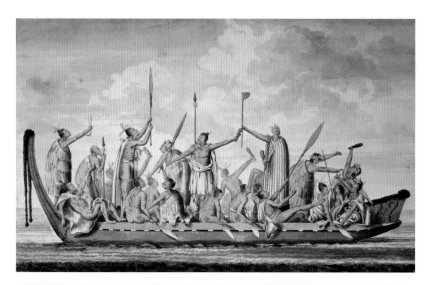

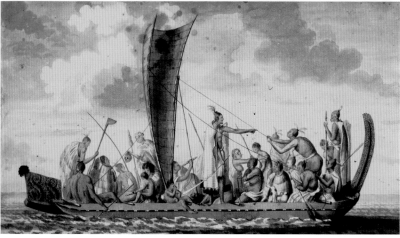

Print depicting a war canoe. Tools, accessories and decorations
of these boats often represent forms of art in their own right
Stich mit Darstellung eines Kriegskanus. Die Werkzeuge,
Accessoires und Dekorationen dieser Boote sind oft eigenständige
Kunstformen
Beeld van een oorlogskano. Instrumenten, accessoires en
decoratie van deze schepen zijn vaak vormen van kunst op zich
Estampa que representa una canoa de guerra. Las herramientas,
los accesorios y las decoraciones de estas embarcaciones
representan a menudo formas de arte independientes
ca. 1768-1780
British Library, London

Drawing of Maori war canoe with sail
Zeichnung eines Kriegskanus der Maori mit Segel
Tekening van Maori: oorlogskano met zeil
Dibujo de canoa de guerra maorí con vela
ca. 1768-1780
British Library, London

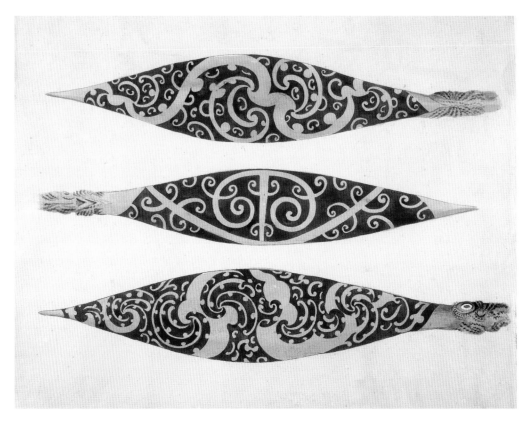

Three painted paddles (*hoe*)
Drei bemalte Paddel (*hoe*)
Drie peddels (*hoe*) geschilderd
Tres pagayas (*hoe*) pintadas
ca. 1768-1780
British Library, London

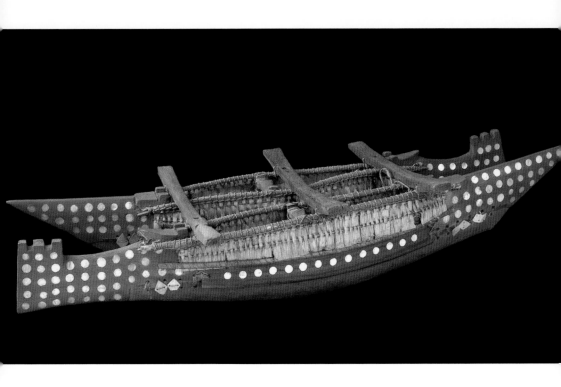

Model of pirogue of the Atoll of Manihiki, Northern
Cook Islands; wood, plant fibres and turtle shell
Modell einer Piroge aus dem Manihiki-Atoll, Northern
Cook Islands; Holz, pflanzliche Fasern
und Schildkrötenpanzer
Model kano van het atol van Manihiki, Noordelijke
Cook Islands; hout, plantaardige vezels en schild
van de schildpad
Modelo de piragua del atolón de Manihiki, Northern
Cook Islands; madera, fibras vegetales y caparazón
de tortuga
Musée du quai Branly, Paris

▶ **Nuku Hiva, Marquesas Islands**
Sculpture (*taiohae*) that shows some slaves rowing; lava rock
Skulptur (*taiohae*), die einige Rudersklaven darstellt; Lavastein
Beeld (*taiohae*), die een aantal slaven op de riem
vertegenwoordigt; lavasteen
Escultura (*taiohae*) que representa algunos esclavos remando;
piedra lavica

▶ Detail of archaic Maori drawing on rock
Detail einer archaischen Felsenzeichnung der Maori
Detail van een tekening archaïsche Maori op een rots
Detalle de un dibujo arcaico maorí sobre roca
Canterbury Museum, Christchurch

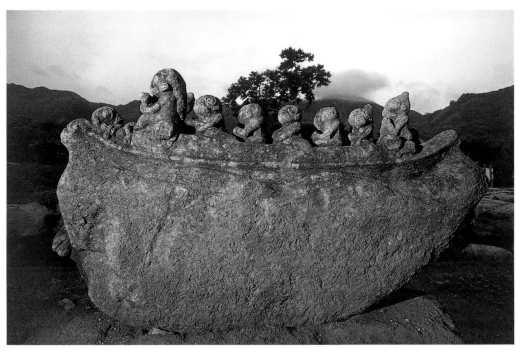

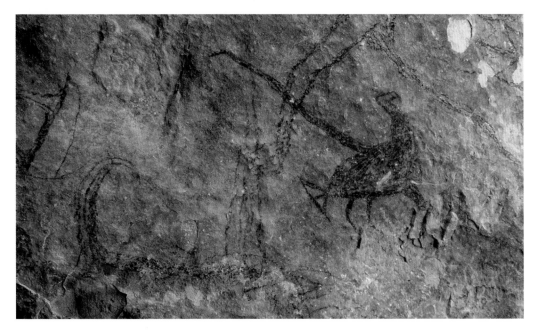

▌ *Weaving is the Polynesian craft that has reached the dignified status of art.*
▌ *Die Textur ist die Form des polynesischen Kunsthandwerks, die am meisten künstlerische Achtung verdient.*
▌ *De textuur en vorm van het Polynesische ambacht heeft de waardigheid van de kunst bereikt.*
▌ *El tejido es la forma de artesanía polinesia que ha alcanzado el nivel más alto dentro de su arte.*

Typical Polynesian fabric (*tapa*), Cook Islands;
pounded bark, pigment
Typisch polynesischer Stoff aus Polynesien (*tapa*),
Cook Islands; geschlagene Rinde, Pigmente
Karakteristiek Polynesisch weefsel (*tapa*),
Cook Islands; schors, pigmenten
Característico tejido polinesio (*tapa*),
Cook Islands; corteza trabajada, pigmento
Musée du quai Branly, Paris

▶ Fabric painted with geometric designs typical
of the Fiji Islands; pounded bark, pigment
Mit geometrischen Motiven bemalter Stoff, der
typisch für die Fiji-Inseln ist; geschlagene
Rinde, Pigmente
Stof beschilderd met geometrische motieven
kenmerkend voor de Fiji-eilanden; schors, pigmenten
Tela pintada con motivos geométricos característicos
de las islas Fiji; corteza trabajada, pigmento
Museo di Antropologia ed Etnologia, Firenze

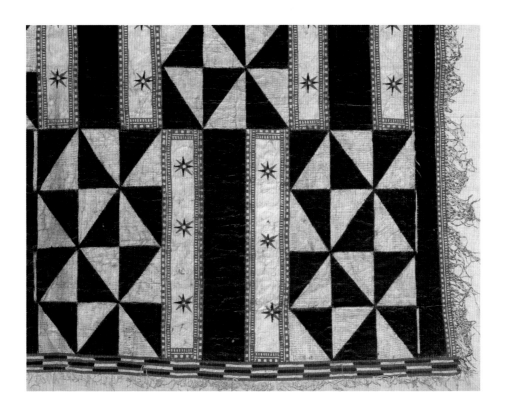

Tapa of the Fiji Islands; mulberry bark, pigment
Tapa der Fiji-Inseln; Maulbeerbaumrinde, Pigment
Tapa van de Fiji-eilanden; moerbeischors, pigment
Tapa de las islas Fiji; corteza de morera, pigmento
Museo di Antropologia ed Etnologia, Firenze

▶ **Rodolphe Festetics de Tolna**
(Boulogne-sur-Seine 1865 - 1933?)
Sapo Svenga, Samoan chieftain
Sapo Svenga, samoanischer Häuptling
Sapo Svenga, Samoaans stamhoofd
Sapo Svenga, jefa samoana
1893-1901
Musée du quai Branly, Paris

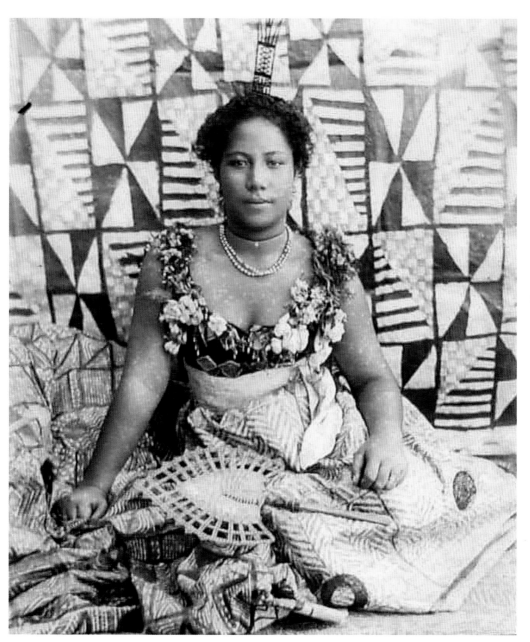

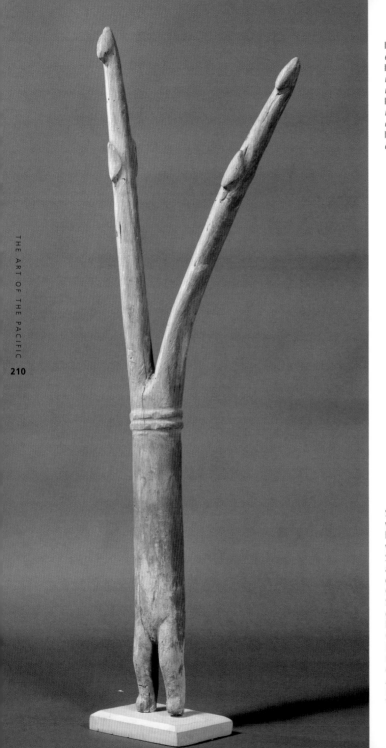

❚ *The variety of forms, expressions and uses, explains the inexhaustible appeal of the Tiki.*
❚ *Die Vielfalt an Formen, Ausdrücken und Verwendungszwecken erklärt die unerschöpfliche Faszination der Tiki.*
❚ *De verscheidenheid van vormen, uitdrukkingen, gebruiksvoorwerpen toont de onuitputtelijke charme van de Tiki.*
❚ *La variedad de formas, expresiones y usos explica el inagotable encanto de los Tiki.*

Statue of the god Tupo, the upper part of which recalls the tools for the collection of bread fruit, Mangareva, Gambier Archipelago; wood
Statue des Gottes Tupo, deren oberer Teil an Instrumente erinnert, die man zur Ernte des Brotfruchtbaums benutzt, Mangareva, Gambierinseln; Holz
Standbeeld van de god Tupo het bovenste gedeelte herinnert aan de instrumenten voor het verzamelen van broodvrucht, Mangareva, Gambier-archipel; hout
Estatua del dios Tupo, cuya parte superior recuerda los utensilios para la recolección de los frutos del árbol del pan, Mangareva, Archipiélago Gambier; madera
Museo Missionario-Etnologico, Città del Vaticano

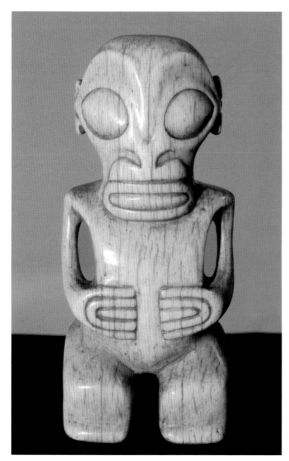

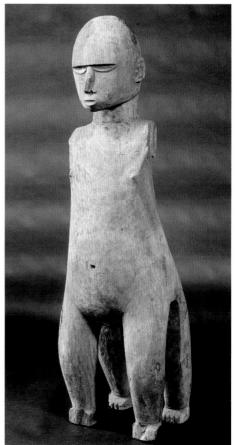

Anthropomorphic figure (*tiki*), possibly
a pendant, Marquesas Islands; ivory
Anthropomorphe Figur (*tiki*), möglicherweise ein
Anhänger, Marquesas-Inseln; Elfenbein
Antropomorfe figuur (*tiki*), misschien
een hanger, Marquesas eilanden; ivoor
Figura antropomorfa (*tiki*), probablemente un
colgante, islas Marquesas; marfil

Statuette of the god of war Tu, coming from Polynesia
Statuette des Kriegsgottes Tu, aus Polynesien stammend
Beeldje van de oorlogsgod Tu, afkomstig uit Polynesië
Estatuilla del dios de la guerra Tu, proveniente de la Polinesia
Museo Missionario-Etnologico, Città del Vaticano

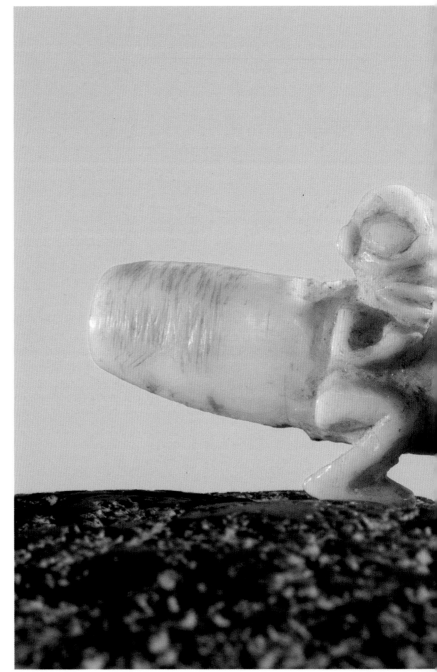

Decorative earring with
three small *tiki* figures,
Marquesas Islands; ivory
Ohrschmuck mit drei
kleinen *Tiki*-Figuren,
Marquesas-Inseln;
Elfenbein
Decoratief element voor
het oor met drie kleine
tiki figuren, Marquesas
eilanden; ivoor
Elemento decorativo de
oreja con tres pequeñas
figuras *tiki*, islas
Marquesas; marfil

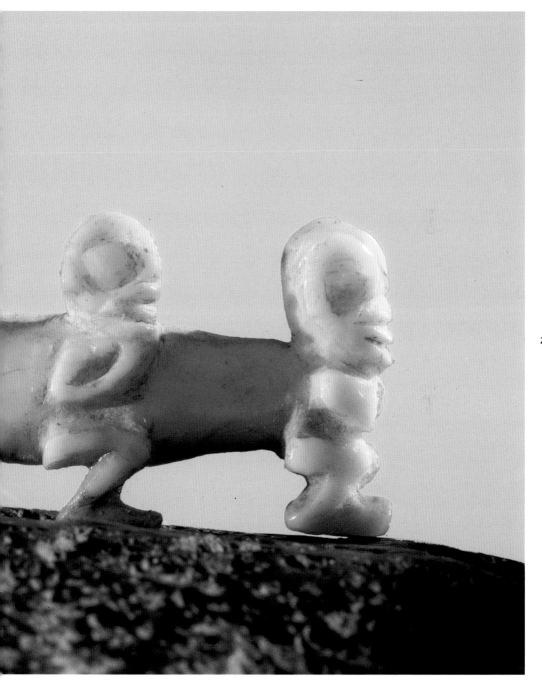

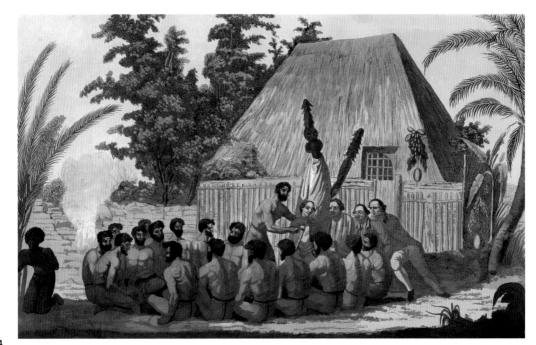

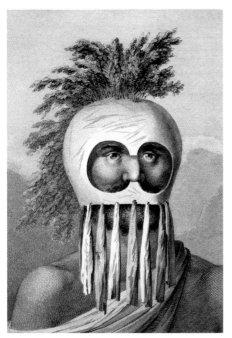

▌ *Captain Cook, who landed in Tahiti, was the first European to fully document information about Polynesian traditions.*
▌ *Kapitän Cook, der auf Tahiti gelandet war, war der erste Europäer, der ausführliche Informationen über die polynesischen Traditionen gesammelt hat.*
▌ *Kapitein Cook landde in Tahiti, werd opnieuw de eerste Europeaan, die op een biologische wijze verslag uitbracht over Polynesische tradities.*
▌ *El capitán Cook, quien desembarcó en Tahití, fue una vez más el primer europeo en registrar de manera sistemática noticias sobre las tradiciones polinesias.*

Angelo Biasioli
(1790-1830)
Engraving that represents Captain Cook as he looks at a gift
Stich mit der Darstellung von Kapitän Cook beim Betrachten eines Geschenkes
Incisie van Kapitein Cook als hij een geschenk bekijkt
Grabado que representa al capitán Cook observando una ofrenda
ca. 1778-1779
Stapleton Historical Collection, London

Print depicting a man of the Sandwich Islands (today Hawaii) with a mask
Stich mit der Darstellung eines Mannes von den Sandwich-Inseln (heute Hawaii) mit einer Maske
Afbeelding van een man van de Sandwich-eilanden (nu Hawaii) met een masker
Estampa que representa a un hombre de las islas Sandwich (hoy Hawaii) con una máscara
ca. 1768-1780

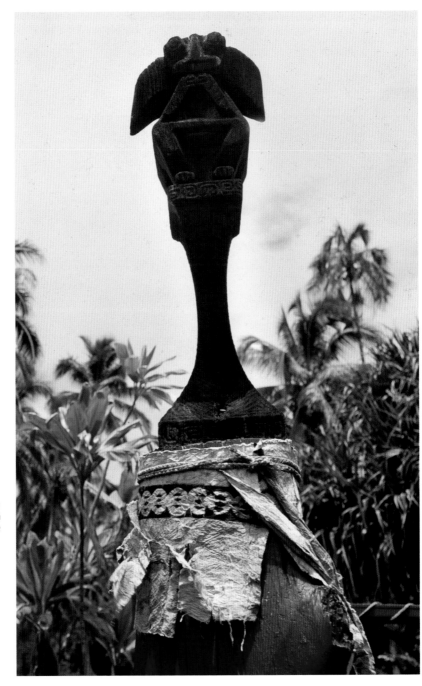

Tahiti, Society Islands
God mounted on pillar in
the sacred area of Marae
Attahooroo
Auf einen Pfeiler
gehobene Gottheit
im heiligen Gebiet
von Marae Attahooroo
Godheid gemonteerd
sop een zuil in de
heilige zone van Marae
Attahooroo
Divinidad montada
sobre un pilar en el
área sagrada de Marae
Attahooroo

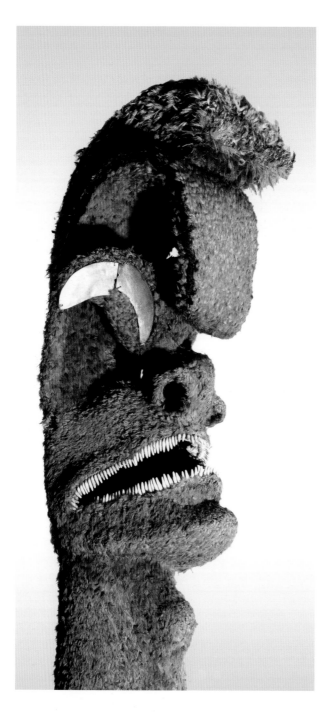

Head of the god of war, Kukailimoku, Hawaii
Islands; reed, feather and mother-of-pearl
Kopf des Kriegsgottes Kukailimoku, Hawaii
-Inseln; Binsengras, Feder und Perlmutt
Hoofd van de god van de oorlog Kukailimoku,
Hawaii-eilanden; riet, veren en parels
Cabeza del dios de la guerra Kukailimoku, islas
Hawaii; junco, plumas y nácar
1700-1800
British Museum, London

▶ God of war highly venerated in Hawai
and object of a cult that included human
sacrifice; feathers, dog's teeth, reed
Ein auf Hawaii hoch verehrter Kriegsgott,
dessen Kult unter anderem Menschenopfer
vorsah; Federn, Hundezähne und Binsengras
God van de oorlog veel vereerd in Hawaï
en het object van aanbidding met menselijke
offers; veren, hondentanden, riet
Dios de la guerra muy venerado en las islas
Hawaii y objeto de un culto que incluía
sacrificios humanos; plumas, dientes de perro,
junco
1700-1800
Musée du quai Branly, Paris

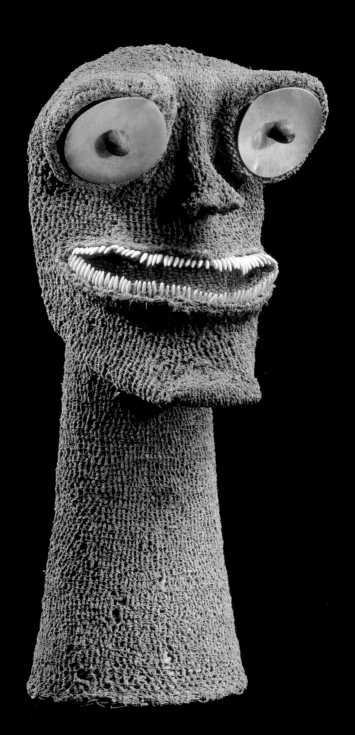

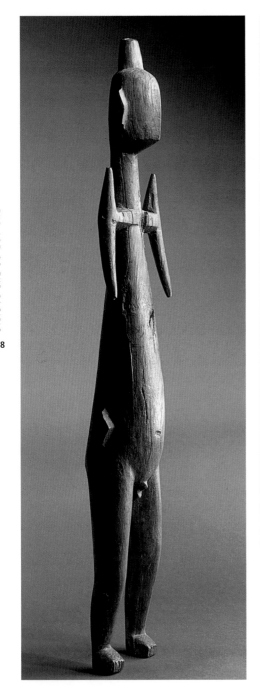

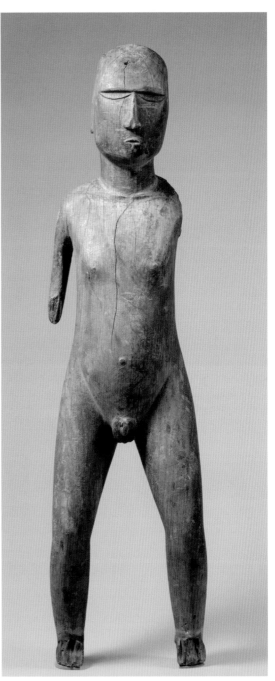

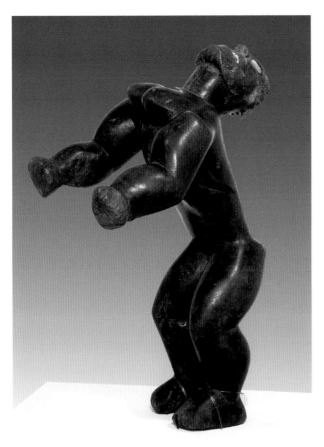

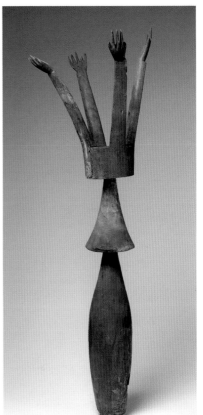

◄ Anthropomorphic figure of the god Rao,
Mangareva, Gambier Archipelago; wood
Anthropomorphe Figur des Gottes Rao,
Mangareva, Gambierinseln; Holz
Antropomorfe beelden van de god Rao,
Mangareva, Gambier-archipel; hout
Escultura antropomorfa del dios Rao,
Mangareva, Archipiélago Gambier; madera
Musée du quai Branly, Paris

◄ Male figurine, possible representation of Rogo, god
of rain, Mangareva, Gambier Archipelago; wood
Männliche Figur, möglicherweise der Regengott Rogo,
Mangareva, Gambierinseln; Holz
Vrouwbeeldje, misschien wel de voorstelling van Rogo,
de god van de regen, Mangareva, Gambier-archipel; hout
Estatuilla masculina, posiblemente una representación de Rogo,
divinidad de la lluvia, Mangareva, Archipiélago Gambier; madera
ca. 1790-1810
The Metropolitan Museum of Art, New York

Male figurine pointed out by Cook; wood
Von Cook erwähnte männliche Figur; Holz
Mannelijk figuur gemeld door Cook; hout
Figurilla masculina señalada por Cook; madera
1700-1800
British Museum, London

Sole example of support for offerings
(patoko), Gambier Archipelago; wood
Einzig erhaltenes Beispiel eines Gabenbehälters
(patoko), Gambierinseln; Holz
Uniek exemplaar van steun voor offers
(patoko), Gambier-archipel; hout
Ejemplar único de sostén para ofrendas
(patoko), Archipiélago Gambier; madera
ca. 1800-1820
Musée du quai Branly, Paris

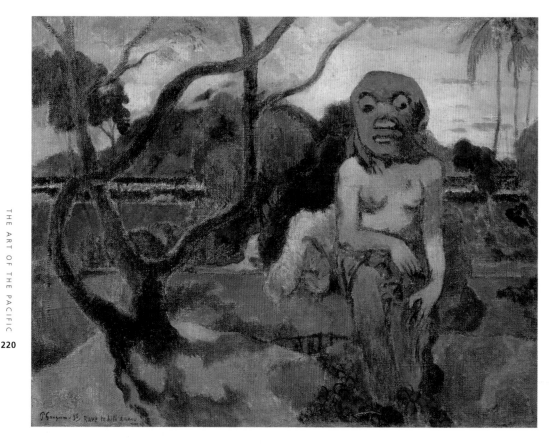

▌ *Many of Paul Gauguin works of art repropose the local tradition in modern forms.*
▌ *Viele Werke von Paul Gauguin greifen lokale Traditionen auf und interpretieren diese mit modernen Formen.*
▌ *Een groot deel van de productie van Paul Gauguin plaatst de lokale traditie in moderne vormen.*
▌ *Gran parte de la producción de Paul Gauguin reformula la tradición local plasmándola en formas modernas.*

Paul Gauguin
(Paris 1848 - Hiva Oa 1903)
*Rave te hiti ramu (Presence
of evil demon)*; oil on canvas
*Rave te hiti ramu (Anwesenheit
des bösen Dämons)*; Öl auf Leinwand
*Rave te hiti ramu (Aanwezigheid
van de slechte demon)*; olie op doek
Rave te hiti ramu (El ídolo);
óleo sobre lienzo
ca. 1898
State Hermitage Museum, St. Petersburg

▶ **Paul Gauguin**
(Paris 1848 - Hiva Oa 1903)
Idol with the shell; wood and shell
Idol mit Muschel; Holz und Muschel
Idool met de schelp; hout en schelpen
Ídolo con concha; madera y concha
1892-1893
Musée d'Orsay, Paris

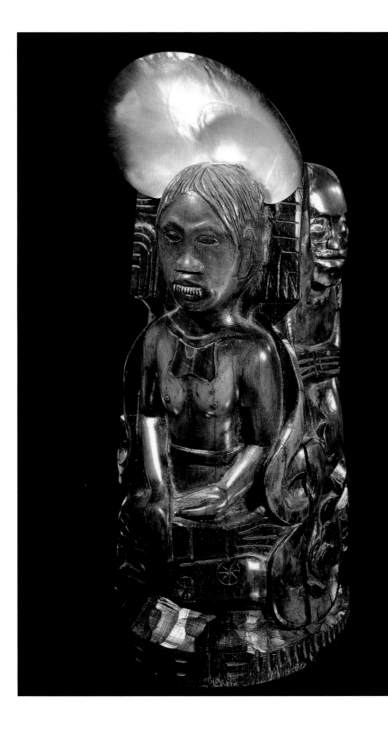

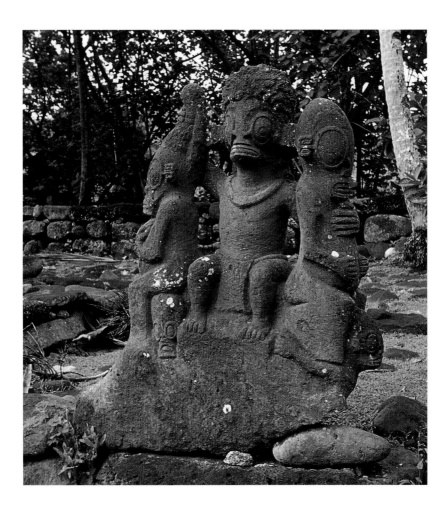

◄ **Nuku Hiva, Marquesas Islands**
Sculpture in lava rock by the Master Uk
Lavasteinskulptur des Meisters Uk
Lavastenen beeld van Meester Uk
Escultura en piedra lavica del Maestro Uk

Nuku Hiva, Marquesas Islands
Sculptures depicting *tiki* of fertility
at the site of Hikokua
Tiki der Fruchtbarkeit darstellende
Figuren in Hikokua
Tiki beelden voor de vruchtbaarheid
op de site Hikokua
Esculturas que representan un *tiki*
de la fertilidad en el sitio de Hikokua

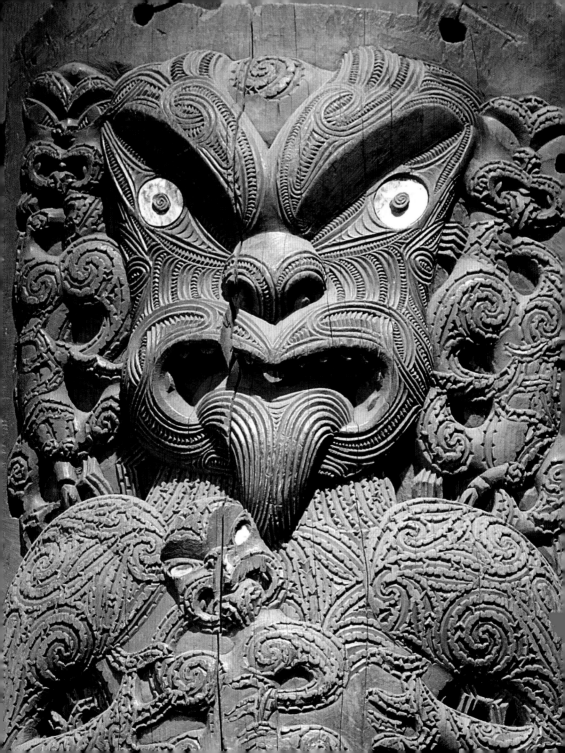

The Maori epic

Most of what we know about Maori art comes from works collected by European visitors starting in the 18th century, including composite sculptures in wood decorating meeting houses and other buildings, the bows and sterns of their pirogues, and various portable works of art, such as containers, ceremonial axes, staffs of command and musical instruments. The style that distinguishes them has been placed in a later period, which flourished in the centuries that preceded European contact, during which native art reached its culmination.

Das Epos der Maori

Ein Großteil dessen, was wir über die Kunst der Maori wissen, beruht auf Werken, die europäische Reisende seit dem 18. Jahrhundert gesammelt haben: das sind vor allem Komposit-Holzskulpturen zur Dekoration von Versammlungshäusern und anderen Gebäuden, von Bügen und Hecks großer Einbäume, aber auch verschiedene tragbare Gegenstände wie Behälter, Zeremonial-Äxte, Szepter und Musikinstrumente. Ihr spezieller Stil wird einer späteren Periode zugeordnet, den Jahrhunderten vor der Kontaktaufnahme zu den Europäern, als sie eine Blütezeit erlebten und das künstlerische Schaffen der Ureinwohner seinen Höhepunkt erreichte.

8

Het Maori epos

Veel van wat we weten over de Maori kunstwerken is afgeleid van de verzamelde werken door Europese bezoekers sinds de achttiende eeuw; samengestelde houten sculpturen sieren de buurthuizen en andere structuren, de voor- en achtersteven van grote kano's en andere voorwerpen meubelkunst, zoals kisten, ceremoniële bijlen, vechtstukken en muziekinstrumenten. De stijl die hen onderscheidt wordt toegeschreven aan een late fase, die bloeide in de eeuwen vóór het Europese contact, waarin de artistieke productie van de inboorlingen haar hoogtepunt zou hebben bereikt.

La epopeya Maorí

Gran parte de lo que conocemos sobre el arte Maorí proviene de las obras coleccionadas por los visitantes europeos desde el siglo XVIII; destacan las esculturas fabricadas en madera que adornan las casas de reunión y otras estructuras, las proas y las popas de las grandes piraguas y distintos objetos de arte mobiliario, como contenedores, hachas ceremoniales, bastones de mando e instrumentos musicales. El estilo que los distingue está vinculado a una fase tardía, que floreció en los siglos precedentes al contacto europeo, durante la cual la producción artística de los nativos habría alcanzado su culmen.

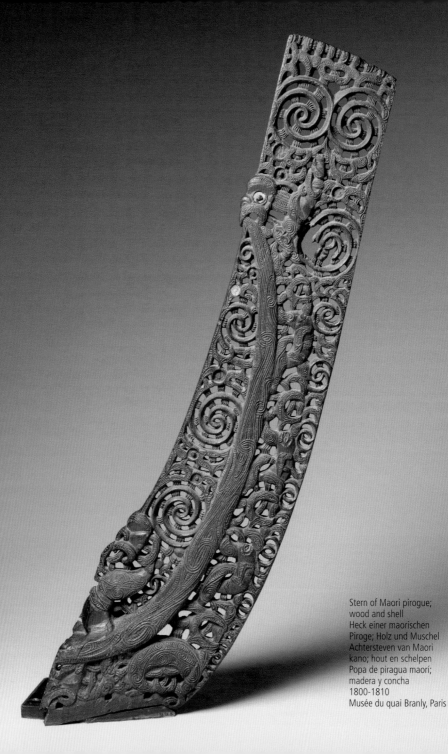

Stern of Maori pirogue;
wood and shell
Heck einer maorischen
Piroge; Holz und Muschel
Achtersteven van Maori
kano; hout en schelpen
Popa de piragua maori;
madera y concha
1800-1810
Musée du quai Branly, Paris

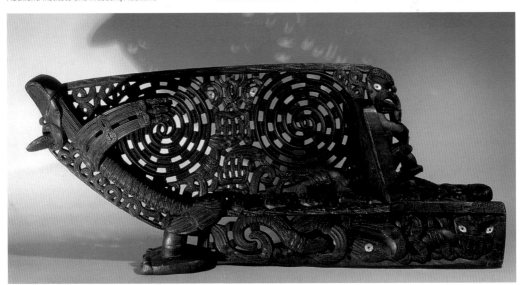

Antonio Zatta
(*ca.* 1757-1797)
Map of New Zealand
Landkarte von Neuseeland
Kaart van Nieuw-Zeeland
Mapa de Nueva Zelanda
1778
British Library, London

Prow (*tauihu*) of a carved war canoe; wood
Bug (*tauihu*) eines geschnitzten Kriegskanus; Holz
Boog (*tauihu*) van een oorlogskano ingesneden; hout
Proa (*tauihu*) de una canoa de guerra tallada; madera
ca. 1800-1820
Auckland Institute and Museum, Auckland

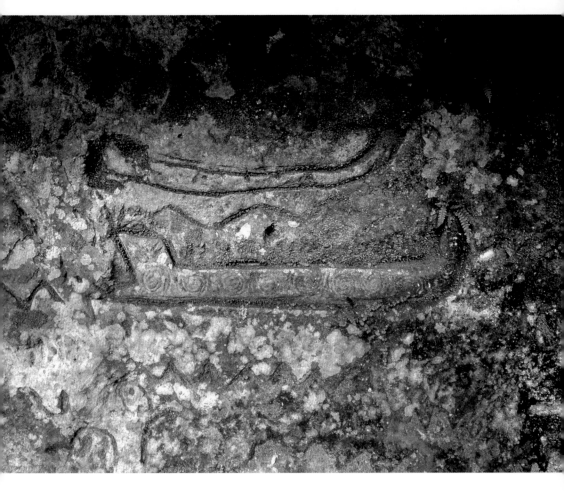

▌ *The memory of the "great Maori migration" is sculpted in stone of Te Aotearoa.*
▌ *Die Erinnerung an die "große Maori-Wanderung" ist in den Stein von Te Aotearoa gehauen.*
▌ *De herinnering aan "de grote Maori migratie" is uitgehakt in steen van Te Aotearoa.*
▌ *La memoria de la "gran migración maorí" está esculpida en la piedra de Te Aotearoa.*

Kaingaroa Forest, New Zealand
Rock carvings in the Kaingaroa
caves depicting canoes
Felseinritzungen mit Kanus
in den Grotten von Kaingaroa
Rotstekeningen in de grotten
van Kaingaroa afgebeeld is een kano
Grabados rupestres en las grutas de
Kaingaroa que representan canoas

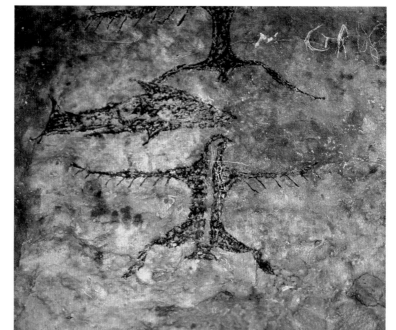

Maori drawing depicting a fish and many figures similar to birds
Maorische Zeichnung mit Darstellungen eines Fisches und vieler vogelähnlicher Figuren
Maori-tekening van een vis en veel figuren die lijken op vogels
Dibujo maorí que representa un pez y varias figuras parecidas a pájaros
Canterbury Museum, Christchurch

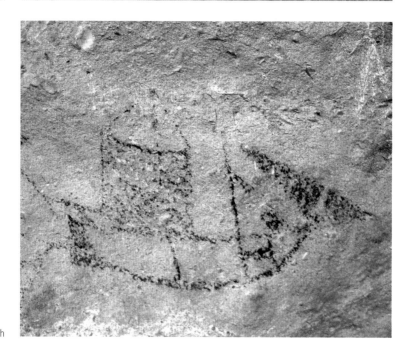

Detail of Maori rock petroglyph
Detail einer maorischen Petroglyphe auf Felsen
Detail van Maori rotstekeningen
Detalle de petroglifo maorí sobre roca
Canterbury Museum, Christchurch

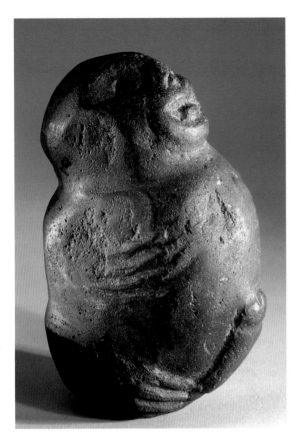

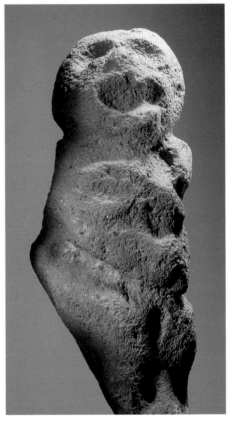

Anthropomorphic Maori stone
Anthropomorpher Maori-Stein
Antropomorfe Maori steen
Piedra maorí antropomorfa
Taranaki Museum, New Plymouth

▶ Maori stone indicated as "resting
place" of the god of agriculture Rongo
Maori-Stein, der als "Erholungsort"
des Gottes der Landwirtschaft Rongo gilt
Maori steen als "rustplaats" van de
god van de landbouw Rongo
Piedra maorí indicada como "lugar
de reposo" por el dios de la agricultura
Rongo
Taranaki Museum, New Plymouth

Maori stone, North Island, New Zealand
Maori-Stein, North Island, Neuseeland
Maori steen, North Island, Nieuw-Zeeland
Piedra maorí, North Island, Nueva Zelanda
Taranaki Museum, New Plymouth

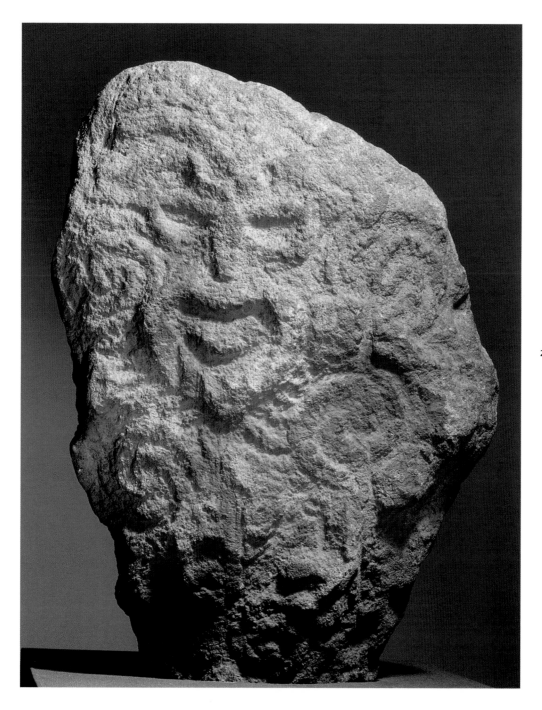

Seated figure, possibly fragment of a ritual stick; wood
Sitzende Figur, vielleicht Fragment eines rituellen Stocks; Holz
Zittend figuur, misschien een deel van een rituele stok; hout
Figura sentada, probablemente fragmento de un bastón ritual; madera
Maori and Pioneer Museum, Okains Bay

Anthropomorphic sculpture; jade
Anthropomorphe Skulptur; Jade
Antropomorf beeld; jade
Escultura antropomorfa; jade
Musée du quai Branly, Paris

▶ Detail of a ceremonial club of a Maori chieftain; wood
Detail vom Zeremonienschlägel eines Maori-Häuptlings; Holz
Detail van een ceremoniële knuppel van het Maori opperhoofd; hout
Detalle de una maza ceremonial de jefe maorí; madera
Entwistle Gallery, London

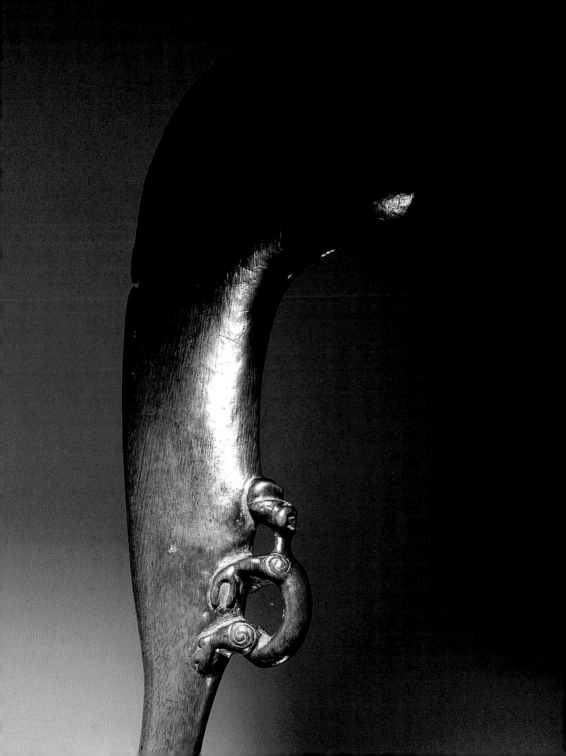

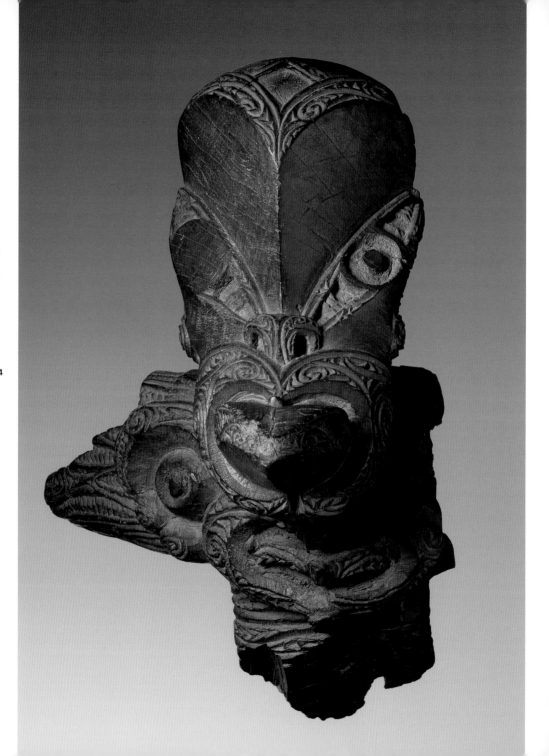

One of the ways the Maori terrorize their enemies, whether they be human or supernatural, is to show them their tongue.

Eine der Methoden, mit denen die Maori ihre menschlichen oder übernatürlichen Feinde erschrecken, ist ihnen die Zunge zu zeigen.

Eén van de Maori gebruiken om de vijand angst aan te jagen, mens of bovennatuurlijk, is het tonen van de tong.

Sacar la lengua es uno de los recursos utilizados por los Maoríes para aterrorizar al enemigo, sea éste humano o sobrenatural.

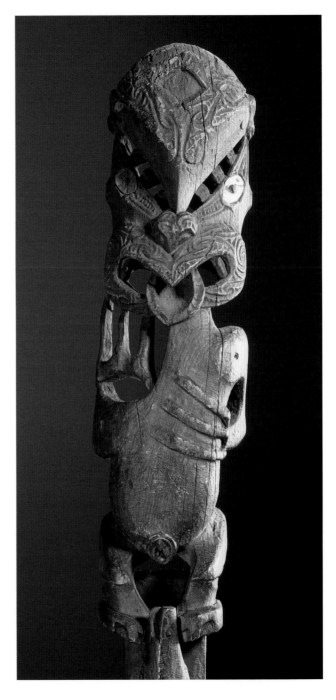

Representation in human form (*tekoteko*)
of Tuwharetoa, ancestor of the Maori people; wood
Darstellung in Menschengestalt (*tekoteko*) von
Tuwharetoa, dem Urahnen des Maori-Volkes; Holz
Uitbeelding van een menselijke vorm (*tekoteko*)
van Tuwharetoa, stamvader van de Maori volk; hout
Representación en forma humana (*tekoteko*) de
Tuwharetoa, antepasado del pueblo maorí; madera
1800-1900
Museum für Völkerkunde, Staatliche Museen, Berlin

◀ Prow of Maori pirogue depicting Tumatauenga,
god of war; wood
Bug einer Maori-Piroge, die den Kriegsgott
Tumatauenga darstellt; Holz
Boeg van een Maori kano met de beeltenis
van Tumatauenga, de god van de oorlog; hout
Proa de piragua maorí que representa a
Tumatauenga, dios de la guerra; madera
ca. 1790-1810
Musée du quai Branly, Paris

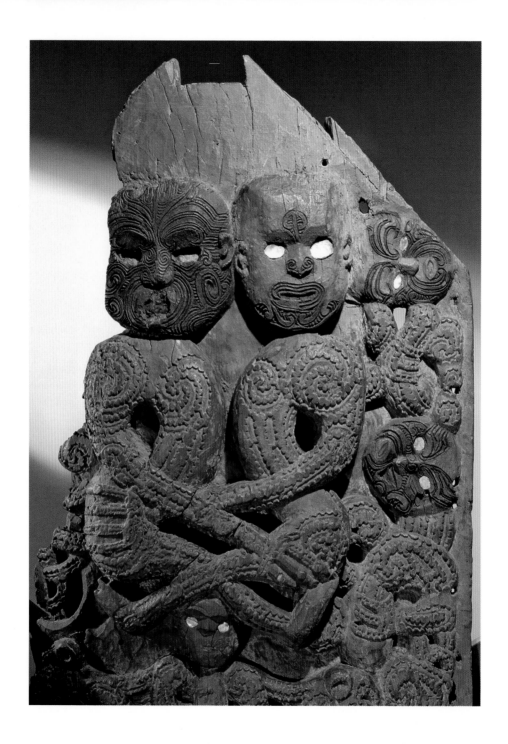

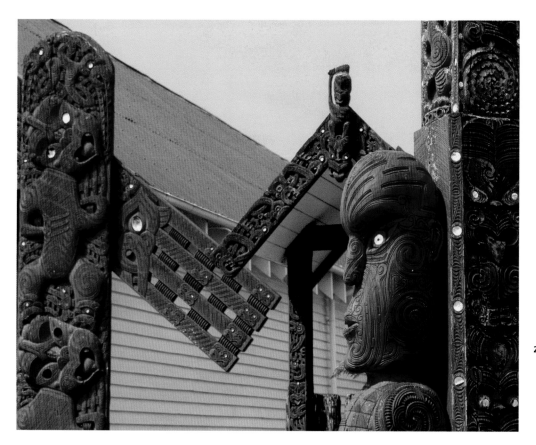

▌ *Ruler-artists often lead the tribes.*
▌ *Herrscher-Künstler stehen häufig an der Spitze der Stämme.*
▌ *Soeverein-kunstenaars bevinden zich vaak aan het hoofd van de stam.*
▌ *Las tribus son a menudo regidas por soberanos-artistas.*

◀ Sculpture that represents the Maori gods Rangi
(Father Sky) and Papa (Mother Earth) as a couple; wood
Skulptur mit Darstellung der Maori-Götter Rangi (Vater
Himmel) und Papa (Mutter Erde) als Paar; Holz
Beeldhouwwerk van de Maori Rangi (vader Lucht)
en Papa (Moeder Aarde) als een paar uitgebeeld; hout
Escultura que representa los dioses de los maoríes Rangi
(el Padre Cielo) y Papa (la Madre Tierra) como pareja;
madera
1700-1800
Otago Museum, Dunedin

Detail of sculpture of the region of Rotorua, New Zealand
Detail einer Skulptur aus der Region von Rotorua, Neuseeland
Detail van de beeldhouwkunst van de regio van Rotorua,
Nieuw-Zeeland
Detalle de escultura de la región de Rotorua, Nueva Zelanda
1900-2000

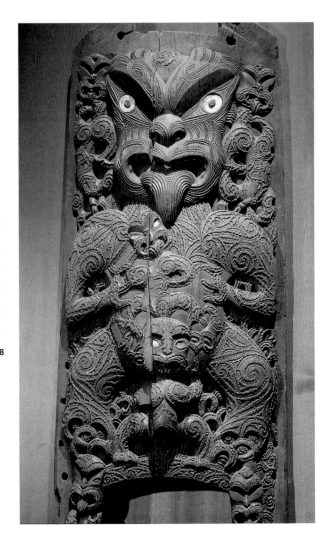

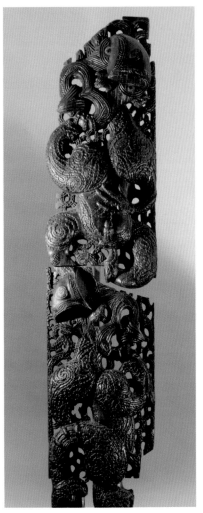

Kuwaha Pataka, symbol of access
to the underworld; wood
Kuwaha Pataka, Symbol des
Zugangs zur Unterwelt; Holz
Kuwaha Pataka, symbool van de
toegang tot de onderwereld; hout
Kuwaha Pataka, símbolo de acceso
al inframundo; madera
1800-1900
Museum für Völkerkunde,
Staatliche Museen, Berlin

Carved panel of the entrance to a storehouse (*pataka*),
place of great importance in the Maori tradition; wood
Geschnitztes Relief am Eingang eines Warenlagers
(*pataka*), einem Ort von großer Bedeutung für die
maorische Tradition; Holz
Gesneden panelen van de ingang van een opslagplaats
(*pataka*), een plaats van groot belang in de Maori
traditie; hout
Panel tallado del ingreso a un depósito (*pataka*), lugar
de gran importancia en la tradición maorí; madera
1800-1900
Entwistle Gallery, London

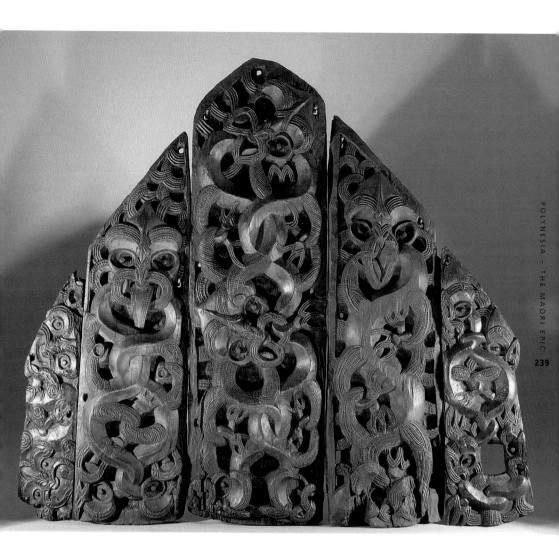

Carved panels from a storehouse; they depict the interlacing
of human forms and the supernatural world; wood
Geschnitzte Reliefs aus einem Lagerraum; sie stellen die
Verknüpfung der menschlichen Formen mit der Welt des
Übernatürlichen dar; Holz
Gesneden panelen uit een opslagplaats; uitbeelding van de
verwevenheid van menselijke vormen en de bovennatuurlijke
wereld; hout
Paneles tallados de un depósito; representan el vínculo entre
las formas humanas y el mundo sobrenatural; madera
1800-1900
Entwistle Gallery, London

▌ *Wood sculpture is the preferred medium in the cult of the ancestors.*
▌ *Die Holzskulptur ist das bevorzugte Medium des Ahnenkults.*
▌ *Houtsnijwerk verdient de voorkeur bij de verering van voorouders.*
▌ *Para el culto de los antepasados se prefiere la escultura en madera.*

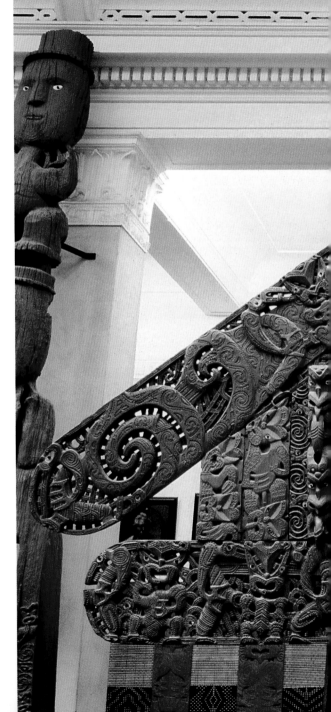

Warehouse and storehouse of food (*pataka*) with panels carved by Waeranga near Lake Rotorua; wood
Lebensmitteldepot (*pataka*) mit geschnitzten Reliefs aus Waeranga beim Rotoruasee; Holz
Magazijn of opslag van voedsel (*pataka*) met gebeeldhouwde panelen uit Waeranga op Lake Rotorua; hout
Depósito de víveres (*pataka*) con paneles tallados de Waeranga en las cercanías del lago Rotorua; madera
ca. 1820
Canterbury Museum, Christchurch

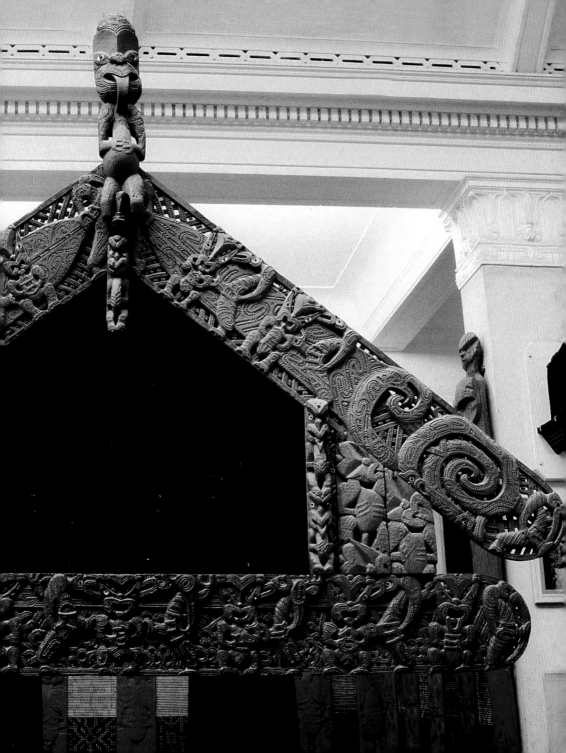

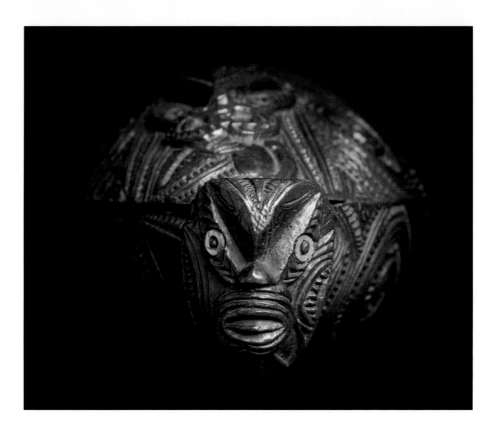

Case for the preservation of jade and feather
ornaments of the Maori, North Island, New
Zealand; wood
Dose zum Aufbewahren von Jade- und
Federornamenten der Maori, North Island,
Neuseeland; Holz
Koffer voor de instandhouding van jade en
veren ornamenten van de Maori, North Island,
Nieuw-Zeeland; hout
Pequeño baúl para guardar los ornamentos
en jade y plumas de los maoríes, North Island,
Nueva Zelanda; madera
ca. 1850-1900
Musée du quai Branly, Paris

▶ View of an interior of a Te
Hau-Ki-Turanga meeting house
Innenansicht eines Te Hau-Ki-
Turanga-Versammlungshauses
Een blik in het interieur van een
bijeenkomsthuis Te Hau-Ki-Turanga
Escorzo de un interior de la casa
de reunión Te Hau-Ki-Turanga
1842
National Museum of New Zealand,
Wellington

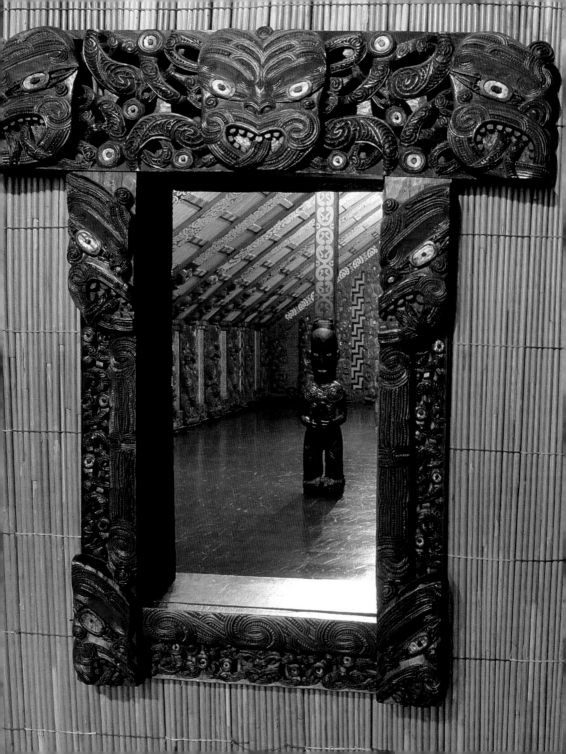

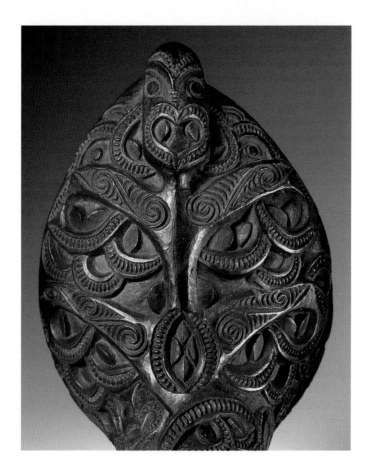

▌ *Tattoo art evolved from Polynesian tradition, with curvilinear or spiral motifs.*
▌ *Die Kunst der Tätowierung entstammt aus der polynesischen Tradition mit ihren kurven- oder spiralförmigen Motiven.*
▌ *De kunst van het tatoeëren ontwikkelt zich in de Polynesische traditie, waarbij de voorkeur wordt gegeven aan bochtige of spiraalachtige vormen.*
▌ *El arte del tatuaje evoluciona desde la tradición polinesia, privilegiando los motivos curvilíneos o en espiral.*

Cone used by the priests and chiefs of the Maori to get in touch with the gods and to have their face tattooed, New Zealand; wood
Von Maori-Priestern und Häuptlingen verwendeter Kegel, mit dem man in Kontakt zu den Göttern treten oder sich das Gesicht tätowieren lassen kann, Neuseeland; Holz
Trechter gebruikt door priesters en leiders van de Maori om in contact te komen met de goden of om het gezicht te tatoeëren, Nieuw-Zeeland; hout
Embudo utilizado por los sacerdotes y los jefes de los maoríes para entrar en contacto con los dioses o para hacerse tatuar el rostro, Nueva Zelanda; madera
ca. 1800-1820
Musee du quai Branly, Paris

▶ Detail of the portrait of Raharuhi Rukupo, chief responsible for the carvings of the Te Hau-Ki-Turanga meeting house; wood
Detail des Bildnisses von Raharuhi Rukupo, dem für das Schnitzwerk am Versammlungshaus Te Hau-Ki-Turanga verantwortlichen Meister; Holz
Detail van het portret van Raharuhi Rukupo, hoofd van het houtsnijwerk van het bijeenkomsthuis Te Hau-Ki-Turanga; hout
Detalle del retrato de Raharuhi Rukupo, jefe responsable de los tallados de la casa de reunión Te Hau-Ki-Turanga; madera
1842
National Museum of New Zealand, Wellington

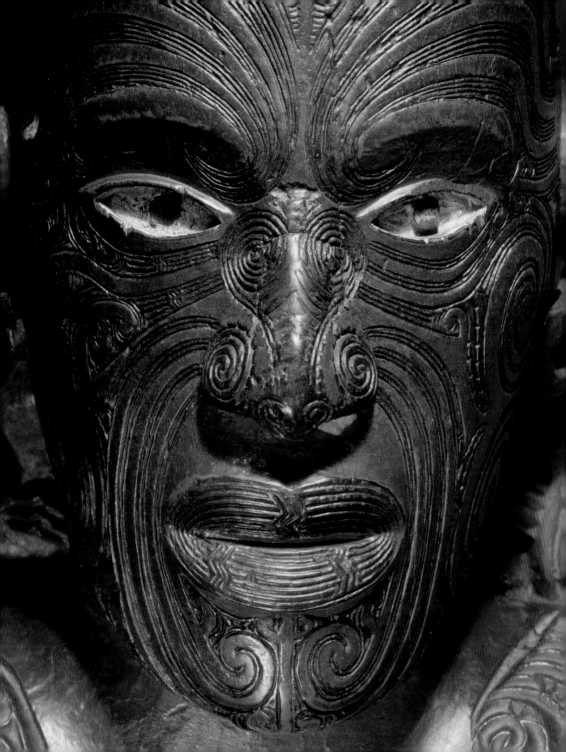

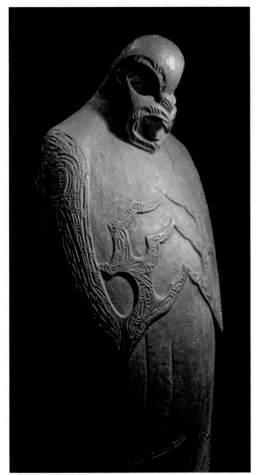
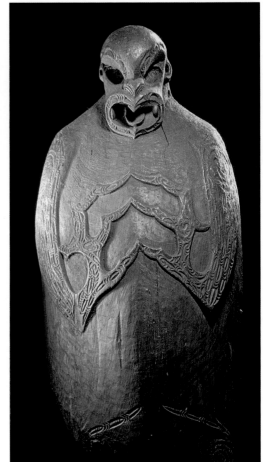

Views of the sarcophagus of the Ngapuhi Maori group; wood
Ansichten des Sarkophags der Maorigruppe Ngapuhi; Holz
Standpunten van de sarcofaag van de Ngapuhi Maori; hout
Vistas del sarcófago del grupo Ngapuhi Maorí; madera
ante 1800
National Museum of New Zealand, Wellington

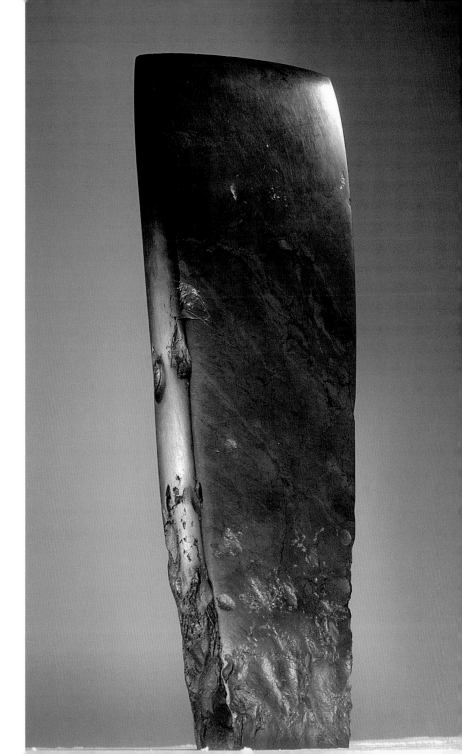

Sacred axe; stone
Heilige Axt; Stein
Heilige bijl; steen
Hacha sagrada; piedra
1400-1500
Taranaki Museum,
Taranaki

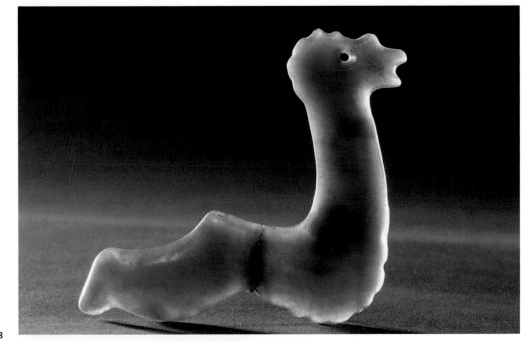

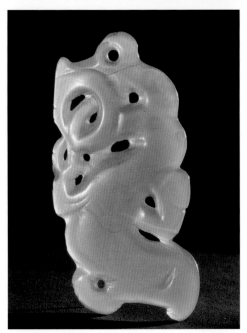

Ornament depicting an oceanic mythological
creature; jade
Ornament mit Darstellung einer mythologischen
Kreatur Ozeaniens; Jade
Ornament dat een mythologisch oceaanwezen
vertegenwoordigt; jade
Ornamento que representa una criatura mitológica
oceánica; jade
ca. 1750
Maori and Pioneer Museum, Okains Bay

Small ornament depicting a *Taniwha*, spirit of caves
and marine depths; jade
Kleines Ornament mit Darstellung eines *Taniwha*,
einem Geist der Grotten und Meerestiefen; Jade
Kleine afbeelding van een ornament *Taniwha*, een
geest van grotten of diepe zee; jade
Pequeño ornamento que representa un *Taniwha*,
espíritu de las grutas o de las profundidades
marinas; jade
ca. 1750
Maori and Pioneer Museum, Okains Bay

▌ Jade, a substance from the land that is reminiscent of the ocean, has a unique role in Maori tradition.
▌ Jade ist ein Erdmaterial, das an den Ozean erinnert und eine zentrale Rolle in der Maori-Tradition spielt.
▌ Jade, aards materiaal dat aan de oceaan doet denken, heeft een bijzondere rol in de Maori traditie.
▌ El jade, material terrestre que evoca el océano, juega un rol fundamental en la tradición Maorí.

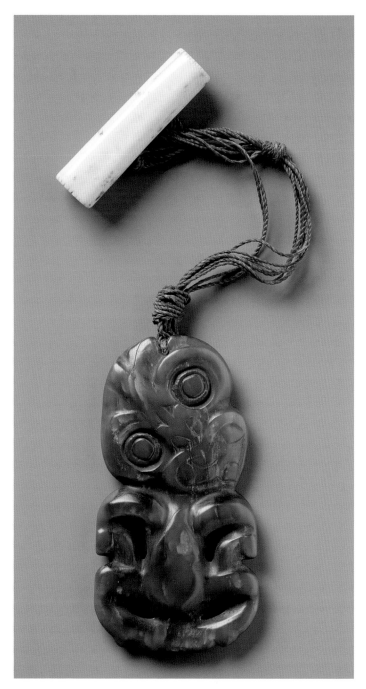

Hei-tiki, neck pendant handed down through the family; jade, bone and wax
Hei-tiki, ein in der Familie weitergegebener Halsanhänger; Jade, Knochen und Wachs
Hei-tiki, nekhanger doorgegeven in de familie; jade, bot en was
Hei-tiki, colgante transmitido por vía familiar; jade, hueso y cera
ca. 1800-1820
Musée du quai Branly, Paris

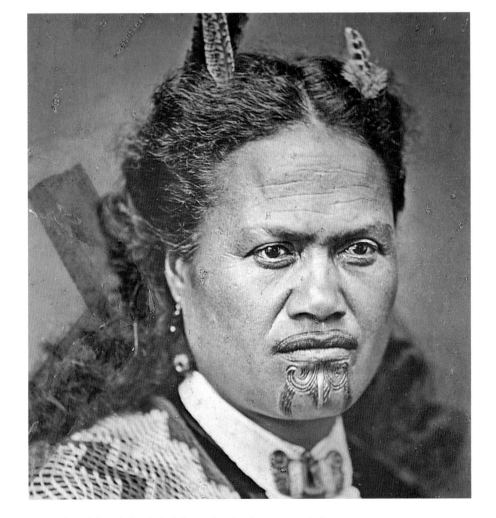

▌ Due to the cool climate in New Zealand, the prevalent place for tattoos was the face.
▌ Aufgrund des kühlen Klimas in Neuseeland werden Tätowierungen vor allem am Gesicht vorgenommen.
▌ Door de kenmerken van het klimaat in Nieuw-Zeeland heeft het gezicht de voorkeur bij toepassing van de tatoeage.
▌ Por las características del clima neozelandés, la cara es el lugar preferido para la aplicación del tatuaje.

Burton Brothers
(1866-1914)
Maori woman with tattoo on chin
Maori-Frau mit Tätowierung am Kinn
Vrouw met een Maori tatoeage op haar kin
Mujer maori con un tatuaje sobre el mentón
1868-1898
Musée du quai Branly, Paris

▶ **Sydney Parkinson**
(ca. 1745-1771)
Portrait of son of Maori chief
Porträt eines maorischen Häuptlingssohns
Portret van de zoon van een Maori opperhoofd
Retrato de hijo de jefe maorí
ca. 1768-1780
British Library, London

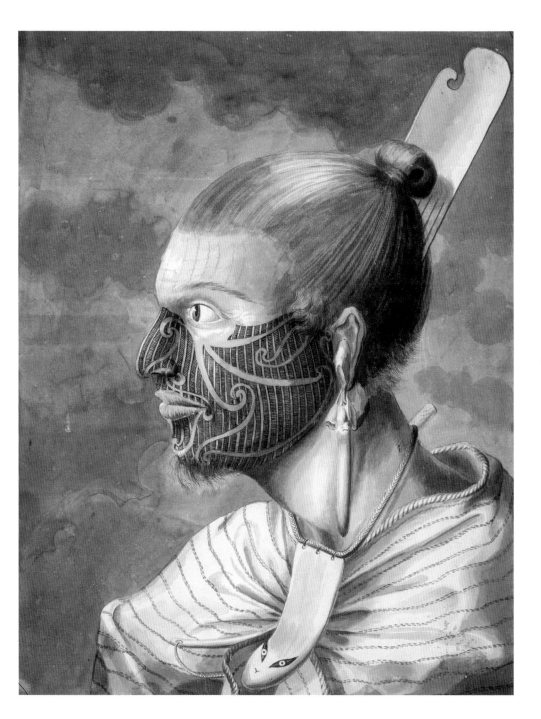

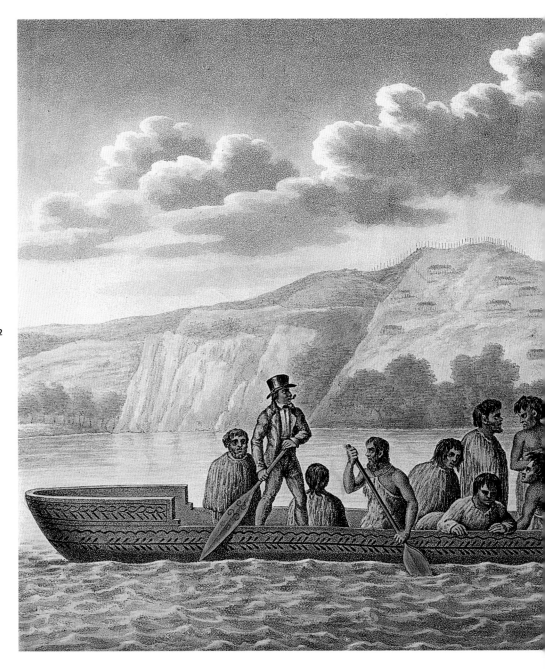

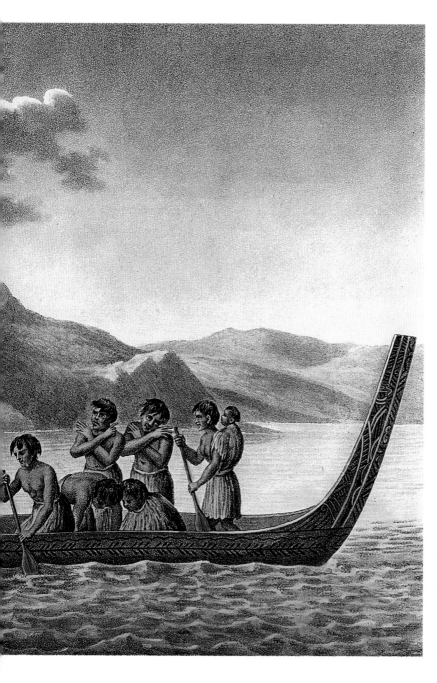

Maori pirogue sailing
Maori-Piroge in Fahrt
Varende Maori kano
Piragua maorí
navegando
1700-1800
Private collection
Private Sammlung
Privécollectie
Colección privada

© 2011 SCALA Group S.p.A.
62, via Chiantigiana
50012 Bagno a Ripoli
Florence (Italy)

Text and picture research: Stefano Vecchia

Printed in China 2011

ISBN (English): 978-88-6637-069-7
ISBN (German): 978-88-6637-068-0
ISBN (Dutch): 978-88-6637-070-3

Created and distributed in cooperation with Frechmann Kolón GmbH
www.frechmann.com

Project Management: E-ducation.it S.p.A. Firenze

Picture credits

Appendix to image credits:

THE METROPOLITAN MUSEUM OF ART, NEW YORK:
Statuette of the god Tu from Polynesia; Forked statue (the god Tupo) from Polynesia; Plaitwork mask (Papua, New Guinea); Wooden panel carved with water deities - back (Papua, New Guinea); Tapa cloth; from the Fiji Islands; Gauguin, Paul (1848-1903) Nave Nave Moe (Spring or Sweet Dreams), 1894 Oil on canvas, 73 x 98 cm.;Gauguin, Paul (1848-1903) Rave te hiti ramu (Presence of the Bad Demon); Gauguin, Paul (1848-1903) Idol with Seashell; Smith David (1906-1965) Australia, 1951 Painted steel, 6' 7 1/2' x 8' 11 7/8' x 16 1/8' (202 x 274 x 41 cm.); at base, 14 x 14' (35.6 x 35.6 cm). Gift of William Rubin. 1533.1968 ; Taniguchi, Yoshio (b. 1937) The Sculpture Garden and, beyond it, the new gallery building, looking west, 2004 Photograph by Timothy Hursley. 82087; Mask, from Sepik Nuova Guinea; Male figure, from Abelam (Papua New Guinea) Nuova Guinea. Legno scolpito e policromo; Sail Pirogue for high sea with a stabilizing item. From Bismarck Archipelago (Micronesia), 19th cent. Wood, coconut fiber, palm leaves, bamboo, length 14,98 m; width: 380 cm (stabilizing item included); h. 780 cm (foremast). Inv.: VI 23116. Photo: Waltraud Schneider-Schuetz; Australian Aborigine, 1937 Inventar-Nr.: V+W12780. Foto: Walther Günther Schreckenbach; Aborigines making fire, 1900 Foto: Charles Kerry; Artist from the Caroline Islands, Mens meeting house (bai) with a representation of the myth of fish growing on a breadfruit tree , 1907 Wood, l. 12,80 m. Inv 26.814; Rastrelli, Bartolomeo Francesco (1700-1771) Winter Palace, 1754-1762; Moai. Ahu Akivi Site (anthropomorfic monolith sculptures); North Territory - Alice Springs surroundings, sacred mountain of the Aboriginal people;Kimberley. Cave painting by Aboriginal people; Micronesian handicraft; North Territory, Katherine. Djanana tribe. Aboriginal people during a holy ceremony; Micronesia. Caroline Islands. Yap Islands. Ancient coins; Ayers Rock. sacred place called 'ngaltawaddi' by the Aboriginal people; North Territory - Kakadu National Park. Anbangbang gallery, cave paintings by aboriginal people; North Territory - Marquesas Islands - Nuku Hiva Island - Taiohae, lavic stone sculpture by the sculptor Uki (also called The Master); Marquesas Islands - Nuku Hiva Island - Taiohae, lavic stone sculpture depicting slaves; Australia, Katherine. Djauana tribe. Ceremony; Australia - Northern Territory - Kakadu National Park. Nourlangie Rock, Aboriginal rock paintings; Federated States of Micronesia - Yap Islands. Group of girls in traditional costume while playing a propitiatory rite for rain; French Polynesia (Overseas Territory of the French Republic) - Marquesas Islands - Island of Nuku Hiva - Hikokua. Site of Tohu. Tiki deity of fertility; A New Zealand war canoe with sail, 1768-1780 ; New Zealand war canoe, c1769-c1780; Three painted paddle blades, c1768-c1780; Parkinson, Sydney (c. 1745-1771) Portrait of a New Zealand Man', c1768-1780; Man of the Sandwich isles in a mask, c1768-c1780; Zatta, Antonio (fl. 1757-1797) Map of New Zealand, 1778; Natives in a canoe, New Guinea, 1887; Australian aborigines butchering a kangaroo (chromolithograph from 'Volkerkunde' by Friedrich Ratzel, Leipzig, 1885-1888); Aerial view of Uluru (Ayers Rock), Australia; Kata Tjuta (The Olgas), Northern Territory, Australia; Uluru (Ayers Rock), Northern Territory, Australia; Murray River, Victoria, Australia, 1877. Aboriginal men on the bank of the river; War Costume of the Natives of the Caroline islands', central Pacific Ocean, 1877; Tattooing', 1800-1900. Engraving to illustrate different tattooing styles from around the World. 'Negress, New Zealand Chieftain, New Zealand King, Caroline Islander, Hand and Foot of Dayak of Borneo, Japanese.' Original print by the Bibliographisches Institue, Leipzig; Captain Cook claims Botany Bay, New South Wales, Australia, 1770 (1886). James Cook proclaiming New South Wales a British possession after landing there on his first voyage of discovery. Wood engraving from 'Picturesque Atlas of Australasia, Vol I', by Andrew Garran, illustrated under the supervision of Frederic B Schell, (Picturesque Atlas Publishing Co, 1886); Natives of Queensland, Australia, late 19th century. Group portrait of Aboriginal people, whose culture and way of life were suppressed by white settlers. Photograph from 'Portfolio of Photographs, of Famous Scenes, Cities and Paintings' by John L Stoddar; View on the Dodinga River, New Guinea, 1877; Affray of Aboriginal, three miles from Brisbane, New South Wales', 1854. An engraving from 'The Illustrated London News', 17th June 1854; Medicine man of the Worgaia, central Australia, 1922. From 'Peoples of All Nations, Their Life Today and the Story of Their Past', volume I: 'Abyssinia to the British Empire', edited by JA Hammerton and published by the Educational Book Company (London, 1922); Biasioli, Angelo (19th cent.) Captain Cook observes an Offering, Sandwich Islands', 1778-1779 (19th century). James Cook (1728-1779) became the first European to visit the Hawaiian Islands when he arrived there in January 1778. He named the islands after the Earl of Sandwich, First Lord of the Admiralty at the time. After exploring and charting the west coast of North America and attempting, unsuccessfully, to pass through the Bering Strait, Cook returned to Hawaii in 1779. On February he was killed when a dispute with a group of islanders over the theft of one of the expedition's boats got out of hand and resulted in violence; House of the Ancients, Island of Tinian', c1820-1839, Male Figure, 18th-early 19th century Wood, H. 38 3/4 in. (98.4 cm).The Michael C. Rockefeller Memorial Collection, Bequest of Nelson A. Rockefeller, 1979. Acc.n.: 1979.206.1464; Male Figure (Moai Tangata), late 18th-early 19th century Wood, obsidian, bone, H. 16 in (40.6 cm). Gift of Faith-dorian and Martin Wright, in honor of Livio Scamperle, 1984. Acc.n.: 1984.526.Photo: Schecter Lee; Female Gable Figure (Dilukai), 19th-early 20th century Wood, paint, kaolin, H. 25 2/3 in (65.2 cm).The Michael C.; Rockefeller Memorial Collection, Gift of Nelson A. Rockefeller and Purchase, Nelson A. Rockefeller Gift, 1970. Acc.n.: 1978.412.1558a-d; Yam Cult Head (Yena), 19th-early 20th century Wood, paint, H. 42 1/2 in (108 cm).The Michael C. Rockefeller Memorial Collection, Purchase, Mr. and Mrs. Wallace K. Harrison Gift, 1974. Acc.n.: 1978.412.1699; Female Figure, 19th-20th century Wood, paint, H. 42 1/2 in. (108 cm).The Michael C. Rockefeller Memorial Collection, Purchase, Nelson A. Rockefeller Gift, 1962. Acc.n.: 1978.412.819; Skull Hook (Agiba), 19th-early 20th century Wood, paint, H. 55 7/8 in (141.9 cm).The Michael C. Rockefeller Memorial Collection, Gift of Nelson A. Rockefeller, 1969. Acc.n.: 1978.412.796; Eharo Mask, early 20th century Barkcloth, pigment, cane, dried grasses, sago palm leaves, H. 37 3/4 in. (95.9 cm).The Michael C. Rockefeller Memorial Collection, Gift of Nelson A. Rockefeller, 1972. Acc.n.: 1978.412.725; Ancestor Figure (Korwar), late 19th-early 20th century Wood, glass beads, H. 10 1/4 in. (26 cm). Purchase, Fred and Rita Richman Family Foundation Gift and Rogers Fund, 2001.Acc.n.: 2001.674 ; Funerary Carving, 19th-20th century Wood, paint, opercula shell, facsimile hair, Height 100-1/2 in.. The Michael C. Rockefeller Memorial Collection, Gift of Nelson A. Rockefeller, 1972. Acc.n.:

1978.412.712.Photo: Schecter Lee, Facade, from Fifth Avenue looking southwest, 2006. The Metropolitan Museum of Art, New York, NY. Architects: East wing designed by Richard Morris Hunt (1827-1895); South wing designed by Charles Follen McKim (1847-1909) for McKim, Mead and White; House-post Figure, 19th century Wood, paint, fiber, 19. The Michael C. Rockefeller Memorial Collection, Gift of Nelson A. Rockefeller, 1969. Inv.1978.412.823; Bis Pole, Mid-20th century Wood, paint, fiber, 2000. The Michael C. Rockefeller Memorial Collection, Bequest of Nelson A. Rockefeller, 1979. Inv.1979.206.1611; Weather Charm (Hos), Late 19th–early 20th century Wood, stingray spines, fiber, lime, 20. Gift of Faith-dorian and Martin Wright Family, in memory of Douglas Newton, 2003. Inv.2003.243; Man's Sash (Tor). Caroline Islands, Late 19th–early 20th century Bana fiber, trade yarn, H x W: 4 3/4 x 72 7/8in. (12 x 185.1cm). Purchase, Caroline H. Newhouse Foundation Inc. Gift, 1982. Acc.n. 1982.351; Boomerang. Western Kimberley (Australia), Mid to late 19th century Wood, ocher, H x W x D: 21 7/8 x 4 1/2 x 3/8in. (55.6 x 11.4 x 1cm). The Michael C. Rockefeller Memorial Collection, Bequest of Nelson A. Rockefeller, 1979. Acc.n. 1979.206.1608; Dance Paddle (Rapa). Easter Island, Early 19th century Wood, H x W: 6 1/8 x 28 1/4 in. (15.5 x 71.8 cm). The Michael C. Rockefeller Memorial Collection, Gift of Mrs. Gertrud A. Mellon, 1972. Acc.n. 1978.412.1571; Fan (Drel or Ral). Marshall Islands , Late 19th–early 20th century Pandanus leaves, hibiscus fiber, H x W: 16 1/2 x 11in. (41.9 x 27.9cm). Gift of American Friends of the Israel Museum, 1983. Acc.n. 1983.545.5; Fragment of a Pendant (Marremarre Lagelag or Buni). Marshall Islands, 19th century or earlier Tridacna shell, H x W x D: 1 3/8 x 1/4 x 2 3/8in. (3.5 x 0.6 x 6cm). Gift of American Friends of the Israel Museum, 1983. Acc.n. 1983.545.19; Gable Ornament (P'naret). Vanuatu, Mid 20th century Fernwood, H x W x D: 43 1/4 x 15 3/4 x 21 1/2 in. (109.9 x 40 x 54.6 cm). The Michael C. Rockefeller Memorial Collection, Bequest of Nelson A. Rockefeller, 1979. Acc.n. 1979.206.1584; Sepik Mask. Papua New Guinea, 19th century Wood, H x W: 9 1/2 x 23 5/8in. (24.1 x 60cm). Rogers Fund, 1978. Acc.n. 1978.7; Shield. Cape York (Queensland, Australia), Mid to late 19th century Wood, paint, H x W x D: 30 1/4 x 14 1/4 x 4 5/8in. (76.8 x 36.2 x 11.7cm). The Michael C. Rockefeller Memorial Collection, Bequest of Nelson A. Rockefeller, 1979. Acc.n. 1979.206.1802; Bird Figure, Papua New Guinea, Date unknown Stone, Length 4-1/2 in.. Purchase, Discovery Communications Inc. Gift, 1996. Acc.n. 1996.373.2

Seated Figure, Caroline Islands, Late 19th–early 20th century Wood, shell, traces of paint and resin, H. 8 ¼ in. (21 cm). Purchase, Fred and Rita Richman Gift, in memory of Douglas Newton, 2003. Acc.n. 2003.8; Navigational Chart (Rebbilib). Marshall Islands, 19th-early 20th century Coconut midrib, fiber, 35 1/4 x 41 1/4 x 1 in. (89.5 x 104.8 x 2.5 cm). The Michael C. Rockefeller Memorial Collection, Gift of the Estate of Kay Sage Tanguy, 1963. Acc.n. 1978.412.826; Woman's valuable (toluk), Late 19th–early 20th century Turtle shell, H x W: 4 1/4 x 7 1/8 in. (10.8 x 18.1 cm). The Michael C. Rockefeller Memorial Collection, Gift of Mr. and Mrs. Sidney Burnett, 1960. Acc.n. 1978.412.756; Ancestor Figure, Early to mid 20th century Wood, paint, fiber, pig tusk, cassowary quills, H: 49 1/2 in. (125.7 cm). The Michael C. Rockefeller Memorial Collection, Bequest of Nelson A. Rockefeller, 1979. Acc.n.: 1979.206.1589; Body Mask (Det), Mid 20th century Fiber, sago palm leaves, wood, paint, H 65 3/4 in. (167 cm). The Michael C. Rockefeller Memorial Collection, Gift of Nelson A. Rockefeller and Mrs. Mary C. Rockefeller, 1965. Acc.n.: 1978.412.1282a. ; Family Emblem/Maternity Mat, Nauro (Micronesian South Pacific). Late 19th-early 20th century Pandanus leaves, feathers, shell beads, sharks teeth, fiber, H: 5 3/4' (14.6 cm). Gift of American Friends of the Israel Museum, 1983. Acc.n.: 1983.545.27.; Feast Bowl (Kelemui?), Papua New Guinea, Admiralty Islands, Lou, Matankol. Late 19th-early 20th century Wood, W: 53' (134.6 cm). The Michael C. Rockefeller Memorial Collection, Bequest of Nelson A. Rockefeller, 1979. Acc.n.: 1979.206.1453.; Pendant or Head Ornament (Kapkap), Papua New Guinea, Admiralty Is., Matankol (?). Late 19th-early 20th century Tridacna shell, turtle shell, fiber, glass bead, Diam: 3 1/4' (8.3 cm). The Michael C. Rockefeller Memorial Collection, Gift of Mr. and Mrs. John J. Klejman, 1960. Acc.n.: 1978.412.739; Figure (Gra or Garra), Middle Sepik, Korewori River, Papua New Guinea, Bahinemo, Namu village. Late 19th-early 20th century Wood, paint, H: 31 1/2' (80 cm). The Michael C. Rockefeller Memorial Collection, Purchase, Mr. and Mrs. John J. Klejman Gift and Nelson A. Rockefeller Gift, 1968. Acc. n.: 1978.412.1526; Mask, Lower Sepik, Papua New Guinea, Biwat. Late 19th-early 20th century Wood, paint, fiber, H: 12 1/8' (30.8 cm). The Michael C. Rockefeller Memorial Collection, Bequest of Nelson A. Rockefeller, 1979. Acc.n.: 1979.206.1634; Debating Stool (Kawa Rigit), Middle Sepik, Papua New Guinea, Iatmul. 19th century Wood, paint, shell, H: 39 1/2' (100.3 cm). The Michael C. Rockefeller Memorial Collection, Anonymous Gift, in memory of Rene dHarnoncourt, 1968. Acc.n. 1978.412.1546; Canoe Board (Gope), Papua New Guinea, Kiwai. Late 19th-early 20th century Wood, paint, H: 32 1/4' (81.9 cm). The Michael C. Rockefeller Memorial Collection, Gift of Allan Frumkin, 1961. Acc.n.: 1978.412.768; Finial of a Ritual Staff or Lime Spatula, Papua New Guinea, Massim region. 19th-early 20th century Wood, H: 5 1/4' (13.3 cm). The Michael C. Rockefeller Memorial Collection, Purchase, Nelson A. Rockefeller Gift, 1966. Acc.n.: 1978.412.1503; Ceremonial Axe, Papua New Guinea, Massim region. Mid to late 19th century Wood, stone, fiber, L: 27 3/8' (69.5cm). The Michael C. Rockefeller Memorial Collection, Bequest of Nelson A. Rockefeller, 1979. Acc.n.: 1979.206.1526; Male Figure (Malita Malagbwag or Murup), Lower Sepik, Papua New Guinea, Murik. 19th-early 20th century Wood, H: 7 1/2' (19.1 cm). The Michael C. Rockefeller Memorial Collection, Purchase, Nelson A. Rockefeller Gift, 1965. Acc.n.: 1978.412.845; Betel-nut Mortar, Lower Sepik, Papua New Guinea, Murik. 19th-early 20th century Wood, H: 6' (15.2 cm). The Michael C. Rockefeller Memorial Collection, Purchase, Nelson A. Rockefeller Gift, 1965.Acc.n.: 1978.412.846; Mask (Mai), Middle Sepik,

Papua New Guinea, Nyaula (western) Iatmul. Late 19th-early 20th century Wood, paint, fish vertebrae, H: 28' (71.1 cm). The Michael C. Rockefeller Memorial Collection, Bequest of Nelson A. Rockefeller, 1979. Acc.n.: 1979.206.1480; Mask, Papua New Guinea, probably Umboi or Siassi Islands. 19th century Wood, paint, H: 18 1/8' (46 cm). The Michael C. Rockefeller Memorial Collection, Gift of Nelson A. Rockefeller, 1972. Acc.n.: 1978.412.721; Ceremonial Bowl, Papua New Guinea, Tami Islands. 19th-early 20th century Wood, traces of lime pigment, L: 18 1/4' (46.4cm). The Michael C. Rockefeller Memorial Collection, Bequest of Nelson A. Rockefeller, 1979. Acc.n.: 1979.206.1767. ; Suspension Hook, Papua New Guinea, Tami Islands. 19th century Wood, H: 18' (45.7 cm). Rogers Fund, 1980. Acc.n.: 1980.495; Head, Papua New Guinea, Wapo Creek, probably Gope. 19th century Wood, H : 7 5/8' (19.4 cm). The Michael C. Rockefeller Memorial Collection, Bequest of Nelson A. Rockefeller, 1979. Acc.n.: 1979.206.1580; Mask (Le op), Australia, Torres Strait, Erub Island. Mid to late 19th century Turtle shell, hair, fiber, pigment, H: 16 1/8' (41cm). The Michael C. Rockefeller Memorial Collection, Gift of Nelson A. Rockefeller, 1972. Acc.n.: 1978.412.729; Female Figure (Moai Papa), Chile, Rapa Nui (Easter Island), 19th century Wood, glass, paint, H: 23 5/8' (60 cm). The Michael C. Rockefeller Memorial Collection, Bequest of Nelson A. Rockefeller, 1979. Acc.n.: 1979.206.1478.

THE MUSEUM OF MODERN ART, NEW YORK
Smith David (1906-1965) Australia, 1951 Painted steel, 6' 7 1/2' x 8' 11 7/8' x 16 1/8' (202 x 274 x 41 cm); at base, 14 x 14' (35.6 x 35.6 cm). Gift of William Rubin. 1533.1968; Taniguchi, Yoshio (b. 1937) The Sculpture Garden and, beyond it, the new gallery building, looking west, 2004 Photograph by Timothy Hursley. 82087.